D0209248

Beyond Critique

Beyond Critique: Contemporary Art in Theory, Practice, and Instruction

Edited by
Pamela Fraser and Roger Rothman

BLOOMSBURY ACADEMIC
NEW YORK · LONDON · OXFORD · NEW DELHI · SYDNEY

BLOOMSBURY ACADEMIC
Bloomsbury Publishing Inc
1385 Broadway, New York, NY 10018, USA
50 Bedford Square, London, WC1B 3DP, UK

BLOOMSBURY, BLOOMSBURY ACADEMIC and the Diana logo are
trademarks of Bloomsbury Publishing Plc

First published in the United States 2017
Paperback edition first published 2018

© Pamela Fraser, Roger Rothman, and Contributors, 2017

Cover design: Irene Martinez Costa
Cover image © Pamela Fraser, March 3, 2015, 2:05 p.m., Barnard, 2015

All rights reserved. No part of this publication may be reproduced or
transmitted in any form or by any means, electronic or mechanical,
including photocopying, recording, or any information storage or
retrieval system, without prior permission in writing from the publishers.

Bloomsbury Publishing Inc does not have any control over, or responsibility for,
any third-party websites referred to or in this book. All internet addresses given
in this book were correct at the time of going to press. The author and publisher
regret any inconvenience caused if addresses have changed or sites have
ceased to exist, but can accept no responsibility for any such changes.

Names: Fraser, Pamela, editor. | Rothman, Roger, editor. | College Art Association (U.S.).
Annual Conference (101st : 2013 : Los Angeles, Calif.)
Title: Beyond critique : contemporary art in theory, practice, and instruction /
edited by Pamela Fraser and Roger Rothman.
Other titles: Beyond critique (Bloomsbury (Firm))
Description: New York : Bloomsbury Academic, 2017. | Outgrowth of a panel discussion at
the 2013 conference of the College Art Association in New York. |
Includes bibliographical references and index.
Identifiers: LCCN 2016045118 (print) | LCCN 2016045818 (ebook) |
ISBN 9781501323461 (hardback : alk. paper) | ISBN 9781501323454 (ePUB) |
ISBN 9781501323447 (ePDF)
Subjects: LCSH: Art, Modern–21st century.
Classification: LCC N6497 .B49 2017 (print) | LCC N6497 (ebook) | DDC 709.05–dc23
LC record available at https://lccn.loc.gov/2016045118

ISBN: HB: 978-1-5013-2346-1
PB: 978-1-5013-4718-4
ePub: 978-1-5013-2345-4
ePDF: 978-1-5013-2344-7

Typeset by RefineCatch Limited, Bungay, Suffolk

To find out more about our authors and books visit
www.bloomsbury.com and sign up for our newsletters.

Contents

Notes on Contributors

Adrian Anagnost is Assistant Professor of Art History in the Newcomb College of Art at Tulane University. Her research centers on issues of urban space, architectonic form, and theories of the social in modern and contemporary art. Essays on Brazilian artist Waldemar Cordeiro's approach to mass politics, embodiment and spectatorship in the work of Spanish filmmaker Pedro Almodóvar, and the problem of medium for the Polish avant-garde have appeared or are forthcoming in *Hemisphere: Visual Cultures of the Americas*, *Chicago Art Journal*, and *Woman's Art Journal*. Her current book project is entitled *Ambientes: Art and Urban Space in Modern Brazil*.

Jen Delos Reyes is a creative laborer, educator, writer, radical community arts organizer, and author of countless emails. She is the director and founder of Open Engagement, an international annual conference on socially engaged art that has been active since 2007. Delos Reyes currently lives and works in Chicago, Illinois, where she is the Associate Director of the School of Art and Art History at the University of Illinois at Chicago.

Andreas Fischer holds an MFA in Studio Art and an MA in Art History from The University of Illinois at Chicago, and a BFA in Studio Art from the School of the Art Institute of Chicago. He also attended the Universität der Künste, Berlin. Exhibitions include Museum of Contemporary Art, Chicago; Mattress Factory, Pittsburg; Hyde Park Art Center, Chicago; Nathalie Karg Gallery and Hudson Franklin Gallery, New York; Devening Projects and Andrew Rafacz Gallery, Chicago; among others. Awards include an Artadia Grant and The International Studio and Curatorial Program Artadia Residency in New York City. He is Associate Professor at Illinois State University.

Pamela Fraser is an artist whose work explores possibilities for abstraction. Her exhibitions include Galerie Schmidt Maczolleck in Cologne, Germany; asprey jacques in London, England; Casey Kaplan in New York; the Blaffer Museum in Houston, Texas; the Albright-Knox Art Gallery in Buffalo, New York; Wurttembergischer Kunstverein in Stuttgart, Germany; and Omi International

Art Center in Ghent, New York. In addition to her art practice, she writes about art and organizes exhibitions. Her book *How Color Works: Color Theory in the 21st Century* will be published by Oxford University Press in 2017. Fraser is Assistant Professor of Studio Art at the University of Vermont.

Coco Fusco is a New York-based interdisciplinary artist and writer who explores the politics of gender, race, war, and identity. She has won numerous awards, including 2016 Greenfield Prize in Visual Art; Guggenheim Fellowship (2013); Absolut Art Award for Art Writing (2013); CINTAS Foundation Visual Arts Fellowship (2014–2015); USA Berman Bloch Fellow (2012); and Herb Alpert Award in the Arts (2003). Fusco received her BA in Semiotics from Brown University (1982), her MA in Modern Thought and Literature from Stanford University (1985), and her PhD in Art and Visual Culture from Middlesex University (2007).

Anthony E. Grudin is Associate Professor of Art History at the University of Vermont. He is the author of *Working Class Warhol* (University of Chicago Press, forthcoming). His articles have appeared in *Warhol: Headlines* (National Gallery, 2011), *13 Most Wanted Men: Andy Warhol and the 1964 World's Fair* (Queens Museum/Andy Warhol Museum, 2014), *ON&BY Andy Warhol* (Whitechapel/MIT, 2016), *October*, *Criticism*, and *Oxford Art Journal*. He is working on a second book on Warhol and animal life.

David Joselit is Distinguished Professor in the Art History PhD Program at the CUNY Graduate Center. He has taught at the University of California, Irvine, and Yale University where he was Department Chair from 2006–2009. Joselit is author of *Infinite Regress: Marcel Duchamp 1910–1941* (MIT Press, 1998); *American Art Since 1945* (Thames and Hudson, World of Art series, 2003); *Feedback: Television Against Democracy* (MIT Press, 2007); and *After Art* (Princeton University Press, 2012). He is an editor of the journal *October* and writes regularly on contemporary art and culture.

Grant Kester is a Professor of Art History in the Visual Arts department at the University of California at San Diego. His publications include *Art, Activism and Oppositionality: Essays from Afterimage* (Duke University Press, 1998), *Conversation Pieces: Community and Communication in Modern Art* (University of California Press, 2004) and *The One and the Many: Contemporary Collaborative*

Art in a Global Context (Duke University Press, 2011). He is currently completing work on the book *Collective Situations: Readings in Contemporary Latin American Art 1995–2010*, co-edited with Bill Kelley (Duke University Press, forthcoming 2017).

Billie Lee is an interdisciplinary artist and a cultural critic. She holds an MFA from Yale University, a BFA from the Rhode Island School of Design and has taught at the University of Hawai'i at Mānoa, University of New Haven, Yale University Art Gallery, and the Queens Museum. Lee is currently a PhD candidate in American Studies at the University of Hawai'i at Mānoa working in the areas of contemporary art and pedagogy, critical and cultural theory, and art and politics.

Judith Leemann is an artist, educator, and writer living in Boston. She holds an MFA from the School of the Art Institute of Chicago and is Associate Professor in Fine Arts 3D/ Fibers at the Massachusetts College of Art and Design. Her writings have appeared in *Textile: A Journal of Cloth and Culture*, as well as in the edited volumes *The Object of Labor: Art, Cloth, and Cultural Production* (School of the Art Institute of Chicago and MIT Press, 2007) and *Collaboration through Craft: Theory and Practice* (Bloomsbury Academic, 2013).

Sofia Leiby is an artist based in New York. Recent exhibitions include solo exhibitions at Kimmerich Gallery, Berlin, Clifton Benevento, New York, and Michael Jon Gallery, Miami, Florida; and was included in group exhibitions at American Medium, New York; The Composing Rooms, Berlin; Joe Sheftel, New York; 247365, New York; Loyal Gallery, Stockholm; and Future Gallery, Berlin. She has contributed criticism to rhizome.org, *BOMB* magazine, *Newcity Chicago*, *WOW HUH* and was a founding editor of *Chicago Artist Writers* and contributing editor of *Pool* journal.

Shona Macdonald was born in Aberdeen, Scotland, and lives and works in Western Massachusetts where she is a Professor of Studio Art at the University of Massachusetts, Amherst. She has had selected solo exhibitions in Wellington, New Zealand; Berlin, Germany; Boston, Massachusetts; New York; Chicago, Illinois; Roswell, New Mexico; and Los Angeles, California. Her work has been reviewed in *Art in America*, *Art News*, the *LA Times*, *Chicago Tribune*, *Chicago Sun Times*, and *Harpers'* magazine. She has received grants from the

Pollock-Krasner Foundation, the Roswell Artist-in-Residence program, Can Serrat, Barcelona, Spain, the Cromarty Arts Trust, Scotland, and Ballinglen, Co. Mayo, Ireland.

AnnMarie Perl is an historian of twentieth-century European and American art. Currently, her main project is a book, titled *The Integration of Showmanship into Modern Art*. She is a Postdoctoral Research Associate and Lecturer in the Department of Art and Archaeology at Princeton University.

Paul Preissner runs Paul Preissner Architects, which is located in Chicago. He has written about architecture for publications including *Volume*, *Clog*, *PLOT*, and *NewCity*. Preissner's work has been exhibited in the United States and abroad, including the Museum of Contemporary Art in Chicago, the Chicago Architecture Biennial, the Buenos Aires International Biennale of Architecture, and the Rotterdam Biennale, and is a part of the permanent collection at the Art Institute of Chicago. He is also a founding partner of Paul or Paul, and an Associate Professor of Architecture at the University of Illinois at Chicago.

Roger Rothman is the Samuel H. Kress Professor of Art History at Bucknell University. He is the author of *Tiny Surrealism: Salvador Dali and the Aesthetics of the Small* (Nebraska 2012). His writings have been published in journals such as *Modernism/Modernity*; *Aesthetics and Art Criticism*; *Culture, Theory and Critique*; and *symplokē*. He is currently at work on a book entitled *Uncritical: Fluxus and the Affirmative Avant-Garde*.

Craig Saper is a Professor at the University of Maryland, Baltimore County and the author of multiple books, including *The Amazing Adventures of Bob Brown*, *Intimate Bureaucracies*, *Networked Art*, *Artificial Mythologies*, as well as journal issues on *Posthumography* and *Drifts*, and chapters in *The Fluxus Reader*, *At A Distance*, *Networks*, *Information*, and *Anna Banana*. He is editor/co-editor of *Electracy*, *Imaging Place*, and he co-curated TypeBound (readies.org/typebound), Noigandres, and Assemblings. He has also edited four new editions of Brown's publications: http://rovingeyepress.com.

Karen Schiff is an artist and writer based in New York. She holds an MFA in Studio Art from the School of the Museum of Fine Arts / Tufts University, and a PhD in Comparative Literature and Literary Theory from the University of

Pennsylvania. Her artwork is in private, public, and corporate collections in the US and Europe; her writings have been published in *Art in America*, *Art Journal*, *Hyperallergic*, *The Brooklyn Rail*, and elsewhere. She teaches at the Rhode Island School of Design and at the Boston Architectural College, where she created the BAC's undergraduate Degree Project curriculum in Design Studies.

Acknowledgments

Beyond Critique grew out of a panel discussion at the 2013 conference of the College Art Association in New York. Organized by Pamela Fraser and Randall Szott, "Critiquing Criticality" involved the following participants: Michael Aurbach, Charles Dobson, Andreas Fischer, Elisabeth Friedman, Shona Macdonald, AnnMarie Perl, Roger Rothman, Karen Schiff, and Buzz Spector. We would like to thank all of the panel's discussants for having inspired this project, and thank Randall Szott for the crucial role he played, including forming the initial idea.

Pamela thanks the University of Vermont as well as colleagues and friends who have contributed to this dialogue in both specific and general ways. Greatest thanks go to Randall and Oliver Szott for patient listening and sound advice.

For providing funds to support this publication, Roger thanks Bucknell University and the Samuel H. Kress Professorship. Additional thanks go to Matthew Simms, Julie Vandivere, and Ian Verstegen for responding so generously and insightfully to the many queries they received over the course of this book's development.

Permissions

Coco Fusco's chapter is a slightly shorter version of a text first published in *Modern Painters*, February 22, 2012 and online at www.blouinartinfo.com, http://www.blouinartinfo.com/news/story/760842/still-in-the-cage-thoughts-on-two-undiscovered-amerindians-20-years-later.

David Joselit's chapter was previously published in *October* 103 (Winter 2003), 3–13.

Grant Kester's chapter was previously published in *FIELD* 2 (Fall 2015), http://field-journal.com/issue-2/kester-2.

Portions of Sofia Leiby's chapter were published online in 2014 at http://wowhuh.com/posts/062.html.

Craig Saper's chapter is a modified version of a text previously published as *Intimate Bureaucracies: A Manifesto*. Brooklyn, NY: Punctum Books, 2012.

Introduction: Beyond Critique

Pamela Fraser and Roger Rothman

The collapse of grand narratives—of coordinating principles on which consensus is built—has long been considered a defining feature of postmodernism (Lyotard 1984). Nevertheless, at least one grand narrative has held on long after modernism's eclipse: *critique*. For the bulk of the past century, and up to the present, critique has been the *sine qua non* of advanced art. Recently, however, the ground beneath it has begun to show signs of wear, and alternatives are springing up in its cracks. *Beyond Critique* seeks to spotlight these emergent alternatives and map the contours of their *post*-critical ambitions.

Critique's animating ambitions derive from Frankfurt School Critical Theory and its understanding of both art and theory as attempts "to liberate human beings from the circumstances that enslave them" (Horkheimer 1975: 244). The essays in this volume do not seek to challenge the original aims of Critical Theory, but to reconsider their effectiveness in the present. The authors represented here all seek, in one way or another, to identify alternatives to critique—alternatives aimed at enabling observations and practices currently inaccessible within the confines of the critical enterprise.

In the wake of the Frankfurt School's defense of critique as the first and most crucial step in the dialectics of liberation, the art and criticism of the past century witnessed a pair of nearly simultaneous schisms. On the one hand, there was the shift from modernist orthodoxy (emblematized by Clement Greenberg's notion of medium specificity) to postmodernist pluralism (evidenced by Jean-François Lyotard's suspicion of all metanarratives). On the other hand, the mid-twentieth century also witnessed the shift from the historical avant-garde and its logic of relentless negativity, to the neo-avant-garde and its more ambivalently positioned practices of institutional critique. Institutional critique, initiated in the sixties and seventies by artists such as Daniel Buren, Michael Asher, and Hans Haacke, grew more performative in the eighties and nineties with the work of artists such

as Andrea Fraser and Fred Wilson, and more participatory in the past ten to fifteen years with the projects of Tania Bruguera, Thomas Hirschhorn, and Santiago Sierra.

The question today is whether either of these two positions—postmodernist pluralism or the neo-avant-gardist critique of institutions—are still capable of responding effectively to the problems of the present. Pluralism, by virtue of the absence of an organizing principle, is incapable of resistance, reform, or revolution. Unable to fashion a new metanarrative to disrupt the established state of affairs, pluralism yields variety within conformity. As such, pluralism has seen only a handful of adherents; to most, it is hopelessly inadequate to the task.

However, the second position, institutional critique, has been hailed for decades as the avant-garde's best chance for survival within the context of neoliberal politics and global capitalism. Though failing to perform the immediately transformative work of the historical avant-garde (Tristan Tzara's "great negative work of destruction"), institutional critique has long been defended as enabling such work to begin at some unidentified future date. The semiotic analysis performed by Roland Barthes in his 1957 classic, *Mythologies* is perhaps the earliest incarnation of the liberatory possibilities announced by the turn from avant-garde negation to neo-avant-garde critique. Where the Dadaist destroys, the mythologist "unmasks" (Barthes 1972: 128). One can identify a similar turn from material destruction to semiotic unmasking in the shift from Nietzschean self-overcoming to Derridian deconstruction. Where the former terminates in the figure of the overman, the latter, precisely because it has substituted critique for negation, never suffers the fate of finality. It is interminable. As Derrida put it, deconstruction speaks to "the necessity of an interminable analysis: the hierarchy of dual oppositions always reestablishes itself. Unlike those authors whose death does not await their demise, the time for overturning is never a dead letter" (Derrida 1981: 42).

So, unlike the situation faced by the avant-garde, a situation in which the logic of negativity leads inevitably and ultimately to the position of self-negation—the result of what theorist Matei Călinescu described as the avant-garde's compulsion, motivated "by its own sense of consistency," to "commit suicide" (Călinescu 1987: 124), there is nothing inherent in the logic of critique to compel it to destroy itself. Beneath every myth uncovered lies yet another myth still deeper. The work of critique is never complete, can never be complete. As such, critique suffers a fate altogether different from that of the avant-garde; not self-destruction, but self-incorporation. As artist Andrea Fraser has argued, critique doesn't die, it is merely "institutionalized," defanged and domesticated (Fraser 2006: 123–35).

Another way to put it is this: where the avant-garde will eventually destroy itself, critique will merely "run out of steam" (Latour 2004). Because the critique's object is ideological, not material, there is no moment of cataclysmic self-annihilation. As a semiotic system, there is always another thread to be found on the screw. So, though never under threat of self-annihilation, critique can only ever suffer exhaustion. The question concerning the present can now be refined: is it the case that critique's engine has indeed run out of fuel?

A number of indicators suggests that this may be the case. Consider the work of Sierra for example. If Călinescu is correct in his description of the avant-garde as a "parody of modernity itself" (Călinescu 1987: 141), then might we not identify Sierra's theater of exploitation—paying prostitutes in heroin to have their backs tattooed, paying workers to hide silently in cardboard boxes as gallery goers wander unknowingly around them—as itself a parody? Is it not, at least in some sense, a "parody of the *avant-garde*"? Sierra's boxed laborers, displayed for gallerists yet hidden beneath cardboard, are in some sense an involution of the critical practice that Hans Haacke initiated in 1971 when he proposed to include detailed records of the real-estate holdings of one of New York City's biggest landlords. The materials included one hundred and forty-two photographs of buildings held by the Harry Shapolsky company (the bulk of which were from the poor and decidedly non-white neighborhoods of the Lower East Side and Harlem) as well as typewritten documentation of the various holdings (addresses, lot sizes, building type, etc.). Its unequivocal implication of the wealthy patrons who support the museum through profits earned by such exploitative real-estate holdings provoked the museum director, Thomas Messer, to demand that it (along with two other works) be removed. Haacke refused and the exhibition was cancelled, just a month and a half before it was to open. The curator, Edward Fry was fired almost immediately.

When a similar controversy erupted some twenty years later and twenty blocks south, at the 1993 Biennial of the Whitney Museum of American Art, the curatorial team, led by Elisabeth Sussman, had little to fear. Indeed, the myriad practices of institutional critique that Haacke had almost single-handedly generated were on full and unapologetic display. Among the most prominent works on view were the admissions buttons designed by the artist Daniel Martinez that read "I can't imagine ever wanting to be white." Like Haacke's *Shapolsky et al.*, Martinez's buttons hold an uncomfortable mirror to the artworld and the systemic privileges that maintain it. At the same time, however, the focus is redirected, judo-like, away from the institution's center of power—the 1 percent who finance its production—toward the 99 percent who consume it.

Jumping forward another twenty years—to Laura Hoptman's exhibition of contemporary painting at the Museum of Modern Art (December 2014)—we find ourselves faced with an entirely different conception of artistic practice, in which the relentless negativity of institutional critique is set aside in favor of a transhistorical universality. "The Forever Now: Contemporary Painting in an Atemporal World," was MoMA's first group show of new painting since "The New American Painting," MoMA's famed 1958 exhibition of Abstract Expressionist and Color Field Painters that traveled through Europe as evidence of the US's cultural superiority (the show included almost all of the most celebrated American abstractionists of the period, including Franz Kline, Willem de Kooning, Robert Motherwell, Barnett Newman, Jackson Pollock, and Mark Rothko). Like its predecessor, "The Forever Now," included seventeen artists (thirteen Americans), but the tone of muscular domination and absolutely contemporaneity is nowhere to be found. Simultaneously effortless and labored, grand and grandiloquent, with tongue in cheek and sweat on brow, works like those of Laura Owens, Mark Grotjahn, Nicole Eisenman, and Josh Smith reconstruct the modernist picture plane not as open field for heroic battle but as inchoate archive of aesthetic endeavors past and present. "The New Americans" was mounted during a period of unprecedented economic growth and political dominance; "The Forever Now" comes at a radically different moment in American history: after 9/11, the great recession, and the Occupy movement. Though both exhibits posited universality, the former aligned it with mastery, the latter with its absence. This new condition, of universality without mastery, may well be the most defining feature of the present. If so, it will determine much of what comes of both the art of institutional critique and of any endeavor to go beyond it.

The ambiguities of critique have become all the more problematic now that we are fully immersed in an international art market in which museum institutions have become inextricably enmeshed with the collections and ambitions of a handful of ultra-wealthy collectors. As Kester notes in his contribution to this volume, the present paradox is emblematized by Swiss artist Thomas Hirschhorn's piece *Gramsci Monument*. Though ostensibly aimed at performing a critical appraisal of contemporary institutions of power well beyond the walls of the museum and the private collection, in fact the network of relations activated by the monument remained those of art market, rather than the small, local institutions that might have effected real change. This, in addition to the skyrocketing monetary valuation of new art works, and the subsequent creation of a new investor class for whom art is pure commodity,

confirms what must be considered a failure of institutional critique to have provoked extra-artistic change. One conclusion is this: it is naive to persist in the claim that critique is the only antithesis to complicity. Indeed, in a number of instances (of which *The Gramsci Monument* may be one) critique has itself become a form of complicity. To the degree that this is the case, now is the time to explore whatever alternatives seem at all promising.

The sixteen essays collected here approach the problem of critique from different perspectives. Nevertheless, one constant emerges: where critique is *corrective*, post-critique is *expansive*. Critique begins with the identification of error (objective, impersonal, singular) and it ends with the revelation of the true. Post-critique begins with the identification of limitations (subjective, personal, plural) and it never ends—because limitations may shrink and shift, but they can never be made to disappear entirely. It is a "thought style"—to use Rita Felski's recent term—that seeks to go beyond the hermeneutics of suspicion at the core of the critical enterprise (Felski 2015).

Beyond Critique is divided into three sections, "History and Theory," "Practice," and "Instruction." The first of the three provides historical and theoretical reflections on the critic and its alternatives, opening with a reprint of David Joselit's reflection on the history of late twentieth-century art criticism. Framed as a response to Craig Owens's enormously influential essay, "The Allegorical Impulse: Toward a Theory of Postmodernism" (Owens 1980), Joselit's essay directs our attention to the pivotal role played by the journal *October* in the establishment of institutional critique as the privileged mode of artistic production. By reclaiming the protean career of Michael Shamberg, an artist typically overlooked in accounts of sixties and seventies art, Joselit offers a different postmodernist allegory, one in which criticality and subversion are supplemented by a positive program of developing "new modes of image consumption." A related act of historical recovery lies at the center of Roger Rothman's account of Fluxus as an exemplary affirmative movement. Rothman argues that Fluxus artists, like Shamberg, sought to go beyond the limits of institutional critique as practiced by the pop, minimalist, and conceptual artists of the period. Drawing on the writings of Eve Kosofsky Sedgwick and Bruno Latour, Rothman argues that John Cage and the Fluxus artists who followed in Cage's wake, set out to develop what he calls an "affirmative avant-garde" at odds with both the historical avant-garde of the teens and twenties and the postwar neo-avant-garde privileged by the same *October* critics identified by Joselit. AnnMarie Perl looks back at the historical formation

of the concept of "criticality" to reconsider the significance of Donald Kuspit's writings, writings long overshadowed by those of Owens and other theorists of institutional critique. At the same time, Perl proposes that Sherrie Levine and other artists of the so called "Pictures Generation," who were identified by critics as emblematic of critical subversion, in fact repudiated such readings of their work. In doing so, Perl underscores the limitations of critique, especially in light of the historical responses to the AIDS crisis in the eighties. Like Perl, Anthony E. Grudin focuses on the works of Levine and other significant artists of the eighties. But rather than turn to theorists of the period in question, Grudin draws on the recent writings of Jacques Rancière to provide an alternative post-critical reading of the work of the Pictures Generation. Grudin's detailed analysis of Rancière's "politics of aesthetics" provokes a radical reassessment of these artists' works, and with it, an account of artistic practices that struggled to escape what Rancière dubbed "critical art's vicious circle." Paul Preissner's essay expands the purview of the previous essays by turning from art to architecture. Focusing on shifts within architectural circles during the turn of the new century, Preissner highlights the sense among architects that the limitations of the self-critical, deconstructive orientation of the previous generation of architectural theorists and practitioners was becoming impossible to ignore. In its place, notes Preissner, younger architects turned to the writings of Gilles Deleuze and computer software capable of complex visual simulation as a means with which to develop new architectural forms unencumbered (for both good and ill) by the dictates of the critical enterprise. The results, Preissner notes, at times revealed an "indifference to history and ideology alike" and thus serve as a cautionary conclusion to the essays in Part 1.

Part 2, "Practice," offers accounts by artists and historians on a range of post-critical practices. The section opens with a reflection by Coco Fusco on her seminal performance piece in collaboration with Guillermo Gómez-Peña: *Two Undiscovered Amerindians Visit the West*. In addition to reflecting on the piece itself, Fusco analyzes various changes to its critical reception, changes which Fusco demonstrates to be linked to shifts in the political climate of the moment. Adrian Anagnost's essay concerns the work of contemporary artists whose practice is deeply indebted to Fusco. Her text examines artists who have adopted the tactics of "the parasite" as a means of responding more effectively to contemporary networks of global capital. Focusing on the work of Theaster Gates and Tania Bruguera, Anagnost shows how their parasitic practices are rooted in a long history of procedures that have emerged within sites like Chicago, which lie

outside dominant art centers. With a concern for a related set of artists and ambitions, Grant Kester focuses on the negative consequences of maintaining critical distance from social systems in need of transformation. Identifying Thomas Hirschhorn as an artist celebrated for maintaining critical distance even as his work engages directly with the community, Kester argues that the result is a practice that prevents itself from effecting real social change. With a similar attention to the dynamics of community engagement, Sofia Leiby calls for the development of artistic communities outside the dominant art-world centers. Her proposal recalls the sorts of regionalist positions articulated by American artists in early part of the last century—and with them, a number of the same contradictions (in-group/out-group dynamics, self-promotion instead of self-critique, etc.). Whether such formations can work through these contradictions under the new conditions of the present remains an open question. Drawing upon a number of theorists introduced in Part 1 (Latour, Rancière, Sedgwick), Andreas Fischer focuses on a central dilemma faced by contemporary painters: what are the conditions under which painting can move beyond both modernist detachment and postmodernist critique? As Fischer notes, debates over "provisional painting" and "zombie formalism" speak to a context in which painting—abstract painting in particular—is struggling to redefine itself in the wake of postmodernism's demise. Setting recent works by Nicole Eisenman and Merlin James in dialog, Fischer offers an account of contemporary painting that eschews skepticism for faith, and deconstruction for reconstruction. Under the name dj readies, Craig Saper concludes Part 2 with a call for an art that is simultaneously "intimate" and "bureaucratic." Like Joselit in Part 1, Saper comprehends contemporary artistic practices within the expanded field of television, film, and now internet media. Recognizing the ineffectiveness of a frontal assault on contemporary media institutions, Saper's artistic alter-ego, dj readies, instead advocates an art of small-scale, intimate incursions into the institutional web. The ambition is self-consciously modest, a small-scale romanticism in which individual powerlessness is the ground for collective enthusiasms.

Part 3, "Instruction," focuses on critique in the classroom and introduces a range of pedagogical efforts to move beyond it. Before outlining the contributions in this section, it is worth drawing attention to our commitment to taking seriously the question of pedagogy in an environment in which teaching, especially the longstanding practice of studio critique (the "crit") has increasingly modeled itself after the ever-expanding logic of institutional critique.

The expectation that the studio crit will "unpack" and "expose" the flaws of work-in-progress is the result of a critical practice focused exclusively on distinguishing the real from the ideological, the true from the false. Though unquestionably indispensable, such a practice is, at the same time, insufficient. To think beyond critique is to reopen the question of teaching and learning as experiences that include the possibility of unpredictable insights and unexpected transformations.

The section opens with Billie Lee's essay on the use of critical discourse to interrogate critical discourse itself. Lee argues that the critical approach operates today as a rote performance, naturalized but emptied of meaning and purpose. Though the method is meant to liberate, Lee paints a solemn picture of the ways it can reinforce marginalization and especially diminish the agency of people of color. Karen Schiff argues against the pervasive hostility that is engendered when critique is established as the dominant paradigm within studio art education. In place of critique, Schiff proposes what she calls "consideration." Where critique is founded on separation and judgment, consideration begins with wonder and, as such, is generative and inclusive. Like Schiff, Jen Delos Reyes calls for moving beyond the negativity of critique. Detailing the MFA program at Portland State University as a model of instruction in which the central ambition is the cultivation of engagement rather than critical distance, she highlights the program's unorthodox practices and advocates for a pedagogy founded on compassion and caring. Where Delos Reyes's essay focuses on the institutional framework of studio instruction, Judith Leemann's contribution reports on a pedagogical experiment undertaken at MassArt and offers a concrete proposal for ways to transform the studio crit. Drawing in particular on the work of Stefano Harney and Fred Moten, Leemann identifies the ways in which critique can not only alienate some participants, but also bolster the very norms it attempts to overthrow. Her counterproposal, "to invent as relentlessly in their classroom as they do in their studio," is founded on the cybernetic theory of Gregory Bateson and its understanding of "noise"—that which eludes critical comprehension—as the emergent sign of the new. Part 3 concludes with Shona Macdonald's investigation of Lewis Hyde's concept of the gift as a model for studio instruction. Like Leemann, Macdonald offers both a theoretical framework for her pedagogy and a concrete description of its realization. Leemann's pedagogy utilizes artist Paul Ryan's practice of "threeing," a technique explicitly designed to decenter the authorial position of the instructor and thereby move from a corrective model to a *transformative* one. Leemann's text is a fitting

conclusion to the volume, as it offers both a critique of critique and a means of moving beyond it.

If the defining feature of modernism is its faith in the present (Apollinaire's and Pound's cult of the new), and that of postmodernism is its melancholic critique of modernism's misplaced faith (Benjamin's angel of history), then perhaps our current moment will be defined by a sense in which both faith and critique, affirmation and negation, are no longer, in themselves, tenable positions from which to respond to the present. If the concept of the post-critical is to prove useful, it will require a movement beyond both modernist faith and postmodernist melancholy. It will require a willingness to construct, if only provisionally, on ground that is constantly shifting and that offers no guarantee of future reward. The way beyond critique will require us to adopt a position that is more tentative and more modest than either modernism or postmodernism has prepared us to be.

References

Barthes, Roland (1972), *Mythologies*, trans. Annette Lavers, New York: Hill and Wang.

Călinescu, Matei (1987), *Five Faces of Modernity*, Durham, NC: Duke University Press.

Derrida, Jacques (1981), "Interview with Jean-Louis Houdebine and Guy Scarpetta," in *Positions*, Chicago, IL: University of Chicago Press.

Felski, Rita (2015), *The Limits of Critique*, Chicago, IL: University of Chicago Press.

Fraser, Andrea (2006), "From Institutional Critique to an Institution of Critique," in *Institutional Critique and After*, Zurich: JRP Ringier.

Horkheimer, Max (1975), *Critical Theory: Selected Essays*, trans. Matthew O'Connell, New York: Continuum Publishing.

Latour, Bruno (2004), "Why Has Critique Run Out of Steam? From Matters of Fact to Matters of Concern," *Critical Inquiry* 30(2): 225–48.

Lyotard, Jean-François (1984), *The Postmodern Condition: A Report on Knowledge*, trans. Geoff Bennington and Brian Massumi, Minneapolis, MN: University of Minnesota Press.

Owens, Craig (1980), "The Allegorical Impulse: Toward a Theory of Postmodernism," *October* 12 (Spring, 1980): 67–86.

Part One

History and Theory

1

An Allegory of Criticism[*]

David Joselit

I

subvert: 1. to destroy completely; ruin

The American Heritage Dictionary 2000: 1728

In the 1980s a new critical desideratum arose: *to subvert.* Works of art—especially those engaged in various modes of appropriation—were seen to unveil the mechanisms of commercial culture, and in so doing to deliver a fatal blow to the society of the spectacle.[1] When Sherrie Levine, for instance, rephotographed the reproduction of a modernist photograph, or Jeff Koons imprisoned a pristine vacuum cleaner in Plexiglas, these works were interpreted as blunt reiterations of reified social relations. In a dazzling instance of vulgar Freudianism (especially remarkable for an art world besotted with Lacan), such acts of revelation were themselves regarded as politically efficacious, just as the analysand's free associative speech is supposed by her analyst to release her from the grip of pathology.[2] What I wish to remark on, however, is not the legitimacy of such judgments, but rather the distinctive nature of their form. It is worth noting that in the years between the respective heydays of modernist and postmodernist criticism in the United States, the locus of aesthetic value shifted from quality to criticality—from the "good" to the "subversive." I take it as axiomatic that with postmodernism the art object began to absorb the critic's function into itself, rendering the boundary between art and criticism confusingly porous, and more or less causing the latter's obsolescence.[3] An analysis of this condition begs three

[*] An earlier version of this text was delivered as a lecture at the Clark/Getty conference "Art History and Art Criticism" at the Getty Research Institute in February 2002. I am grateful to both institutions for their support and especially to the Clark Art Institute, which granted me a fellowship in 2001–02 to work on this and related projects. This version of the text also reflects my participation in the roundtable "The Present Conditions of Art Criticism," published in *October* 100 (October 2002).

sets of questions. First, what exactly constitutes efficacy in an art work and how does an aesthetics of "subversion"—or is more recent lexical cousin, "criticality"—function as a politics? Second, what kind of critic is the artist? And third, what is left for the critic to do?

Craig Owens's theory of allegory is a good place to start. Building on a variety of thinkers, and especially Walter Benjamin, Owens developed a pithy model of postmodern allegory in a two-part essay published in successive numbers of *October* in 1980. Early on in the text he offered a fundamental definition: "Let us say for the moment that allegory occurs whenever one text is doubled by another ..." (Owens [1980] 1992: 53).[4] Allegory, then, is the doubling—indeed, the multiplication—of "texts" within and around a work of literature or art. Such doubling (or multiplication) necessarily functions as an act of interpretation—a mode of criticism that is *built into the work*. Owens makes this point explicitly through a comparison: "In modern aesthetics, allegory is regularly subordinated to the symbol, which represents the supposedly indissoluble unity of form and substance which characterizes the work of art as pure presence" (Owens [1980] 1992: 62). If allegory is the rhetorical figure corresponding to postmodernism, the symbol, in which essential experience is made manifest, corresponds to American midcentury modernism. Owens's distinction clarifies the fundamental role of the critic in assessing modernist art: it is s/he who *recognizes* the essential link between gesture and the unconscious among painters of the New York School, or opticality and "grace" in the canvases of their successors. Such an act of recognition is superfluous to the critical doubling of allegorical (postmodern) art, which is by definition *self-conscious*. Here is where the violence enfolded in the term "subversive" surges forth in the seemingly benign concept of allegory. An allegory destroys the autonomy of the text. Benjamin compares allegory to a ruin, and, as *The American Heritage Dictionary* affirms, to subvert is to "destroy completely; [to] ruin" (*American Heritage Dictionary* 2000: 1728).

The allegory of my own title denotes something simpler than the nuanced associations elaborated by Owens. For in this essay I have elected a single figure, Michael Shamberg, as the protagonist of a fable—an allegory—of criticism. Shamberg was not a major figure in art criticism; indeed, he had little to do with art at all. This very marginality vis-à-vis the art world in combination with his current power and influence in the realm of commercial culture make him a fit object of allegorization. As will become clear in the course of this text, Shamberg's story has everything to do with the shift marked by Owens: from an art of essence to an art of appropriation rooted in allegorical extensions of the mass

media. In that sense, I hope the allegory of my title will carry the complexity of Owens's use of it after all. For what I will demonstrate is a second order of doubling or multiplication, not solely of texts, but of the publics interpellated by those texts.

II

At different points in his career Michael Shamberg worked as a writer, video activist, and Hollywood producer, earning himself a significant place in the history of video, television, and film. In these capacities he was among the first to recognize the thoroughgoing commercialization of public space brought about by television's explosion at midcentury. He called this phenomenon "Media-America," and in his 1971 book *Guerrilla Television*, he identified an array of visual practices of the 1960s and '70s, ranging from psychedelia to video art, which were aimed at democratizing or revolutionizing the electronic nation. The allegory suggested by his career pivots on the difficulties of sustaining such criticism. Most professional art critics produce little more than sophisticated press releases. Such writings are valuable to art history as *documents*, which may be read symptomatically in the brilliant ways that figures like T. J. Clark have done. I am less interested in this diagnostic use of criticism than in those moments when critical writing becomes prescriptive—when it invents new kinds of objects rather than simply interpreting those it finds readymade. Shamberg's story is exemplary in this regard because he tried in a variety of ways to construct new networks for criticism. These efforts fall roughly into four stages, which I will describe briefly.

Phase 1: Industrial Journalism. After graduating from college in 1966 and writing for a newspaper called *Chicago's American*, where he covered the Democratic Convention in 1968, Shamberg worked for about a year for *Time* and *Life*. It is well known that these publications require a highly Taylorized form of writing where individual authorship is less important than a "house voice." As Shamberg remarked in an interview of 1971, "I quit because I felt irrelevant, not co-opted" (Levin 1971: 373).[5] This distinction is significant because it indicates Shamberg's career-long recognition that constructing an audience is as important as constructing an argument. At least one of his assignments for *Time* did prove relevant. In the issue of May 30, 1969, Shamberg published an unsigned review of the video exhibition *TV as a Creative Medium* at the Howard Wise Gallery in

New York. In his opening paragraph, Shamberg perhaps unwittingly summarizes his program for the next decade:

> The younger generation has rebelled against its elders in the home. It has stormed the campuses. About the only target remaining *in loco parentis* is that preoccupier of youth, television. Last week the television generation struck there too, but the rebellion was half in fun: an art exhibition at Manhattan's Howard Wise Gallery entitled "TV as a Creative Medium."
>
> <div align="right">Shamberg 1969: 74</div>

Included in *TV as a Creative Medium* was *Wipe Cycle* (1969), a work by Frank Gillette and Ira Schneider, which particularly impressed Shamberg. *Wipe Cycle* consisted of a bank of nine monitors and a closed-circuit video camera, which recorded live images of viewers as they approached the work. These fragments of footage were played on eight- and sixteen-second delays, jumping from monitor to monitor and intercut with broadcast TV and prerecorded segments. Periodically all of the screens would be wiped clean. Gillette's description of the work links it explicitly to an ethics of televisual communication: "The intent of this [image] overloading ... is to escape the automatic 'information' experience of commercial television without totally divesting it of the usual content" (Gillette and Schneider 1969: unpaginated). In other words, *Wipe Cycle* was meant to break apart the monolithic "information" of network TV through a spectator's unexpected encounter with her or his own act of viewing. As I will argue, such a shift in the balance of power between the producers and the consumers of media images would remain central to Shamberg's program.

Phase 2: Raindance Corporation. Shamberg was so impressed by Gillette and Schneider that he joined with them to form the Raindance Corporation, a video collective intended to function as an alternative think tank—a progressive version of the RAND Corporation. The activities of Raindance proceeded on two tracks—video-making and publishing—but all of its work emerged from the group's fascination with the kind of media ecology theorized by such figures as Marshall McLuhan, Buckminster Fuller, and Gregory Bateson. Raindance believed that television could be democratized by redressing the imbalance of power between video producers and video consumers. To this purpose, its members executed a number of informal videotapes in which ordinary people on the street were given the time and space to communicate. The group attempted to institutionalize its alternative vision of media communication in an unrealized Center of Decentralized Television that would have been housed at the Jewish

Museum where the watershed exhibition *Software* took place in 1970. Between 1970 and 1974 Raindance was affiliated with a fascinating journal, *Radical Software*, whose founding editors were Beryl Korot and Phyllis Gershuny (now Segura). This publication included a frothy mix of Zen, cable activism, video theory, and applied cybernetics. While some have poked fun at this delirious collision of politics, media, and ecology, it is sobering to acknowledge how closely it prefigures the ecstatic prognostications that surround the Internet in our own time. In fact, from a political perspective, *Radical Software's* analysis of the failings and potentials of television was both more prescient and more radical than any recent product of the digerati I am aware of.

Shamberg's book, *Guerrilla Television*, was a Raindance publication and it brought together many of the themes that percolated through *Radical Software*, including a combination of theoretical analysis and practical advice for the many community-based groups that sought to use video as a tool during this period. Two themes recur throughout *Guerrilla Television*. First, a call to transform passive video consumers into active video producers by making video equipment accessible to anyone, and by establishing alternate community-oriented networks in partnership with cable television. Second, Shamberg insisted that the media be regarded as a social and psychological *process* rather than as a static *product*. In other words, rather than simply watching a commercially derived reality on TV, viewers could use videotape therapeutically to become aware of their own experience. As in Gillette and Schneider's *Wipe Cycle*, where the efficacy of the work hinged on the viewer seeing her- or himself on par with a live feed of network TV, Shamberg proposes a *politics* of feedback. He gives several examples of what such a politics might look like in *Guerrilla Television*. In one passage he writes:

> A more genuine radical strategy for middle-America would be to build a base at the actual level of repression, which for whites is mostly psychic, not physical. This means developing a base of indigenous information to work from. It might include tactics like going out to the suburbs with video cameras and taping commuters. The playback could be in people's homes through their normal TV sets. The result might be that businessmen would see how wasted they look from buying the suburban myth.
>
> Shamberg and Raindance Corporation 1971: 29

Phase 3: Top Value Television (TVTV). The self-reflexivity characteristic of Shamberg's recommendation that suburbanites play back images of their own middle-class alienation was applied to the forms and biases of network news in

the next project he was involved with, Top Value Television (or TVTV), an open-ended video collective that produced a variety of programs throughout the seventies. TVTV originally included Shamberg's companion Megan Williams and the media activist Allen Rucker, as well as members of the flamboyant San Francisco artists collective Ant Farm (famous for upending a row of Cadillacs in Amarillo, Texas). The group was initiated to produce alternate coverage of the 1972 Democratic and Republican conventions in Miami. After succeeding against the odds in acquiring press credentials for the conventions as well as raising a modest budget of a few thousand dollars contributed by four cable TV stations, TVTV moved in together in a rented house in Miami like members of a commune or a rock band.

Unencumbered by the heavy equipment the networks required to make broadcast-quality footage, TVTV members gained greater access to the intrigue of the convention floor with their portable PortaPak cameras, capturing stories that more experienced journalists missed. Most significant was TVTV's policy of turning its cameras on the network coverage of the convention, in part by interviewing celebrity correspondents about the limits and conventions of legitimate TV news. This self-reflexivity—or feedback—was taken a step further by the informal nature of TVTV interviews themselves, in which no effort was made to hide the interviewer or the intrusiveness of the interview, shattering both the neutrality of the questioner and the questioned. In other words, these tapes and others TVTV produced during the seventies applied to documentary video the feedback loop between viewer and viewed that Gillette and Schneider had presented as an aesthetic strategy in *Wipe Cycle*. Despite receiving significant critical praise, TVTV had trouble sustaining itself economically. Cable and public television stations hired them on a project-by-project basis, making survival nearly impossible and always precarious. Ultimately, in the late 1970s, the group underwent two shifts: It moved away from documentary and toward fictionalized programming reminiscent of *Saturday Night Live*, and it began to pitch projects to the networks. Like his earlier activities in Raindance and TVTV, Shamberg's concept for the *TVTV Show*, which had a brief unsuccessful run on NBC in 1977, satirized what he had called "Media-America"—but in the context of entertainment. As Deirdre Boyle recounts in her excellent history of TVTV, Shamberg told a *Village Voice* critic in 1976:

> When you create a really effective fictional character, you have a much bigger impact than with a documentary. There have been plenty of documentaries of

the working class which have been forgotten, but Archie Bunker is on every T-shirt in America. So we've decided to do fiction TV as well.[6]

Phase 4: Hollywood. Given Shamberg's rather startling nomination of the television character Archie Bunker as a working-class hero, it is not surprising that in the next and current phase of his career he moved entirely into the realm of fiction as a producer of Hollywood films. His first hit, and for my purposes the most interesting of his many credits, which include *Pulp Fiction* (1994), *Gattaca* (1997), and *Erin Brockovich* (2000), was *The Big Chill* of 1983, a paean to the lost hope of the sixties generation. In this movie a crowd of former college radicals—now mostly prosperous professionals—reunite for the funeral of one of their friends. *The Big Chill* is a sophisticated and nuanced story about the vulnerability of idealism, which, like Shamberg's earlier work, includes prominent scenes of video therapy in which the William Hurt character—one of the few who has failed to "evolve" into yuppiedom—interviews himself and his friends using a home video camera, allowing everyone to watch his or her confessions on the television screen.

It would be easy enough to describe Shamberg's shift from political documentary to palliative entertainment as a simple instance of selling out, but I think this would be unfair. Shamberg and his colleagues spent ten years of their lives, at significant economic sacrifice, attempting to build an alternative mode of television. If today Michael Shamberg were on the faculty of the UCLA Film Department instead of occupying an office at Jersey Films a few miles away, would that make him any less of a sellout? Logically, I think, the answer can only be "no." On the contrary, it is more accurate to say that Shamberg ultimately looked to commercial arenas of production and fictional narratives because noncommercial networks, such as community, cable, and public television in the 1970s, proved untenable. In other words, instead of scoffing at Archie Bunker as an effective social critic, perhaps we should hold open the possibility that commercial culture can carry oppositional content.

I wish to draw two sets of conclusions from my brief digest of Shamberg's career. First, his activities demonstrate that *criticism is as much about producing an audience as it is about producing a message.* In *Guerrilla Television* Shamberg wrote, "True cybernetic guerrilla warfare means re-structuring communications channels, not capturing existing ones" (Shamberg and Raindance Corporation 1971: 29). And, indeed, both the Raindance Corporation and TVTV were efforts to challenge *institutional* networks as well as to develop new kinds of oppositional

or therapeutic information. In other words, the critical act in guerrilla television consisted of developing and promoting *new modes of image consumption*. As it turned out, this proved much more difficult than simply producing oppositional content. For nearly a decade, TVTV attempted to develop alternative networks through, for instance, community television on cable. As the early democratic promise of cable was extinguished through its ultimate commercialization,[7] Shamberg and his colleagues identified particular genres within this commercial arena—comedy and "reality TV"—as sites for criticism. Shamberg's career therefore illustrates the inverse relationship that exists between the radicality of a message and the size of the audience to which that message may be addressed. Ultimately Shamberg himself opted for the largest possible public afforded by Hollywood cinema, and he has used this arena as a mild form of social criticism in projects such as *The Big Chill*.

The second insight regarding criticism that Shamberg's career allows is a recognition of its mobility. Indeed, with the Raindance Corporation and TVTV, Shamberg and his colleagues transported an artistic strategy—closed-circuit video feedback—into the very different realm of documentary video in order to identify and critique the conventions of commercial TV and particularly network news. In this instance criticism consisted of *inventing new categories of analysis that allowed for the invention of new kinds of objects*. Although I have derived this conclusion from the realm of radical TV, it holds equally true with regard to art history. Indeed, many of the most important developments in our discipline of the past thirty years, such as its encounter with literary theory and the emergence of visual culture, result from hybrid methodologies and the constitution of heterogeneous objects of analysis. The fact that these new approaches are now accepted if not universally acclaimed within the academy suggests that whether on account of its success or its failure, efficacious criticism is short-lived, always vulnerable to the twin dangers of incorporation or irrelevance. I think we are naive to believe anything else. For me the poignancy of Shamberg's career—its allegory—is precisely this demonstration of criticism's mortality.

III

Miwon Kwon has recently argued that "[t]he artist as an over specialized aesthetic object maker has been anachronistic for a long time already. What they *provide*

now, rather than produce, are aesthetic, often 'critical-artistic,' services" (Kwon 2002: 50). Kwon's insight is confirmed by the widespread migration by artists such as Jorge Pardo or Pae White into design, and by the converse elevation of architect-designers such as Rem Koolhaas to star status within the art world.[8] Given this shift in the nature of artmaking Shamberg's story is particularly pertinent. Unlike the latest generation of aesthetic service providers, his career originates in industrial journalism, embraces activism for a significant period of time, and only then returns to commercial culture. In other words (under the most generous interpretation), his work in the film industry is to some degree a continuation of his activism (or an acknowledgment of its impossibility, which is not quite the same thing). Furthermore, Shamberg's engagement with television and film suggests how the paradigm shift Kwon articulates may be tied to a particular historical moment—one characterized by the rise of network television.

Owens suggested that the allegorical imagination proper to postmodernism is rooted in media of mechanical reproduction: for him, photography is "an allegorical art ... [that] would represent our desire to fix the transitory, the ephemeral, in a stable and stabilizing image" (Owens [1980] 1992: 56). Through the mechanism of feedback, television too functions allegorically. Feedback, like allegory, is a doubling back, not only of information but also of the spectator who finds her-or himself reflected on the screen, either directly in works such as *Wipe Cycle* or indirectly in the lexicon of stereotypical identities that constitute television narratives. It is during the age of network television that "communities" (as the term is currently used to indicate a circle of shared identity or experience, like the "gay community" or the "AIDS community"[9]) began to be intensively commodified. As Richard Serra famously proclaimed in a work of 1973, what television sells (to advertisers) is its audience.[10] The product of TV, then, is not merely its programming, but a set of highly stratified demographic "communities" to which each program corresponds. Shamberg's career manifests not only the search for new narratives, but a search for new communities—both on the screen and among its audiences. Here, then, would be my prescription for both the artist and the critic: to reinvent modes of the collective in a world where publics have become a new type of commodity.

Rethinking "communities" is inseparable from rethinking identity politics. Just as postmodernism of the 1980s addressed what Sherrie Levine has identified as the nature of images as property,[11] the best art of the last decade has explored the conditions of identity *as property* in the fullest material and psychological sense. This does not mean simply asserting the identity one possesses, but rather

questioning why we should experience the self as a possession in the first place. To relax one's proprietary hold on subjectivity might enable the kind of malleability and mobility characteristic of Shamberg's career. He happened to have landed in Hollywood, but his allegory might lead elsewhere. In such an artistic/critical project terms like "subversion" or even "criticality" no longer seem appropriate. They connote revolutionary destruction divorced from its compensatory utopian promise. Taking my inspiration from William Burroughs—and perhaps in an effort to *détourne* the massive damage accomplished by AIDS in the era of post-modernism—I propose a *viral* mode of practice. In 1964, before there was an Internet, Burroughs understood the relation between the virus and information. In a section of his *Nova Express* (1964) titled "Technical Deposition of the Virus Power" he "explains":

> Gentlemen, it was first suggested that we take our own image and examine how it could be made more portable. We found that simple binary coding systems were enough to contain the entire image however they required a large amount of storage space until it was found that the binary information could be written at the molecular level, and our entire image could be contained within a grain of sand. However it was found that these information molecules were not dead matter but exhibited a capacity for life which was found elsewhere in the form of virus. Our virus infects the human and creates our image in him.
>
> Burroughs (1964) 1992: 49

The viral is a model of allegory multiplied ad infinitum. A viral art/criticism would be impure and monstrous. It would erode or corrupt the sanctity of the object. It would be recombinant.

Notes

1 Subversion is clearly related to avant-garde models of revolution but it is also quite distinct from them. Whereas the revolutionary paradigm suggests a clearing away of tradition and the establishment of a new—perhaps utopian—social order, subversion seems arrested at the initial moment of destruction, having few, if any, programs for a new society.

2 My criticism here pertains to the writing around appropriation techniques rather than to the art itself, which I think has yet to be given its due.

3 For a provocative discussion of the obsolescence of criticism see the roundtable "The Present Conditions of Art Criticism."

4 For another important and influential account of allegory and postmodern art that, like Owens's, relies heavily on Walter Benjamin's *The Origin of German Tragic Drama*, see Buchloh 1982: 43–56.

5 Interview with Raindance (Michael Shamberg) and Videofreex (David Cort), in Levin 1971.

6 Ingrid Wiegand, "TVTV Turns Its Camera on the Rest of Us," *The Village Voice* (May 17, 1976), quoted in Boyle 1997: 174.

7 I have written about the relationship between early cable and video activism in "A Tale of the Tape: *Radical Software*" (Joselit 2002).

8 For an excellent account of these developments, see Foster 2002.

9 Kwon's discussion of the shift from site-specificity as rootedness in a place to an engagement with a community or discourse is an important point of reference (Kwon 2002).

10 In *Television Delivers People*, Richard Serra presented a simple rolling text composed of excerpts drawn from various papers presented at a broadcasting conference. It read, in part, "The product of television, commercial television, is the audience. Television delivers people to an advertiser. There is no such thing as mass media in the United States except for television."

11 "It's not that I'm trying to deny that people own things. That isn't even the point. The point is that people want to own things, which is more interesting to me. What does it mean to own something, and, stranger still, what does it mean to own an image?" (Siegel 1985: 143).

References

The American Heritage Dictionary of the English Language (2000), Fourth Edition, Boston: Houghton Mifflin Company.

Boyle, Deirdre (1997), *Subject to Change: Guerrilla Television Revisited*, Oxford: Oxford University Press.

Buchloh, Benjamin H. D. (1982), "Allegorical Procedures: Appropriation and Montage in Contemporary Art," *Artforum* 21(1): 43–56.

Burroughs, William S. ([1964] 1992), *Nova Express*, New York: Grove Press.

Foster, Hal (2002), *Design and Crime and Other Diatribes*, London: Verso.

Gillette, Frank and Ira Schneider (1969), "Wipe Cycle" in *TV as a Creative Medium*, New York: Howard Wise Gallery.

Joselit, David (2002), "A Tale of the Tape: *Radical Software*," *Artforum* 40(9): 152–55, 196.

Kwon, Miwon (2002), *One Place After Another: Site-Specific Art and Locational Identity*, Cambridge: MIT Press.

Levin, G. Roy (1971), *Documentary Explorations: 15 Interviews with Film-Makers*, Garden City, NY: Doubleday and Company, Inc.

October Roundtable (2002), "The Present Conditions of Art Criticism," *October* 100: 201–28.

Owens, Craig ([1980] 1992), "The Allegorical Impulse: Toward a Theory of Postmodernism," reprinted in Owens, *Beyond Recognition: Representation, Power, and Culture*, ed. Scott Bryson, Barbara Kruger, Lynne Tillman, and Jane Weinstock; introduction by Simon Watney, Berkeley: University of California Press.

Shamberg, Michael (1969), "The Medium: Taking Waste Out of the Wasteland," *Time*, May 30: 74.

Shamberg, Michael and Raindance Corporation (1971), *Guerrilla Television*, New York: Holt, Rinehart and Winston.

Siegel, Jeanne (1985), "After Sherrie Levine [Interview]," *Arts Magazine* 59(10): 143.

Fluxus and the Art of Affirmation

Roger Rothman

As the debate between modernism and postmodernism recedes into the past, we are now in a position to make better sense of the terrain on which it took place. Among theorists of art, the ground on which the most pitched battles were fought was that of ideology critique. The stakes of this debate over the critical potential of the avant-garde and its postmodern legacy were most famously allegorized by Fredric Jameson in his comparison between a pair of old and worn work shoes rendered by Vincent van Gogh in thick, weighty strokes and a collection of unpaired high-fashion footwear, candy-colored and literally encrusted in diamond dust by Andy Warhol (Jameson 1991). Counterclaims to Jameson's diagnosis of postmodernism's failure by the likes of Foucault and Lyotard held that modernism's practice of ideology critique had not been undermined by the postmodern turn but rather superseded by it, on the one hand through a mode of critical engagement—"discourse analysis" (Foucault 1984: 60)—that understood itself as no longer bound to outmoded distinctions between truth and appearance, subject and object, and on the other by the postmodern sublimity of "the unpresentable in presentation itself" (Lyotard 1984: 81). Perhaps unwittingly, both responses presented the postmodern as fully consistent with Jürgen Habermas's conception of the modernist project as the disclosure of "socially silenced human needs" (Boucher 2011: 62–78).

More recent studies have sought to refigure the very primacy of ideology critique. No longer is it a question of whether modernist or postmodernist practices are better equipped to unmask and debunk. Instead, the pressing question of the moment is whether or not the critical project itself has run its course. For instance, Eve Kosofsky Sedgwick's practice of "reparative reading" (Sedgwick 2003) and Bruno Latour's insistence upon "care" and "construction" (Latour 2004) as alternatives to the practice of unmasking and debunking are set in explicit opposition to the critical project *tout court*, modernist or otherwise.

It's not that we couldn't see this coming. Indeed, the question of critique's standing within politically engaged theory was posed at the very moment of its initial appearance: Karl Marx's most famous *Eleventh Thesis* makes the problem inescapable. Theodor Adorno recalled it, if only negatively, in declaring that "as eminently constructed and produced objects, such works of art, even literary ones, point to a practice from which they abstain: the creation of a just life" (Adorno 1974). And Herbert Marcuse, with unmistakable directness, bore melancholic witness to the impotence at the heart of the critical method: "The critical theory of society possesses no concepts which could bridge the gap between the present and its future; holding no promise and showing no success, it remains negative" (Marcuse 1964: 256–57). Indeed, one wonders how the question of critique's inherent limitations managed to remain hidden for so long. Adorno and Marcuse's diagnoses draw our attention to the ineluctable dilemma at the heart of the critical project. As a practice that lays claim to truth, critical art is required to adopt a position of mimetic remove from the world it seeks to transform. This is the case whether the mimetic gesture sets out to produce objective "pictures of reality" or subjective "structures of feeling" (Williams 1977: 132–34). The impotence of the mimetic image (whether objective, subjective, real, fantasmatic) derives from the same source that serves to legitimate it, and as such, the autonomy that justifies its claim to veracity consigns it to ineluctable powerlessness. It can look, but can't touch.[1]

Marcuse's lamentation calls for a turn from negative critique to positive affirmation, on the formation of a counter-practice founded on touching, not looking. This, I would argue, is precisely the turn proposed by the cluster of artists who followed in the footsteps of John Cage, and who were soon after conjoined under the banner of Fluxus.

The term Fluxus was coined by George Maciunas, a Lithuanian émigré who grew up in a middle-class environment in Long Island. In addition to Cage's musical ideas, the artists involved in Fluxus were drawn to a range of Dadaist (and to a lesser extent Surrealist) ideas about integrating art and life. Yoko Ono is perhaps the most famous Fluxus artist, and Joseph Beuys was for a time loosely connected with it. Other key members include the pioneering video artist Nam June Paik, Alison Knowles—most famous for her 1962 work *Make a Salad*—and her husband, Dick Higgins, who was not only an artist but founder in 1963 of Something Else Press (a pioneering small press that published works by Fluxus artists George Brecht, Emmett Williams, as well as John Cage and Gertrude Stein, one of Higgins' favorite writers). The artists refused to call themselves a

"movement"; they thought that spoke too much of a vanguard and elitist conception. Plus they rejected the idea of a strong central coordinating nucleus. Maciunas did, for a time, expel people, but almost no-one took the expulsions seriously. And by the end of his life (Maciunas died of cancer, in 1978, when he was just 47 years old), he fully accepted the idea of Fluxus as an anti-avant-garde—he called it a "rear-guard" (Kellein 1995: 135).

For a number of years, Fluxus languished under the shadow of other postwar movements; however, in the last two decades, it has begun to receive greater attention. One crucial absence, however, concerns its fundamentally *affirmative* dimension—its almost near-total absence of negativity. Fluxus engaged in little of the negativity that distinguishes previous avant-gardes. Indeed, much of the puzzlement that Fluxus has caused critics and historians, and thus much of the reason behind its delayed reception, stems from this refusal to engage the negative. In short, Fluxus was *post-critical*. Inasmuch as all utterances and activities contain a critical or negative moment (by virtue of implicit choice not to have uttered something else or acted in some other, different way), one cannot say that Fluxus is entirely absent of negativity. But the negativity of Fluxus was a byproduct, a waste material in a sense. It is there because it cannot be entirely eliminated, but is by no means the central, or foundational aspect that it is to the historical avant-garde.

In ways that reflect on the conditions in which Fluxus emerged out of the critical practices of the historical avant-garde, a number of recent theorists have developed accounts of both the limitations of critique and possibilities inherent in moving beyond it. Among the most important belongs to Eve Kosofsky Sedgwick. In the years before her early death, Sedgwick had been working to develop alternatives to the prevailing—if not altogether compulsory—requirement that texts be engaged with what Ricoeur so famously dubbed "the hermeneutics of suspicion"—which, as he argued, was the great combined legacy of Marx, Nietzsche, and Freud. In the wonderfully titled essay, "Paranoid Reading and Reparative Reading, or You're So Paranoid, You Probably Think This Essay Is About You," from 1997, Sedgwick questioned the utility of relying so heavily—indeed, it would seem exclusively—on the hermeneutics of suspicion. Suspicion, which Sedgwick associates with what she calls "the paranoid position," has so dominated literary analysis that there seems to be no room for alternatives; why, she asks, is suspicion "a mandatory injunction rather than a possibility among other possibilities"? (Sedgwick 2003: 125). After an extensive account of the force and tenacity of the suspicion, Sedgwick proposes one alternative in

particular, what she calls "reparative reading." Drawing on Melanie Klein and Silvan Tomkins rather than Nietzsche and Freud, she writes:

> To read from a reparative position is to surrender the knowing, anxious paranoid determination that no horror, however apparently unthinkable, shall ever come to the reader as new; to a reparatively positioned reader, it can seem realistic and necessary to experience surprise. Because there can be terrible surprises, however, there can also be good ones. Hope, often a fracturing, even a traumatic thing to experience, is among the energies by which the reparatively positioned reader tries to organize the fragments and part-object she encounters or creates.
>
> Sedgwick 2003: 146

With gay, lesbian, and queer practices foremost in her mind, Sedgwick proposes that paranoid readings fail to register the reparative position from which they stem. For example, she notes: "The queer-identified practice of camp ... may be seriously misrecognized when it is viewed ... through paranoid lenses ... [on the other hand] to view camp as ... the communal, historically dense exploration of a variety of reparative practices is to do better justice to many of the defining elements of class camp performances" (Sedgwick 2003: 146). Sedgwick names a number of these defining elements, including: "the startling, juicy displays of excess erudition ... the passionate, often hilarious antiquarianism, the prodigal production of alternative historiographies; the 'over' attachment to fragmentary, marginal, waste or leftover projects" (Sedgwick 2003: 149–50). Her claim is not that the paranoiacs are speaking untruths when they speak from suspicion, but rather that, in their exclusive adherence to this one affective position, they foreclose other, no less justifiable articulations.

I take it as a meaningful sign that, a similar argument appeared just a few years later in an altogether different context—that of science and technology studies. In an essay from 2004, Bruno Latour proposed that the legacy of hermeneutic suspicion, which he called the culture of critique had, as he put it in the title of his essay, "run out of steam." In fact, Latour is far more damning of critique than is Sedgwick. Sedgwick's interest was to develop an alternative practice that would stand beside critique. Her objection was not to critique in itself, but in the seemingly compulsory adherence to it as the only legitimate mode of textual engagement. Latour on the other hand, sees no value at all in critique. Although more pointed than Sedgwick's, his argument rests on the claim (which he laid out in his 1991 book *We Have Never Been Modern*) that the critical position—the position that seeks to unmask, debunk, and dismantle—is

based on a flawed dualism of the human and non-human, the active subject and the passive object. Like Sedgwick, critique and unbound suspicion go hand-in-hand. The critical position requires that one "learn[s] to become suspicious of everything people say because of course we all know that they live in the thralls of a complete *illusio* of their real motives" (Latour 2004: 229). In its place, Latour proposes what he calls "a stubbornly realist attitude." At stake here is the attempt to answer the following: "Can we devise another powerful descriptive tool ... whose import ... will no longer be to debunk but to protect and to care ... to transform the critical urge in[to] the ethos of someone who *adds* reality to matters of fact and not *subtract* reality? To put it another way, what's the difference between deconstruction and constructivism?" (Latour 2004: 231–32, original emphasis).

The "constructive turn" that Latour proposes is one that is clearly on the rise of late and is reflected in the general turn from Derrida to Deleuze. A simple title-search on World-Cat reveals that over the decade of the nineties, books on Derrida far outnumbered those on Deleuze. Nevertheless, in terms of annual publications, Derrida's numbers (although stratospheric) increased at gradual pace while Deleuze's were expanding exponentially. By the end of the first decade of the twenty-first century (sometime around 2008) publications on Deleuze outnumbered those on Derrida. The shift is indicative of the constructive and reparative turn that Latour and Sedgwick advocate. The most frequently cited statements by Deleuze stem from the little book he wrote with Guattari, *What is Philosophy?* In it, they define philosophy not as the search for truth—that is as a critical procedure whereby false beliefs are unmasked as such—but rather as an experimental procedure in which new concepts are created.

Related to the recent supersession of Derrida by Deleuze is the newfound interest in reexamining the work of Alfred North Whitehead. Latour ends his essay on the possibilities of a post-critical philosophy of construction with a call for a return to Whitehead's anti-dualist conception of nature: "What set Whitehead completely apart [from those like Kant, Husserl, and Heidegger] ... is that he considered matters of fact to be a very poor rendering of what is given in experience and something that muddles entirely the question, What is there? With the question, How do we know it?" (Latour 2004: 244). In Latour's mind, it is crucial that we set aside the epistemological question (what we know) so that we can better attend to the ontological question (what is there). For him, as for others, it seems as though Whitehead offers a clear path from epistemological suspicion to ontological creation.

This minor turn to Whitehead is perhaps most clearly articulated by Steven Shaviro. Shaviro's 2009 book, *Without Criteria: Kant, Whitehead, Deleuze, and Aesthetics* was born from a counterfactual, or as he calls it, "a philosophical fantasy": What if the history of twentieth century thought, and in particular postmodernist thought, had stemmed not from Heidegger but from Whitehead? "What different questions would we be asking? What different perspectives might we be viewing the world from?" (Shaviro 2009: viii). In this, Shaviro is asking much the same question that Sedgwick asked when she wondered what might be gained from abandoning the paranoid for the reparative, the critical for the constructive.

Finding a place for a constructive dimension within the discourse and practices of the avant-garde is by no means a straight-forward assignment. Indeed, from a certain vantage point it seems all but impossible to imagine what a post-critical avant-garde would look like. For the avant-garde is nothing if not critical. Its significance seems to depend entirely upon its ability to negate and unmask. For what is Marinetti's Futurism if not negation of history? What is Heartfield's Dada if not an unmasking of the myths of Nazism? Magritte's Surrealism seems altogether meaningless when shorn from its roots as a critique of reason and logic.

This interwar conception of art-as-critique has been the most enduring dimension of avant-garde practice. Warhol's Marilyns unmask the banalities of mass culture and Barbara Kruger's posters expose the underlying ideologies of capitalism and patriarchy. Even today, the most widely regarded artists are those who claim the mantle of art-as-unmasking. To take but the most spectacular, consider any one of Santiago Sierra's performances. In 1999 he paid six unemployed Cuban men to have a straight black line tattooed across their backs so that they would become, as a collection, an abstract drawing. Or his work for the 2001 Venice Biennale in which he paid two hundred dark skinned African men to have their hair bleached blond for the duration of the exhibition. On an island of wealthy Europeans, the poor Black men would stand out as gleaming works of art. Sierra's violently exploitative work stands as the farthest reaches of the critical aesthetic of the avant-garde.

On the other hand, cybernetic theory, first developed in the forties and fifties, offers a radically different approach to avant-garde practice. To get a sense of this difference, look a bit more closely at Sierra's tattooed line. The system is one directional—the artist actively creates the line and the men passively submit to it. Here the violence of the dualist system of active subject and passive object is not merely allegorized but actualized on human flesh. The system dismantles

this distinction between active and passive so that the subject and object merge as one. In an affirmative, constructive system, the feedback loop creates (in a cybernetic sense) a system in which outputs become in turn inputs and thus obviate the distinction between actor and acted upon.

One way to begin a discussion of an alternative to compulsory critique is to contrast Sierra's tattooed line with one of La Monte Young's minimalist compositions. Young's work of the fifties was greatly influenced by John Cage's interest in radically transforming musical composition and performance. Young took Cage's practice to new heights of minimalist abstraction. Some, such as *Composition #7*, distil musical performance to its bare essence: "A dyad B-F#, is sustained for an indeterminately long period of time. Others, such as *Composition #2*, for example, go entirely beyond the boundaries of musical construction: it reads: 'The performer is instructed to build a fire in front of the audience.' The most famous of all of Young's early constructions is *Composition #10*: "Draw a Straight Line and Follow It."

Though critics have paid considerable attention to *Composition #10*, the vast majority of it has been directed to the first half of the instruction: "draw a straight line" (leaving the second half of the sentence, "and follow it," in near total obscurity). I attribute this disproportionate attention to the underlying dualism of the critical position. For the instruction to follow requires that the active creator play the passive role. To follow is to submit to an order that precedes the active subject. It is, to use the example of Sierra's tattooed line, to adopt the passive position of the men who submit to the inked needle. Young's proposition articulates the first fundamental step of a constructive feedback mechanism: the output (the drawing of the straight line) becomes the input (the act of following it). Through the establishment of this circular structure, Young's composition displaces the dualism of creator and creation and constructs in its stead a situation in which the two are inextricably entwined.

Attempts like those of Sedgwick, Latour, and Shaviro to lay the groundwork for a post-critical discourse offer the opportunity to think differently about works such as Young's *Composition #10*, as well as other Fluxus objects and performances in which critique is set aside in favor of acts of constructive affirmation. These include works such as Knowles' *Make a Salad* and Maciunas' *Flux Smile Machines* (small and simple devices to be inserted into the mouth to help the wearer produce and maintain a smile). In light of the prefigurative politics at the heart of the Occupy Movement, there seems all the more reason to take this constructive turn seriously. As David Graeber, an anthropologist and a

key figure in the Occupy Movement, has proposed, the negativity of Marxist and deconstructive politics fits poorly with the collectivist affirmations that have emerged in the wake of the Seattle protests of 1999 (Graeber 2004). If Graeber is right, then works like Young's will likely come to be seen as more relevant to the present than many of the explicitly critical gestures that have until now seemed to be the only viable mode of oppositional practice.

Note

1 The paragraphs above are borrowed from my previously published essay on Schiller, Ranciere, and Cage (Rothman 2015: 63–64).

References

Adorno, Theodor (1974), "Commitment," *New Left Review I* 87/88. Available at: https://newleftreview.org/I/87-88/theodor-adorno-commitment. Accessed October 18, 2016.

Boucher, Geoff (2011), "The Politics of Aesthetic Affect: A Reconstruction of Habermas' Art Theory," *Parrhesia* 13: 62–78.

Foucault, Michel (1984), *The Foucault Reader*, ed. Paul Rabinow, New York: Pantheon Books.

Graeber, David (2004), *Fragments of an Anarchist Anthropology*, Chicago, IL: Prickly Paradigm Press.

Jameson, Fredric (1991), *Postmodernism, or the Cultural Logic of Late Capitalism*, Durham, NC: Duke University Press.

Kellein, Thomas (1995), *Fluxus*, London: Thames and Hudson.

Latour, Bruno (2004), "Why Has Critique Run Out of Steam? From Matters of Fact to Matters of Concern," *Critical Inquiry* 30: 225–48.

Lyotard, Jean-François (1984), *The Postmodern Condition: A Report on Knowledge*, trans. Geoff Bennington and Brian Massumi, Minneapolis, MN: University of Minnesota Press.

Marcuse, Herbert (1964), *One Dimensional Man: Studies in the Ideology of Advanced Industrial Society*, Boston, MA: Beacon Press.

Rothman, Roger (2015), "Schiller Upside Down Cake: Recipe for a Materialist Ateleological Aesthetic," in *The Art of the Real: Visual Studies and New Materialisms*, eds Roger Rothman and Ian Verstegen, Cambridge: Cambridge Scholars Publishing, pp. 63–83.

Sedgwick, Eve Kosofsky (2003), "Paranoid Reading and Reparative Reading, or, You're So Paranoid, You Probably Think This Essay Is About You," in *Touching Feeling: Affect, Pedagogy, Performativity*, Durham: Duke University Press, pp. 123–51.

Shaviro, Steven (2009), *Without Criteria: Kant, Whitehead, Deleuze, and Aesthetics*, Cambridge, MA: MIT Press.

Williams, Raymond (1977), *Marxism and Literature*, Oxford: Oxford University Press.

Defining Criticality as an Historical Object of the 1970s and 1980s

AnnMarie Perl

That we have no definition or historical account of the term "criticality" is ironic, given the self-conscious skepticism that the term has roughly come to connote within contemporary art discourse. Since its invention nearly half a century ago, criticality has become, especially during the last quarter century, the dominant means of measuring aesthetic value and, moreover, even an absolute good, with an inherent morality implied. Its dual significance makes the need to examine criticality, including its aesthetics and ethics, all the more fundamental and our failure to have done so yet in equal parts surprising and intriguing. This essay tells the story of criticality's rise to prominence within contemporary art, tracing its etymology and focusing on the social, political and economic conditions and circumstances that were paradoxically favorable to this development— paradoxically, because these were in all cases formidable contradictions and crises overcome. What is to be gained, this study ultimately asks, from defining criticality as an historical object of the 1970s and 1980s? Not only is criticality not forsaken in this inquiry and on the contrary empowered, exponentially, as it were, into a heightened criticality of criticality, but the period that produced this value and good becomes a bit more coherent and less divided.

Invention circa 1970

Criticality was a concept whose invention facilitated an ideological shift within art criticism from the Greenbergian modernism, which had been codified at the start of the 1960s, to a position that took account of the revolutionary social and political movements of that decade. Clement Greenberg's account of modernism's essence in "Modernist Painting," which was first published in 1960,

nevertheless remained sufficiently authoritative into the late 1960s and early 1970s, so that even the next generation's ultimately most influential alternative was couched in its terms. The origins of "criticality" can be found in Greenberg's identification of modernism as the "self-critical tendency that began with the philosopher Kant":

> The essence of Modernism lies, as I see it, in the use of the characteristic methods of a discipline to criticize the discipline itself — *not in order to subvert it, but to entrench it* more firmly in its area of competence. Kant used logic to establish the limits of logic, and while he withdrew much from its old jurisdiction, logic was left in all the more secure possession of what remained to it.
>
> Greenberg in Harrison and Wood 2003: 774; italics mine

The notion of criticality would inherit and later display the rigor, gravity and oftentimes the rhetorical style of philosophical inquiry, however, precisely *for the sake of subversion within the larger world*. In lieu of autonomy then, or self-circumscribed entrenchment within the "self-critical," criticality would by contrast call upon critics and artists to partake in militant engagement, in the trenches, with the parallel task of revising the history of modernism, including the traditions of the avant-garde, falling to art historians and inspiring what would soon come to be called the New Art History.

While the origins of criticality can be traced to Greenbergian modernism, Greenberg himself never employed the term "criticality." Indeed, although Greenberg isolated and celebrated self-criticism as modernism's imperative, he did not elevate this cognitive activity into a universal criterion of aesthetic value, insisting instead upon medium-specific criteria, wherein each artwork, as in the quotation above, would be evaluated according to its ability to define and refine the properties unique to its medium. Self-definition or self-criticism was thus only ever a means to the ends of purity and quality for Greenberg, these ends being the critic's supreme aesthetic values.

In contrast, criticality would become, across media, an end in and of itself, following especially Minimalism's collapse of the concept of the medium—beyond repair—during the late 1960s. Notwithstanding the fact that Minimalism has been considered among the least critical of postwar artistic movements, in at least three respects, Minimalism anticipated and accelerated the emergence of criticality. This stylistic movement was a motley, grassroots rebellion of artists internal to Greenbergian modernism, in which the leading artists penned their own art criticism. That these artists' criticism rivalled the writing of professional

art critics in its precision and power would eventually threaten the specialized role of art critics—although this incipient, art-world social conflict would only come to the fore in the later 1980s. Minimalism would thus constitute an important precedent for criticality, insofar as it made artists at least potentially responsible for art criticism, and also, as it allowed for the possibility of new artistic media, such as Donald Judd's "specific objects," with their own aesthetic criteria, including, for Judd, "power" and "interest" (Judd in Harrison and Wood 2003: 824–28). Additionally, although perhaps even more subliminally, within Minimalism latently bubbled the desire for social and political change that would consequently intensify and solidify into what would become one of the principal properties of criticality. Robert Morris, who was Minimalism's other main leader, described his work thus:

> Such work which has the feel and look of openness, extendibility, accessibility, publicness, repeatability, equanimity, directness, immediacy, and has been formed by clear decision rather than groping craft would seem to have a few social implications, none of which are negative. Such work would undoubtedly be boring to those who long for access to an exclusive specialness, the experience of which reassures their superior perception.
>
> Morris in Harrison and Wood 2003: 834–35

If Minimalism reproduced the militaristic rhetoric of power that gripped American society during the escalation of the Vietnam War, as Anna Chave has convincingly argued, Morris' description nevertheless suggests the desire to create a place, a space for popular, even populist dissent against official dictates (Chave 1990). By the late 1960s, especially after the advent of Pop, Greenbergian modernism, including the critics and artists who subscribed to it, appeared as out of touch as the Johnson and Nixon administrations with the population that it should have been serving and similarly besieged. There was thus a parallel, however barely articulated, between the revolutionary movements internal to the art world and transforming American society in general. While undoubtedly conflicted, Minimalism contained subtle signs that the American avant-garde was finally seeking to regain the social and political role that it had relinquished— in no small part under Greenberg's influence—during the 1940s and 1950s, but, notably, in a manner that preserved some fundamental qualities of Greenbergian modernism. While criticality's proponents would conceive of it as inherently and completely oppositional, criticality would develop within the art-critical establishment and serve to preserve its ideology.

It was neither Greenberg, as one might imagine, intuitively, nor, counterintuitively, the Minimalists, but rather Donald Kuspit who seems to have been the first to invoke the term criticality in the context of art. In an essay on Kandinsky, titled "Utopian Protest in Early Abstract Art" and published in 1970, Kuspit writes of Kandinsky's "concern with criticality—with a recognition of the critical character of objectivity which brings to mind again his shock at the splitting of the atom" (Kuspit 1970: 435). The anecdotal reference to the new, nuclear physics betrays the term's aberrative use and yet also attempts to justify, empirically, if only associatively, the collapse of science, philosophy and their twin notions of objectivity in order to reinterpret Kandinsky's project: "In fact, a case can be made for locating Kandinsky in the Kantian tradition of critical philosophy. Kandinsky in effect introduces the Copernican Revolution into painting, i.e., the insistence that the object conform to the subject, rather than vice versa, as was traditionally the case" (Kuspit 1970: 435). Kuspit's immediate objective was to revise Greenbergian modernism on its own Kantian grounds. More profoundly, Kuspit sought to reenergize, with some significant alterations, Meyer Schapiro's fundamental, innovative idea that abstract art, such as that of Kandinsky, was not only not autonomous but intimately related to its historical context and period, in which it participated actively, whether it sought refuge from the dominant culture, revolution or reform. Schapiro had introduced this influential, counterintuitive idea in the essay, "Nature of Abstract Art," which was published in the first issue of *Marxist Quarterly* in 1937 (Schapiro 1937). Its implications would soon be independently confirmed in the incomparably more broadly diffused and influential manifesto, "Towards a Free Revolutionary Art," jointly written and signed by André Breton, Diego Rivera and Leon Trotsky in 1938. Kuspit's critique of Greenbergian modernism would essentially repeat Schapiro's landmark challenge to Alfred Barr's formalism. From "Avant-Garde and Kitsch," in which Greenberg had relied upon Schapiro's rescue of abstract art from ivory-tower isolationism, if only to reaffirm the avant-garde's specialness, Greenberg had gradually converted to a position akin to that of Barr in "Modernist Painting." Schapiro's essay thus had renewed relevance.

As Serge Guilbaut has persuasively argued, without necessarily intending it, Schapiro's idea rendered abstract art a distinct possibility for leftist artists, who had previously been compelled to choose between either aesthetic experimentation or political commitment, these two directions being mutually exclusive, according to both formalists and Communists during the 1930s (Guilbaut 1983: 25). Emboldened also by Breton, Rivera and Trotsky's

proclamation that "true art is unable *not* to be revolutionary" (Breton, Rivera, and Trotsky in Harrison and Wood 2003: 533), leftist artists, such as Jackson Pollock, were thus licensed to pursue abstraction in good faith; they could believe that their solitary, ostensibly purely subjective struggles would nonetheless play a crucial historical role, even socially and politically—and yet, all the while, steer conveniently clear of any compromising political activities during the McCarthy era. The notion that if this abstract art were subversive, this could only have been unintentionally so, was further reinforced by the contemporary belief in the surrealist unconscious.

As if in anticipation then, Schapiro's conception of abstract art would, for all practical purposes, arguably offer Abstract Expressionism, the first American avant-garde, an alibi, as much as a release from the vice of either aesthetics or politics. Or, if not an alibi, then an exemption, as Greenberg would soon afterwards articulate in "Avant-Garde and Kitsch," in view of the avant-garde's surrogate duty "to keep culture *moving* in the midst of ideological confusion and violence" (Greenberg 1961: 5). As the American art world, however, along with the society at large, was being repoliticized during the late 1960s and early 1970s, this surrogate duty came to seem detached and insufficient, instead of noble, important and even heroic, and, accordingly, the undercurrent alibi, which had been so liberating for artists in the immediate postwar period, less credible and even problematic. And yet, the alibi would remain desirable and necessary, if art were not to be reduced to politics, and would, for that reason, not be rejected but only reconfigured as criticality.

It was on the basis of Schapiro's "Nature of Abstract Art" that Kuspit proposed the "utopian protest" of his own article's title to be the core of abstract art. Kuspit defined this utopian protest as an "objection not to social and political *particulars* but to *general* conditions of existence and the values which sustain them," arguing that this was "one of the major motivating forces behind Kandinsky's early production" (Kuspit 1970: 430, italics mine). Kuspit's argument differed significantly from his proof. While his conception of utopian protest privileged the general over the particular, and, in this respect, corresponded closely to Schapiro's appreciation of abstract art's oftentimes only scarcely perceptible historical embeddedness, Kuspit nevertheless focused on direct and specific connections between Kandinsky and his time, presenting a more extroverted, deliberate and rational Kandinsky than the rather hermetic one that Schapiro had suggested. Whereas Schapiro's Kandinsky had turned within, reflexively, as part of his spiritual protest against materialism, science and socialism, Kuspit's Kandinsky faced the

world head on, including through progressive social activism, even if this was only moral, intellectual and distanced—hence Kuspit's emphasis on Kandinsky's Kantian objectivity. Like Schapiro, Kuspit celebrated Kandinsky's anti-totalitarian and humanistic "spontaneity," but Kuspit located that spontaneity in not only Kandinsky's art but in both the student revolutions in Russian and western universities that Kandinsky had witnessed—but whose "politics," in Kandinsky's words, which Kuspit cited, "did not '*ensnare*' him"—and in what Kuspit argued was Kandinsky's substitute, political and "abstract" activity of studying the law, against whose rigidity Kandinsky valorized the spontaneity of Russian peasant law (Kuspit 1970: 431, italics mine). Kuspit's Kandinsky may well have been a fellow traveler of the Free Speech movement in the 1960s; he would not have been a leader of the Art Workers' Coalition, although these artists for the most part likewise separated their political activities categorically from their artistic practices. Curiously, neither Schapiro nor Kuspit invoked Kandinsky's leadership roles in the art worlds of post-Revolutionary Russia or pre-Nazi Germany, although the artist's ideological opposition to totalitarianism was implied by Schapiro and repeatedly mentioned, however obliquely, by Kuspit. Kuspit pursued his interest in politics strikingly hesitantly, seeking to correlate rather than connect the political and the aesthetic and thus maintain what remained an essential distinction.

Although Kuspit took interest in Kandinsky's politics, his overall argument and definition of utopian protest required only very general evidence of Kandinsky's dissatisfaction with the status quo. Kuspit quite ingeniously derived his concept of utopian protest from Engels' critique of utopian socialists as naive and ineffective; these were utopians, in Engels' words, who "do not claim to emancipate a particular class to begin with, but all humanity at once" (quoted in Kuspit 1970: 430). What was a fault for Engels was paradoxically a plus for Kuspit, who, under the influence of the Frankfurt School, was seeking to reintroduce Marxist theory into the study of art history. Following Engels' critique, artists partaking in utopian protest could not be reasonably evaluated in terms of their objectives or their results, the expectation in advance being that these were merely foolish fantasies. When criticality came into use to approximately designate what Kuspit had defined as utopian protest, this indeterminacy made for a low burden of proof. This low burden of proof would eventually become a prime advantage of criticality. If protest could be utopian, and thus not issue-, class- or movement-specific, then it could not be assessed in any precise terms either. It would consequently be quite easy to claim criticality and rather more difficult to discount or disprove any positive claims, with all argument, perforce, taking place on a rhetorical plane of generalities.

Utopian protest was arguably an oxymoronic concept, which increased the burden of intellectual and moral responsibility on the artist. Naming the members of Greenberg's current stable of artists, including Morris Louis, Helen Frankenthaler and Kenneth Noland, Kuspit concluded that: "Today's abstractionists have lost the core of abstract art" (Kuspit 1970: 436). Although the term criticality would only come into use later, Kuspit's critique of these artists was their lack of utopian protest or criticality. They myopically focused on the aesthetic at the expense of what was "critical," with all of that word's denotations serving as connotations; the critical was very serious and significant, related to aesthetic judgment, demanded taking a firm position, was necessarily personal and subjective and yet strove for objectivity through precise and rigorous consideration of the kind associated with science, mathematics and philosophy. Kuspit's rhetorical emphasis on the utopian at once elevated and evaded the question of politics, which the notion of protest seemed to foreground.

By 1970, Kuspit had already earned a doctorate in philosophy, having studied under the supervision of Theodor Adorno at Frankfurt University, and was then pursuing a second doctorate in art history, from which he would afterwards turn to art criticism, bringing his knowledge of philosophy with him.[1] Kuspit's internal challenge to Greenbergian modernism can be compared to that of the Minimalists, who likewise emphasized the physical, embodied nature of vision, theorized the relationship between objects and subjects, activated intersubjective space and insisted upon art criticism as well as the relevance of philosophy. Both operated in Greenberg's terms but problematized autonomy. Kuspit arrived on the scene shortly after the Minimalists and with, moreover, a background in critical theory. He could thus more easily articulate the period's increasing desire and need to politicize, and yet this remained difficult. Tellingly, Kuspit ultimately retained Schapiro's alibi in "Utopian Protest in Early Abstract Art." The notion of the utopian negated the promise of physical or concrete protest through abstraction.

Entrenchment and retrenchment circa 1984

Not only does Kuspit deserve to be credited as criticality's inventor but also its popularizer, as he would employ the term increasingly frequently, emphatically and influentially in his widely-published art criticism throughout the 1970s and early 1980s—until the term itself, true to its origins in nuclear physics, passed a certain threshold, after which it changed qualitatively and acquired its own

momentum. Criticality's proponents were soon left battling over this precious object, which, among art critics anxious about their own role within the booming art market, signified an alternative value and good, one that was antithetical to contemporary art's increasing market value as a luxury good.

Such a lucrative economic situation would have been unthinkable from the perspective of "Avant-Garde and Kitsch," which Greenberg concluded with an assertion that may have seemed axiomatic in the late 1930s: "Capitalism in decline finds that whatever of quality it is still capable of producing becomes almost invariably a threat to its own existence" (Greenberg 1961: 21). The avant-garde's pursuit of quality doubled, in Greenberg's view, as anti-capitalist subterfuge. During the Great Depression, contemporary art could take moral if not material comfort in its lack of saleability. This lack only further evidenced its social and political independence and incorruptibility and thus its quintessentially avant-garde character—even as many artists found employment within the Works Progress Administration's Federal Art Project. As the New Deal expired, however, and the postwar economic boom finally expanded to include the contemporary American art market in the mid to late 1950s, it became increasingly difficult to ensure the avant-garde character of contemporary art in this manner. That would be true again, as this pattern of recession and boom was repeated, albeit on a smaller scale, from the 1970s to the 1980s. Anti-capitalism had cushioned, as in Greenberg's essay, the depoliticization of the American avant-garde during the 1940s and 1950s and would be reactivated as this process was reversed during the 1960s and 1970s. If the origins of criticality, as in this essay, can be located in Greenberg's emphasis upon the "self-critical," the origins of these origins were in a political commitment displaced onto an anti-capitalism, which had diametrically opposed the quality of the avant-garde with the quantity of kitsch and conflated capitalism with fascism through the prism of kitsch. This initial political and economic ideological source of criticality would resurface as politics took a distinctly conservative turn at the same time that the contemporary art market exploded in the 1980s. With ever more urgency arose the question, which was rhetorical for some, while loaded for others: could avant-garde art participate in the art market?

One extreme and exceptional but indicative point can be identified in the late 1980s when the term criticality could be self-consciously used to valorize almost any kind of art: from the abstract painting of Brice Marden and Gerhard Richter to the political satire of Robert Arneson and street art of Liz-N-Val, including also the neoconceptualism of David Robbins and Wallace and Donahue, and

even Robert Smithson, whose work and influence was so vast and various that it could not be categorized. In 1987, in his essay, "Seven Types of Criticality," Dan Cameron alluded to William Empson's "Seven Types of Ambiguity" in order to problematize the ambiguity of the term criticality and yet demonstrate its complexity and applicability to all of these artists. Most strikingly, Cameron defined critical art by contrasting it with protest art:

> If a work of art is critical, then it supplements its aesthetic function with a social presence or awareness that connotes a dissatisfaction with 'the way things are.' This formula differentiates critical art from, say, protest art, which draws historical significance from the play of contemporary events. Protest art manifests its belief that events may change, but the factors underlying these events are allowed to perpetuate themselves, hence the role of protest art as a model for heightened sociohistorical consciousness. Critical art, on the other hand, recognizes so-called *permanent cultural factors* only insofar as they make themselves evident in the perennial issues that mark the periodic formal upheavals within the art community. To remark on an artwork's criticality is thus a recognition of its status as a cultural emblem, treating real-world matters allegorically (if at all).
>
> Cameron 1987: 14

Despite the fact that criticality had become current in art-critical discourse, and furthermore even de rigueur and comprehensive by this point in the late 1980s, it still retained the same function as in Kuspit's obscure first use in "Utopian Protest in Early Abstract Art." The difference was that Cameron acknowledged the alibi of criticality as a conceit. But Cameron's admission of the relativity and utility of criticality at once was unique and borne of a short-lived moment in which criticality was, on the one hand, being critiqued by artists and, on the other, caught between rival critical camps. At that moment, between 1986 and 1987, when some artists were rebelling against the notion of criticality, Cameron could observe that even Neo-Expressionism possessed criticality: "For an American audience used to debating the fine points of Robert Kushner vs. Jennifer Barlett, having the doors knocked open by Anselm Kiefer or Enzo Cucchi was a cleansing moment of self-deprecation, hence the very essence of criticality in action" (Cameron 1987: 15).

The key critical debate of the decade had been whether or not Neo-Expressionism possessed criticality.[2] Even the subsequently dominant artistic movement of Pictures would be theorized in relation to it. The case for the criticality of Neo-Expressionism, whose most prominent advocate was

Kuspit, became less credible, as the Pictures movement, which came to be known after an exhibition of the same name organized in 1977 by Helene Winer and Douglas Crimp at Artists Space in New York, gained traction. Between these competing movements, the mutually reinforcing differences were demographic, epistemological, formal and ideological. Whereas the Neo-Expressionists were mostly men, who believed in the primacy of the creative individual and subjective experience, worked in the traditional mediums of painting and sculpture, and seemed to pander to the art market, the Pictures artists had internalized the feminist critique and structuralism, preferred the less saleable mediums of photography, film and video, and appropriated already existing imagery from mass culture as if it were a coherent meta-language, whose system of signs could be deciphered and even destabilized. So neatly were these differences aligned that they appeared to be systematic and ultimately served as proof of these movements' diametrically opposed cultural politics.

Despite the contemporaneity of these movements, to its supporters, the Pictures movement seemed an historical epoch apart and ahead of Neo-Expressionism. Throughout the debate over its criticality, Neo-Expressionism remained an international stylistic movement, but the Pictures movement, including artists such as those featured in the landmark exhibition of 1977, namely, Troy Brauntuch, Jack Goldstein, Sherrie Levine, Robert Longo and Philip Smith, soon inspired an intellectual movement, whose leaders constructed a sophisticated theory of postmodernism. It relied upon what is called critical theory today: a combination of postwar French theory, including structuralism and poststructuralism, as well as Frankfurt School philosophy. The cause of postmodernism advanced the critique of Greenbergian modernism even as its theoretical bent ensured that the relationship between art and politics would remain abstract.

It was during the later 1980s, when the debate on the criticality of Neo-Expressionism was finally decided, that Kuspit would arguably be forced to forfeit the term of his invention to the camp that had prevailed. That within this debate Kuspit had been insisting upon the importance of traditional artistic creativity, subjectivity and intentionality in principle opposed Kuspit to the emerging poststructuralists. Simultaneously, however, Kuspit had more generally displaced his notion of criticality from the sphere of art to art criticism and thus was analogously, one could argue, transferring the meaning of the artwork from the author or artist, now dead, to the reader, or the critic, who was becoming not only the judge of criticality in art but also, to a certain extent, its guarantor and bearer.

In the name of criticality, art criticism, it would seem, was becoming more important than art itself. In the preface to Kuspit's collection of art-critical writings, published in 1984 and titled *The Critic is Artist: The Intentionality of Art*, the implausibly overblown proportions that criticality had acquired were without compunctions laid bare; criticality was no longer a property of certain praiseworthy art, but criticism in itself a superior form of art. After epigraphs quoting Charles Baudelaire and Oscar Wilde on the greatness of the critic, Kuspit began:

> It used to be that one could think of 'the critic as artist,' if not as an actual artist. Now it is inevitable that one acknowledge, however reluctantly —for both critic and artist—that 'the critic is artist,' in the fullest sense that the eroding idea of 'artist' retains. All the weight of meaning in the formula of their relationship is now on the critic rather than the artist. The balance has tilted to the critic, although there may be no critic to take the opportunity it affords. It is harder to know what it is to be a critic, and to be one, than to know what it is to be an artist and to be one. The majority of artists tend towards one-dimensionality—towards a set of operations which close down the concept of art they articulate in a style. The critic separates the stylistic operations from the concept to recover the question the concept represents, the painfully uncertain meaning and use of art that the concept embodies. The critic does not accept the anodyne of style as the destiny of art, and he refuses to endorse the established modes of discourse that aim to institutionalize a dominant system of style. Unlike the artist, he does not look for a place in the sun of the existing order of art. Unlike the artist, he does not totally identify with art. He identifies also with the dialectic of ideas from which art emerges and to which it returns. Today, the meaning of criticality has become more uncertain than the meaning of artistry; but this is perhaps the discovery of what has always been the case, which is why criticism and self-criticism have been thought of as the core of art in modern times, its risky means of advance.
>
> Kuspit 1984: xi–xii

What such a boast obscured and arguably opposed was the extreme insecurity of art criticism at that moment for both external and internal reasons. It was a field under siege and divided. In 1984, the National Endowment for the Arts suspended its fellowship program for art critics, citing a report that it had commissioned from the art critic John Beardsley, which pointed to "specific ideological biases" within the field and expressed doubt that the grants positively affected the quality of individual art critics' work or of art criticism in general (quoted in Glueck 1984). Created in 1972, the program had already been once

discontinued and reinstated, in 1981 and 1984, respectively, then President Reagan having sought to curtail if not cut funding for the arts entirely.[3] The decision to suspend the program in 1984 was immediately and widely viewed on the left as a coordinated political act designed to suppress criticism of the government. All three writers, including Kuspit, who expressed their outrage in the "Forum" published in *Artforum*, mentioned the conservative art critic Hilton Kramer, who in various publications, including notably in *The New Criterion*, had been arguing against the politicization of art and the lowering of standards of aesthetic quality. These critiques were arguably criticality's concerns, and doubly so; criticality took account of politics, regarding it as important and even essential, and yet not without considerable unease, as it was equally interested in aesthetic issues. The stakes could not have been higher, or the tone of this collective self-defense more distressed; Kuspit went so far as to cite Joseph Goebbels in his response, published in *Artforum*, Goebbels having issued a "Decree Concerning Art Criticism" (Kozloff, Larson and Kuspit 1984: 78). For critics on the left, it was not only a question of funding or even moral support but a deeply cherished culture of criticism that was under attack.

Against Kramer, there was solidarity on the left, which might have outlasted this attack, had its factions not been so similar and thus competitive. Two rival camps developed: one associated with the journal *October*, which was founded by Jeremy Gilbert-Rolfe, Annette Michelson and Rosalind Krauss in 1976, and centered around the CUNY Graduate Center; and the other with the journal *Art Criticism*, which Lawrence Alloway and Kuspit established in 1979 and edited from their base at the State University of New York at Stony Brook. *Art Criticism*, it must be mentioned, would appear far less frequently than *October* and furthermore oftentimes only irregularly. Both groups were motivated, according to their first editorial statements, by their opposition to the art market, to which, they argued, art criticism had been made subservient by the glossy, flashy art magazines of the period and enslaved as nothing more than intellectually dressed-up advertisement (Gilbert-Rolfe, Michelson and Krauss 1976: 5; Alloway and Kuspit 1979: 1). This was an anti-capitalism rooted in neo-Marxism, to which *October* gestured in its name and which Kuspit discussed in his first essay, "The Necessary Dialectical Critic," whose epigraph quoted Horkheimer and Adorno's *Dialectic of Enlightenment* (Kuspit 1979).

In resistance then to the reigning model of the art magazine as catalogue or brochure, the graphic design of both journals was deliberately bare, consisting almost exclusively of text; "*October* will be plain of aspect," wrote its editors, "its

illustrations determined by considerations of textual clarity," while *Art Criticism* would arguably be even plainer, with scarcely an image, light, sans-serif typeface and the most basic, default layout (Gilbert-Rolfe, Michelson and Krauss 1976: 5). The visual impact of both was nevertheless buoyed by an indisputable trendiness, by their resemblance, in a word, whether by common parentage or as progeny, to the ascetic aesthetic of Conceptualism and its spare, iconoclastic look of linguistic chic. The dematerialization of the art object of the late 1960s and early 1970s had likewise been at least partially motivated by opposition to the art market, although, by the time that these journals were founded in the late 1970s, the market had already proven its adaptability to the most intractable new "conceptual art," much to the disappointment of its leaders (Lippard 1973: 263).[4] Beyond these common ethics and aesthetics, there were ostensibly slight differences that would soon reveal themselves to be significant. *October* was more interdisciplinary and interested in promoting what it considered to be the most important new art, including the work of the Pictures artists, and in developing coherent theoretical models, notably that of postmodernism. *Art Criticism* was at once more narrowly interested in the field of art criticism itself and, as part of this disciplinary specialization, deliberately comprehensive in the kind of art that it examined, while nevertheless restricting its purview to traditional, fine art alone.

If it was Kuspit, who introduced criticality into art criticism, how can it be explained that the term is now associated with *October* and Kuspit's role has been forgotten? Kuspit was as inspired by critical theory, having been a student of Adorno and among the first, if not the very first, to apply critical theory to art criticism and history. Kuspit and Krauss were directly and personally compared, since both were considered to be purveyors of "theory," answering a new need for "philosophical art criticism," although, in general, contemporaries, such as David Carrier, concluded that Krauss' approach was more promising (Carrier 1986: 173).[5] The proponents of what came to be known as pluralism and critical postmodernism developed valid critiques of each other's assumptions and biases.[6] Both couched their art criticism, whether favorable or negative, in terms of the presence or absence of criticality. It could be, however, that the pluralism of *Art Criticism* belonged more properly to the 1970s, while the cultural politics and rebounding art market of the 1980s demanded the increased political commitment and partisanship of critical postmodernism. Ironically, it is the Pictures movement that has had much greater longevity on the art market, not the supposedly cynical, solely market-driven Neo-Expressionism that Kuspit

supported. How to explain, furthermore, why it was only after the market for Neo-Expressionism wavered and then collapsed that the debate over its criticality was definitively decided against it? An irony noted at the time by the curators Tricia Collins and Richard Milazzo was the role that the postmodernist critics played in the sanctification of the Pictures movement, which in turn established them: "We have watched," they wrote, "the 'picture' theory of art pass from the critique of reification into the reification of critique" (Collins and Milazzo 1988: 9). A final irony is that with hindsight Neo-Expressionism and the Pictures movement diametrically opposed to it have come to appear more similar and even related (Foster 2011: 643).

At the time, what seemed most unexpected and unexplainable was Kuspit's exceedingly charitable view of German Neo-Expressionism, including the particular politics of its engagement with German national identity and historical memory.[7] The debate over the criticality of Neo-Expressionism had hinged, internally, upon the meaning of the German movement, one's interpretation of its character determining also the perceived import of the Italian and even American movements, however distinct the latter now appears in retrospect. This debate ultimately became a struggle for criticality itself, as German Neo-Expressionism's scandalous arrival on the international scene pressured precisely the historical origins and necessity of criticality; representing Germany in the German Pavilion, the Nazi imagery of Baselitz and Kiefer at the Venice Biennial of 1980 recalled the moment, the reason, too ambiguously, in and for which criticality had been created in the United States. To argue for the criticality of German Neo-Expressionism thus seemed to be its perversion. Certainly, it involved a fundamental revision of the avant-garde's widely understood but narrowly defined relationships to fascism, capitalism, history and art history.

Critiques of criticality circa 1987

Criticality survived two independent critiques during the later 1980s, the first of which was led by a growing group of artists, while the second came from critics, for whom the dominant model of criticality was insufficiently effective politically. The always delicate and changing balance between aesthetics and politics that criticality maintained was thus tested from both ends. It may be because these challenges came from opposing perspectives in rapid succession that criticality could regain its footing as quickly and durably as it did. At a minimum, if the

artists' rebellion against the criterion of criticality to which their works were being submitted had been successful, there would have been no need for the critics themselves to engage with it. At most, this dynamic testifies to criticality's necessity for our era, in which we remain equally hostile to art for art's sake and political propaganda and can only quibble, depending upon the circumstances, about their optimal relative proportions. Only for some the AIDS crisis made such quibbling irrelevant, obsolete and impossible. Because these critiques were developed by star exemplars of criticality, they had the treasonous and embarrassing quality of defections or desertions.

Sherrie Levine publicly repudiated criticality in a cover story published in the May 1986 issue of *Artnews*. It was news to the art world that Levine, whose work had been essential to the theorization of critical postmodernism, strongly objected, as her interviewer reported, to this interpretation, in which she had nonetheless initially willingly participated:

> She [Levine] spoke that first evening of her boredom with the current deluge of 'mindless' appropriation. There was also the support she was getting critically— that was really bothering her. There may have been a time (she herself is not sure about this) when she was happy to play the role of the theoretical critics' model artist, serving the poststructuralists as Jules Olitski once served the formalists. But by last spring, she was talking as if she wanted out. 'Almost all the critical support for my work was coming from a leftist, academic reading of it,' she said. 'I was very appreciative, even collaborative. But at some point I began to feel boxed in. It had gotten to the point where people couldn't see the work for the rhetoric. People weren't really reading what I was doing as photographs or drawings or watercolors but as position papers. [. . .] I felt I was being judged for purity or correctness,' she continued. 'I had never cared about that. And I really felt envious of those artists who hadn't put themselves in a position to have their work read so narrowly . . .'
>
> <div align="right">Marzorati 1986: 93</div>

The most celebrated artist of the Pictures exhibition of 1977 narrated her intellectual development and named her interlocutors-cum-instructors, notably Krauss, Crimp and Craig Owens, who had introduced her to postmodernism (Marzorati 1986: 96). Perhaps most significant was Levine's repositioning of her work in relation to Neo-Expressionism: "When I think of it now," Levine said, "I don't think what Julian Schnabel was doing was all that different from what I was trying to do" (Marzorati 1986: 92). Not only did this upset the then current dichotomy between the criticality of Pictures and the complicity of Neo-Expressionism but it

also recast the meaning of Levine's own recent artistic development. Levine had begun by re-photographing photographs in reproduction, but then turned to photographing German Expressionist paintings in reproduction in 1982 and afterwards to drawing and painting after reproductions in her own hand in 1983; by 1985, Levine was producing her own "original" and "artistic" paintings, which, given Levine's public repudiation, could be reinterpreted as acts of defiance against critical postmodernism's denunciations of these values and the medium of painting itself as modernist and passé.

Levine's defection from the critical postmodernist camp soon unleashed a younger generation of artists' rebellion, which was more specifically directed against criticality. Its highpoint can be pinpointed by the panel, "From Criticism to Complicity," which was published in the summer 1986 issue of *Flash Art*, shortly after Levine's tell-all interview. Levine's presence signaled her interest in, if not approval of the polemical, contrarian position and value of complicity, which the panel's moderator Peter Nagy and its participants Peter Halley, Haim Steinbach, Ashley Bickerton, Philip Taaffe, and Jeff Koons were variously sketching, and Steinbach most explicitly:

> There has been a shift in the activities of the new group of artists in that there is a renewed interest in locating one's desire, by which I mean one's own taking pleasure in objects and commodities, which includes what we call works of art. There is a stronger sense of being complicit with the production of desire, what we traditionally call beautiful seductive objects, than being positioned somewhere outside of it. In this sense the idea of criticality in art is also changing.
>
> Steinbach quoted in Nagy et al. 1989: 46

While the social and political remained essential to these artists, Bickerton admitted without guilt or hesitation: "This work has a somewhat less utopian bent than its predecessor" (Bickerton quoted in Nagy et al. 1989: 46). Halley ventured furthest, when he stated, "We are now in a post-political situation" (Halley quoted in Nagy et al. 1989: 47). This group, under various names, including especially Simulationism and Neo-Geo, was, perhaps predictably, quickly embraced by the market and, maybe more surprisingly, nearly as rapidly validated by important museum exhibitions, including the New Museum's *Damaged Goods* in the summer and the Boston ICA's *Endgame* in the fall of 1986 (Wallis 1986; Bois 1986); both exhibitions were accompanied by catalogues with serious scholarly essays. The following fall, Koons would debut a systematic critique of criticality, after having reinvented his artistic project from one of

analysis to activism; "Criticality Gone" would serve his manifesto's clarion call, sounded in the November 1987 issue of *Artforum* (Koons 1987: 116).[8]

It is possible that the artists' uprising against the strictures of criticality would have succeeded, as leftist art criticism anyway felt miserably outgunned during the 1980s by both the art market and reigning conservative politics. In a searching self-examination of 1989, Abigail Solomon-Godeau bemoaned, "It should have become abundantly clear in recent years that the function of criticism, for the most part, is to serve as a more or less sophisticated public relations or promotional apparatus," and yet concluded: ". . . it becomes increasingly difficult to say with any assurance what critical practices should actually or ideally seek to do" (Solomon-Godeau 1989: 191, 210). The reason for this state of uncertainty remained, through elaborate reasoning, self-imposed, or imposed by an adherence to the doctrine of criticality:

> Although Heartfield is clearly a political artist, few contemporary artists concerned with critical practice are comfortable with the appellation *political*: first, because to be thus defined is almost inevitably to be ghettoized within a (tiny) art world preserve; second, because the use of the term as a label implies that all other art is *not* political; and third, because the term tends to suggest a politics of content and to minimalize, if not efface, the politics of form. It is for all these reasons that throughout this essay I have chosen to employ the term *critical practice* in lieu of *political practice*.
>
> Solomon-Godeau 1989: 206, italics original

Just as the invention of criticality was motivated by the politicization of the American art world at the height of the anti-war movement around 1970, the need for social and political activism was renewed during the late 1980s, as the AIDS crisis came to a head, hitting the art world, with its large gay community, particularly hard. Given the massive, life-and-death nature of that crisis, which confronted many in the art world firsthand, criticality alone seemed to some an increasingly inadequate answer. Crimp edited a special issue of *October* on the crisis (Crimp 1987), titled "Cultural Analysis/Cultural Activism," although he would for his efforts soon afterwards be "pushed out of *October*" (Crimp quoted in Danbolt 2008). This kind of analysis-cum-activism would be too political and too particular in its concentration on one issue and one social group to qualify as criticality, which insisted upon the equal importance of aesthetics and mandated a certain level of abstraction. Aesthetics did play a role in both the figuration of the AIDS crisis and the success of ACT UP, but this role was hardly

abstract and much too actual. Criticality was theorized from the abstract art of modernist painters like Kandinsky and retained the character of modernist abstraction through Conceptual Art and even the Pictures movement and Simulationism. Rather than succumbing to the internal critiques of artists or activist critics, criticality arguably survived the 1980s, without having to make any real accommodations.

Notes

1 For more information on Kuspit and his legacy, see Craven and Winkenweder 2011.
2 For the major arguments, see Buchloh 1984: 107–35 and Kuspit [1983] in Wallis 1984: 137–51.
3 For a contemporary report, see Honan 1988.
4 See Alberro on how Conceptual Art catered to the art market (Alberro 2003), and Crow on how it accelerated the art market's expansion (Crow 2008).
5 Carrier later wrote an admiring book on Krauss' writings (Carrier 2002).
6 For an excellent summary of the debate surrounding pluralism, see Whiteley 2012: 433–40.
7 For Kuspit's defense of his position, see Kuspit [1983] in Wallis 1984: 137–51.
8 These issues are developed in my unpublished essay on Koons (AnnMarie Perl unpublished manuscript).

References

Alberro, Alexander (2003), *Conceptual Art and the Politics of Publicity*, Cambridge, MA: MIT Press.

Alloway, Lawrence and Donald Kuspit (1979), "Editorial," *Art Criticism*, 1(1): 1.

Barr, A. H. (1936), *Cubism and Abstract Art*, New York: Museum of Modern Art.

Bois, Yve-Alain, ed. (1986), *Endgame: Reference and Simulation in Recent Painting and Sculpture*, Cambridge, MA: MIT and ICA.

Breton, André, Diego Rivera and Leon Trotsky (1938), "Towards a Free Revolutionary Art," in Harrison and Wood (2003), pp. 532–35.

Buchloh, Benjamin H.D. (1984), "Figures of Authority, Ciphers of Regression," in Wallis (1984) pp. 107–35.

Cameron, Dan (1987), "Seven Types of Criticality," *Arts magazine* 61(9): 14–17.

Carrier, David (1986), "Philosophical Art Criticism," *Leonardo* 19(2): 170–74.

Carrier, David (2002), *Rosalind Krauss and American Philosophical Art Criticism: From Formalism to Beyond Postmodernism*, Westport, CN: Praeger.

Chave, Anna C. (1990), "Minimalism and the Rhetoric of Power," *Arts magazine* 64(5): 44–63.

Collins, Tricia and Richard Milazzo (1988), "Hybrid Neutral: Modes of Abstraction and the Social," in *Hybrid Neutral: Modes of Abstraction and the Social*, ed. Tricia Collins, Richard Milazzo, and Gary Indiana, New York: Independent Curators Inc.

Craven, David and Brian Winkenweder (2011), *Dialectical Conversions: Donald Kuspit's Art Criticism*, Liverpool: Liverpool University Press.

Crimp, Douglas, ed. (1987), *AIDS: Cultural Analysis/Cultural Activism*, special issue of *October* 43: 1–273.

Crow, Thomas (2008), "Historical Returns," *Artforum International* 46(8): 286–91, 390.

Danbolt, Mathias (2008), "Front Room—Back Room: An Interview with Douglas Crimp," *Trikster* 2. Available at: http://trikster.net/2/crimp/1.html. Accessed October 13, 2015.

Foster, Hal (2011), "1984b," in *Art Since 1900: Modernism, Antimodernism, Postmodernism*, ed. Hal Foster et al., New York: Thames & Hudson: 640–43.

Gilbert-Rolfe, Jeremy, Rosalind Krauss and Annette Michelson (1976), "About October," *October* 1: 3–5.

Glueck, Grace (1984), "Endowment Suspends Grants for Art Critics," *The New York Times*, April 5, 1984.

Greenberg, Clement (1960), "Modernist Painting," in Harrison and Wood (2003), pp. 773–79.

Greenberg, Clement (1961), "Avant-Garde and Kitsch," *Art and Culture: Critical Essays*, Boston, MA: Beacon Press, pp. 3–21.

Guilbaut, Serge (1983), *How New York Stole the Idea of Modern Art: Abstract Expressionism, Freedom, and the Cold War*, Chicago, IL: University of Chicago Press.

Harrison, Charles and Paul Wood, eds (2003), *Art in Theory, 1900–2000: An Anthology of Changing Ideas*, Malden, MA: Blackwell Publishing.

Honan, William H. (1988), "Book Discloses That Reagan Planned to Kill National Endowment for Arts," *The New York Times*, May 15, 1988.

Judd, Donald (1965), "Specific Objects," in Harrison and Wood (2003), pp. 824–28.

Koons, Jeff (1978), "Baptism: A Project for Artforum," *Artforum* 26(3): 110–16.

Kozloff, Max, Kay Larson and Donald Kuspit (1984), "Forum," *Artforum* 22(9): 77–79.

Kuspit, Donald B. (1970), "Utopian Protest in Early Abstract Art," *Art Journal* 29(4): 430–37.

Kuspit, Donald B. (1979), "The Necessary Dialectical Critic," *Art Criticism* 1(1): 13–31.

Kuspit, Donald B. (1983), "Flak from the 'Radicals': The American Case against German Painting," in Wallis (1984), pp. 137–51.

Kuspit, Donald B. (1984), *The Critic is Artist: The Intentionality of Art*, Ann Arbor, MI: University of Michigan Research Press.

Lippard, Lucy R. (1973), *Six Years: The Dematerialization of the Art Object from 1966 to 1972*, New York: Praeger.

Marzorati, Gerald (1986), "Art in the (Re)Making," *Artnews* 85(5): 90–99.

Morris, Robert (1966; 1967), "Notes on Sculpture 1–3." in Harrison and Wood (2003), pp. 828–35.

Nagy, Peter, Sherrie Levine, Peter Halley, Jeff Koons, Haim Steinbach, Ashley Bickerton, and Philip Taaffe (1989), "From Criticism to Complicity," *Flash Art* 129: 46–49.

Perl, AnnMarie, "'Criticality Gone': Jeff Koons' Critique of Criticality and Alternative of Political Showmanship in the late 1980s," unpublished manuscript.

Schapiro, Meyer (1937), "Nature of Abstract Art," *Marxist Quarterly* 1(1): 77–98.

Solomon-Godeau, Abigail (1989), "Living with Contradictions: Critical Practices in the Age of Supply-Side Aesthetics," *Social Text* 21: 191–213.

Wallis, Brian, ed. (1984), *Art After Modernism: Rethinking Representation*, New York: New Museum of Contemporary Art.

Wallis, Brian, ed. (1986), *Damaged Goods: Desire and the Economy of the Object*, New York: New Museum of Contemporary Art.

Whiteley, Nigel (2012), *Art and Pluralism: Lawrence Alloway's Cultural Criticism*, Liverpool: Liverpool University Press.

4

"The people were smart and hungry": Criticality, Egalitarianism, and the Pictures Generation

Anthony E. Grudin

Over the past two decades, the philosopher and historian Jacques Rancière has offered an unusually powerful and damning assessment of postmodern art. While supporters have cited its critical engagement with contemporary culture, and unsympathetic critics have condemned it as salacious or cynical, Rancière has developed a truly political appraisal that denounces this art as a deeply elitist style that serves to perpetuate hierarchies even as it pretends to denounce them. This "so-called critical" art, which "pretend[s] to reveal to us the omnipotence of market flows, the reign of the spectacle, the pornography of power," is, for Rancière, "entirely integrated within the space of consensus"—fully complicit with what it claims to critique (Carnevale and Kelsey 2007: 264). As a paradigmatically postmodern and critical movement, the Pictures Generation is necessarily vulnerable to Rancière's censure. This essay will gauge the scope of this vulnerability by examining the sources of Picture's supposed criticality, and proposing an alternate model of its political efficacy.

Rancière's aesthetic theory stems directly from his anti-hierarchical theory of politics, which argues that western thought has been predicated on a multi-millennial effort to establish and maintain social hierarchies by defending a distinction between those who are capable of thought and speech and those who are not. "Philosophy," he claims, "can trace the circle of its own autonomy only through an arbitrary discourse on nature and nobility ..." (Rancière 2003: 53). Thus, when Rancière's teacher and collaborator Louis Althusser conceptualized a proletarian class that had not yet attained full consciousness of its exploited potential, Rancière identifies a power struggle in which one privileged thinker has *assumed* the absence of thought in his contemporaries, even as he ostensibly aims to aid them: "As for knowing history, the masses should wait for the 'theses'

that specialists in Marxism work out for their benefit. Roll up your sleeves and transform nature; for history, though, you must call on us" (Rancière 2011a: 10). Against this tradition of hierarchy, Rancière demands an immediate conviction in equality as an axiom, not an ideal: "To pose equality as a goal is to hand it over to the pedagogues of progress, who widen endlessly the distance they promise that they will abolish. Equality is a presupposition, an initial axiom—or it is nothing" (Rancière 2003: 223).

The question of equality is central to Rancière's aesthetic theory as well. Against philosophy's tradition of hierarchy, art, as Rancière understands it, has long been forecasting an egalitarian and anti-hierarchical future. During the period he calls the aesthetic regime (roughly 1800 to the present), art has incrementally challenged the traditional rankings of genre, style, medium, motif, audience, and artist. More and more things, subjects, makers, and techniques that were previously considered low or vulgar have been deemed worthy of artistic inclusion. "From now on," Rancière tells us, "the border between action and life no longer has any consistency. Anything can enter into art. In parallel fashion, there is no longer any separation between a refined and an uncouth nature: art no longer has specific producers nor privileged addressees." (Rancière 2011b: 15). The camera is a transformative moment in this history since, like Walter Benjamin, Rancière sees it opening up the world of creativity to a vast multitude of makers, sights, and audiences.

But Rancière argues that art's egalitarian flows have also encountered powerful resistance, including discourses of both modernism (as defined by Clement Greenberg and his partisans) and postmodernism. Greenberg's modernism attempted to reinstall hierarchy by carefully guarding the various mediums, seeking out the separate truths of painting, sculpture, music, and poetry, protecting them from each other and the world. And postmodernism, which is often seen to have rectified this problem, has instead, for Rancière, exacerbated it:

> ...emancipation can't be expected from forms of art that presuppose the imbecility of the viewer while anticipating their precise effect on that viewer: for example, exhibitions that capitalize on the denunciation of the "society of the spectacle" or of "consumer society"—bugbears that have already been denounced a hundred times—or those that want to make viewers "active" at all costs with the help of various gadgets borrowed from advertising, a desire predicated on the presupposition that the spectator is otherwise necessarily rendered "passive" solely by virtue of his looking.
>
> Carnevale and Kelsey 2007: 258

For Rancière, this is "[c]ritical art's vicious circle": in its purported efforts to critique the society of the spectacle, postmodernism presumes the passivity of its audience (Rancière 2009: 46). It thus surreptitiously produces a familiar hierarchy: the artist (who, like the philosopher, sees, knows, and communicates) above the masses (who are purportedly blind, thoughtless, voiceless, waiting for guidance). Only an art that rejects this hierarchy would be capable of actual democratic force: "An art is emancipated and emancipating when it renounces the authority of the imposed message, the target audience, and the univocal mode of explicating the world, when, in other words, it stops wanting to emancipate us" (Carnevale and Kelsey 2007: 256).

Moreover, by reproducing the images it claims to critique, postmodern art enlarges their sphere of influence (Rancière 2009: 46). Instead of being part of the solution, postmodernism, for Rancière, is part of the problem, and he explicitly calls for its annulment: "If there is a circulation that should be stopped at this point, it's this circulation of stereotypes that critique stereotypes, giant stuffed animals that denounce our infantilization, media images that denounce the media, spectacular installations that denounce the spectacle, etc" (Carnevale and Kelsey 2007: 266). "Today," as Rancière put it in 2010, "the simple act of re-exhibiting identical images of advertising narcissism is itself attributed a critical value" (Rancière 2010: 59). These arguments seem clearly applicable to the work of the Pictures Generation, which has long been described in similar terms. Seminal essays in *October* by Douglas Crimp and Craig Owens helped to inaugurate this reading. According to Crimp, the work of the Pictures Generation is fundamentally demystificatory, defined by its investigation of "the distance that separates us from what those pictures simultaneously proffer and withhold and the desire that is thereby set in motion" (Crimp 1979: 85).[1] For Owens, in the art of Sherman and her peers, "We ... encounter once again the unavoidable necessity of participating in the very activity that is being denounced *precisely in order to denounce it*" (Owens 1980: 79, original emphasis).[2] Again and again, these critics need to justify the work's blatant "complicity" with mass culture by revealing it as a necessary moment in a critical deconstruction.[3]

This emphasis on critique has become practically axiomatic for thinking about the Pictures Generation. Douglas Eklund's authoritative catalogue for his 2009 exhibition at the Metropolitan Museum consolidated the thesis: "Since it was and is not difficult to see the specter of fascism lurking behind the bells and whistles of mass-cultural spectacle, the Pictures artists who wanted to investigate how images achieve their power needed to reflect on the often-troubling history

of our fatal attraction to images and illusion" (Eklund 2009: 173).[4] As Rosalind Krauss put it in the ambitious textbook *Art Since 1900*, "The 'Pictures' group, insofar as it declared that artistic mediums were no longer value neutral but had now, infected by the (communications) media, become part of the battle zone of modern culture, was itself an emblem of postmodernism understood as critique." (Foster et al. 2011: 627).[5] While this demystificatory goal seems laudable from almost every critical perspective, Rancière's approach would identify it as just one more in a long history of attempts to presuppose a stupid audience—passive, hypnotized, manipulated—in need of art's enlightenment. The very quality that Crimp, Owens, Eklund, and Krauss saw as guaranteeing the political efficacy of the Pictures Generation—its critical response to contemporary culture—is reframed by Rancière as its deepest political shortcoming.

Responding to Rancière's assessment thus means pivoting away from traditional defenses of the Pictures Generation. It would not be enough to say that these artists "teach" us something about the postmodern world, nor that they are "critical" of its falsifications. An alternate relationship to the material and the audience would have to be identified. Strikingly, however, and despite the familiarity of the "criticality" arguments discussed above, the artists of the Pictures Generation rarely promised to teach us anything. Instead, an anti-critical and egalitarian thread runs through their stated ambitions—they consistently described their work as investigative and immersive rather than didactic and critical. For Cindy Sherman, the rejection of a hierarchical approach to mass culture was formative: "When I was in school I was getting disgusted with the attitude of art being so religious or sacred, so I wanted to make something which people could relate to without having read a book about it first. So that anybody off the street could appreciate it, even if they couldn't fully understand it; they could still get something out of it" (Nairne 1987: 132). Richard Prince rejected criticality out of hand: "My work is not judgmental; it's like a window I see through" (Rian 1987: 94). Dara Birnbaum concurred, describing video and television as "the architecture of the day," and looking for ways to "not only re-occupy its imagery but also re-occupy the medium" (Birnbaum and Burton 2004). For his part, Allan McCollum would directly dispute the ironic detachment that critics so frequently attributed to his work: "I don't make [the *Perfect Vehicles*] with the kind of irony that people seem to project onto them because I'm actually very suggestible. If I see an object that someone else values to the extreme, I'm moved by that . . ." (McCollum 1996: 10). So did Jack Goldstein: "It's not poking fun at anybody. It's not at anybody's

expense" (Cranston 2012: 206). For Robert Longo, art is the product of immersion, offering no privileged critical perspective: "the artist really becomes essentially the worm in the bottom of the bottle of culture. You absorb all the poisons" (Berger 1990: 206).[6]

This widespread rejection of criticality was frequently paired with an embrace of egalitarianism. Like Rancière, Longo assumed the intelligence of his audience: "The people were smart and hungry" (Ehmke and Licata 1996: 16). A similar spirit drew Nancy Dwyer to Hallwalls: "It was very casual, witty, not private. Anybody could come and go and be a part of it as they pleased. . . . [Artists] all get so damn proprietary, territorial, and petty. Hallwalls definitely was not like that" (Emkhe 1996: 24). Even Louise Lawler, whose work seems so compatible with the criticality thesis, has emphasized her efforts to "say somehow that the rest of the world counts . . ." (Crimp 2000: n.p.) For James Casebere, the Pictures Generation and its compatriots were united around an attempt to "address a larger audience and . . . bring pleasure back into the equation" (Jenkins 1996: 87).

Pictures artworks are striking for their collective and wide-ranging lack of condescension toward the media worlds they investigate and the audiences they anticipate. They do not assume a distance from these worlds, nor do they presuppose an audience that needs to be educated. Instead, like worms in a bottle, they immerse themselves in the strategies and structures of contemporary media. Pictures art could always pass for pictures. As Sherman put it, in an aphoristic claim that might serve as her generation's motto: "To think about why something repulses me makes me that much more interested in it" (Lichtenstein 1992).

The mediums in which these artists worked had to be mastered in order to be operated, and that mastery required an immersion that could not be predicated on disdain. Has anyone ever photographed a crystal ball or a Warhol more beautifully than Charlesworth and Lawler have, or with more sympathy and understanding? Could Longo's stricken figures look any more devastating and devastated, or any less ironic? It's hard to imagine a work in vinyl and neon that could be more attentive to these mediums' emotional force than Bender's *People in Pain*, where the cold light of neon seems to have warped the sheets that it permeates, distorting their capacity to record and reproduce. The force of these titles—"Wings of Desire," "Rubber Bullets"—could not be taken more seriously. McCollum's objects present the minimal conditions for aesthetic reception, but do they undermine these conditions, ultimately, or reinforce them? And Simmons's masked figures—how much less effective they would be if they were

critical, if the disgust that instigated their creation were actually to be visible on their surfaces? In each case, the possibility of understanding a cultural form can only be broached through a complete engrossment in that form. This engrossment had to be guileless, passionate, tender. How much easier it would have been for these artists to condescend to the cheesiness of their mediums and subject matter, but how much less effective! Any assumption of superiority or distance would undermine the whole project, since understanding can only be profound when it fully engages its object: Wonder Woman scraping her cuff across the glass mirror with the utmost concentration, trying to chisel out a route to the other side. The Pictures Generation never promised to cure anyone of anything, not even to cure itself. "We all eschewed the voice of authority," says Dwyer.[7]

"There are politics of aesthetics," as Rancière told an interviewer in 2003, "forms of community laid out by the very regime of identification in which we perceive art . . ." (Rancière 2007: 60). In the work of the Pictures Generation, the egalitarian force behind these politics provoked an immediate "critical" backlash, an effort to tame and contain it.[8] Only "criticality" could suppress and control the anti-hierarchical forces of collaboration, playfulness, and miscegenation that Pictures had unleashed. Each work needed, and continues to need, its accompanying plaque, "reasserting in a quasi-incantatory manner the critical virtue of apparatuses of image displacement." (Rancière 2010: 59).

"We've got to stop meeting like this," Wonder Woman tells her hapless (but secretly psychic) truck-driver colleague, Dell Franklin, after she's jumped through the hall of mirrors in Dara Birnbaum's unforgettable mash-up.[9] Like Pictures, her tone is deadpan but patient, uncondescending. In the spirit of Wonder Woman, the Pictures artists seemed fated to return again and again, almost comically, to the world of mass culture, the hall of mirrors of the spectacle. And like her, they refused the easy comforts of arrogance and criticality, facing up to their subjects with interest and good humor.

None of this, however, should be taken to imply that the Pictures Generation somehow achieved a Rancièrian aesthetic utopia. When Rancière did occasionally turn his attention to these artists, he acknowledged the expansiveness of their art while emphasizing the ways in which it was counterbalanced by a politically regressive dependence on the artist's proper name, since it is this name that holds the broad and anonymous subject matter together, and grants it value within the art market. In a discussion touching on Sherrie Levine and Cindy Sherman, Rancière pointed out that this prominence of the proper name as the point of conceptual origin meant that: "The contemporary author is, in this sense, more

strictly a property holder than any author has ever been" (Rancière 2010: 104). The anonymous and open creative world that these artists had imagined was tamed by market imperatives, which counterbalanced their political force—a disappointing but familiar dynamic in contemporary art. Retroactively ensconcing these artists under the banner of criticality is arguably a more pernicious maneuver, however, since, by installing an unquestioned hierarchy between producer and consumer, it obscures these artists' tenacious efforts to address their audiences without condescension. Perhaps someday, with work, these efforts will become anonymous: just pictures.

Notes

1 Crimp claims that Sherrie Levine's work "steals [mass cultural images] away from their usual place in our culture and subverts their mythologies" (Crimp 1979: 85).

2 Owens has just finished discussing Sherman, but he clarifies in the next sentence that this reading applies to "[a]ll the work discussed in this essay . . ." (Owens 1980: 79).

3 For more on complicity, see Crimp 1980.

4 Some of Eklund's harshest critics felt he had underemphasized this dimension of the work. Howard Singerman accused Eklund of "rejecting *October* and the project of a critical art" (Singerman 2009: 260).

5 See also Pamela Lee, who describes "the 'Pictures Aesthetic'" as "artists championed for their critical relation to media . . ." (Lee 2013: 4–5).

6 When Longo goes on to describe the artist as "like a policeman . . . blowing the whistle on society" (Berger 1990: 206) we thus have to imagine a drunken cop, blowing the whistle from within society's bottle.

7 Private correspondence, February 2015.

8 Sarah Evans has compellingly argued that these critics' efforts to nominate the Pictures artists as paragons of postmodernism effectively obscured "the principle *local-historical* cause for the artists' shift in practice: their loss of Hallwalls, an exceptional artists' community and the site of an idiosyncratic art of installation" (Evans 2009: 96).

9 All of the video clips in *Technology/Transformation* are taken from "Disco Devil," (Season 3, Episode 5), originally aired on October 20, 1978. The complete absence of this episode from discussion of Birnbaum's work is indicative of the dismissive attitude toward popular culture that characterizes most responses to the Pictures Generation.

References

Berger, Maurice (1990), "Robert Longo: The Dynamics of Power," in Jeanne Siegel, ed., *Art Talk: The Early 80s*, Boston, MA: Da Capo Press.

Birnbaum, Dara and Johanna Burton (2004), "My Pop," *Artforum* (October). Available at: http://artforum.com/inprint/issue=200408&id=7663. Accessed September 15, 2015.

Carnevale, Fulvia and John Kelsey (2007), "Art of the Possible: Fulvia Carnevale and John Kelsey in Conversation with Jacques Rancière," *Artforum* 45(7): 256–69.

Cranston, Meg (2012), "Over Here: Interview with Jack Goldstein," in *Jack Goldstein x 10,000*, ed. Philipp Kaiser, New York: DelMonico/Prestel.

Crimp, Douglas (1979), "Pictures," *October* 8: 75–88.

Crimp, Douglas (1980), "The Photographic Activity of Postmodernism," *October* 15: 91–101.

Crimp, Douglas (2000), "Prominence Given, Authority Taken: An Interview with Louise Lawler," in Louise Lawler, *An Arrangement of Pictures*, New York: Assouline Publishing.

Ehmke, Ronald and Elizabeth Licata, eds (1996), *Consider the Alternatives: 20 Years of Contemporary Art at Hallwalls*, Buffalo, NY: Hallwalls Contemporary Arts Center.

Eklund, Douglas (2009), *The Pictures Generation: 1974–1984*, New Haven, CT: Yale University Press.

Evans, Sarah (2009), "There's No Place Like Hallwalls: Alternative-space Installations in an Artists' Community," *Oxford Art Journal* 32(1): 95–119.

Foster, Hall, Rosalind Krauss, Yve-Alain Bois, and Benjamin Buchloh (2011), *Art Since 1900: Modernism, Antimodernism, Postmodernism*, 2nd edition, London: Thames & Hudson.

Jenkins, Steven (1996), "A Conversation with James Casebere," in James Casebere, *Model Culture: Photographs 1975–1996*, ed. Steven Jenkins, San Francisco: The Friends of Photography.

Lee, Pamela (2013), *New Games: Postmodernism After Contemporary Art*, New York: Routledge.

Lichtenstein, Therese (1992), "Interview with Cindy Sherman," *Journal of Contemporary Art* 5:2. Available at: http://www.jca-online.com/sherman.html. Accessed July 21, 2015.

McCollum, Allan (1996), "Allan McCollum interviewed by Thomas Lawson," in *Allan McCollum*, Los Angeles, CA: A.R.T. Press.

Nairne, Sandy (1987), *State of the Art: Ideas and Images in the 1980s*, London: Chatto & Windus.

Owens, Craig (1980), "The Allegorical Impulse: Toward a Theory of Postmodernism, Part 2," *October* 13: 58–80.

Rancière, Jacques (2003), *The Philosopher and His Poor*, trans. John Drury, Corinne Oster, and Andrew Parker. Durham, NC: Duke University Press.

Rancière, Jacques (2007), *The Politics of Aesthetics*, trans. Gabriel Rockhill, New York: Continuum.

Rancière, Jacques (2009), *Aesthetics and Its Discontents*, trans. Steven Corcoran, Cambridge: Polity Press.

Rancière, Jacques (2010), *Chronicles of Consensual Times*, trans. Steven Corcoran, New York: Continuum.

Rancière, Jacques (2011a), *Althusser's Lesson*, trans. Emiliano Battista, New York: Continuum.

Rancière, Jacques (2011b), "A Politics of Aesthetic Indetermination: An Interview with Frank Ruda and Jan Voelker," trans. Jason E. Smith, in Jason E. Smith and Annette Weisser, eds, *Everything is in Everything: Jacques Rancière Between Intellectual Emancipation and Aesthetic Education*, Pasadena, CA: Art Center Graduate Press.

Rian, Jeffrey (1987), "Social Science Fiction: An Interview with Richard Prince," *Art in America* 75: 86–95.

Singerman, Howard (2009), "Language Games," *Artforum* 48(1): 256–61.

5

Shiny Things

Paul Preissner

It was the 1980s. Architecture was in love with buildings that looked like things everyone could recognize as ideas from the past, or objects from the present. There were advertising headquarters that looked like binoculars. There was a building that looked like a picnic basket. Ancient columns showed up everywhere. Pink and powder blue colors were plentiful. These colors came from "real" things too. The paint of the past few decades was exchanged for the "authenticity" of the purple hue of granite, or the reflections of brass. Greek and Roman columns that did not actually hold anything up were constructed in plaster and arranged to signal social space and gravity. None of it was real, and all of it was strange veneer on top of crude actual structure. I was only a kid so I had no real idea of any of it, but while I was in high school the countermovement kind of came up and was hung off the literary work of Ferdinand de Saussure and Jacques Derrida, and possibly Richard Rorty. Literary criticism and philosophy focused on the meaning of words and found it in its context, architecture used this to blow open the overlay of postmodernism and encourage the meaning of architecture to come not from its reference but from its constructive parts, and those parts were without the same hierarchy as had been customary. These were often stylistically exploded, or combined with textual meaning. At the time it seemed really deep. On reflection it was a bit weird and rather confusing and certainly complicated. The work of Libeskind, Hadid, Asymptote, and others found some origin in this clutter. Their work looked complicated and busy and kind of messy and interesting and more feral than the static representational work it was pushing against. But either way, it was work developed in direct response to other forms of work, and was deeply invested in syntax and meaning as something readable.

I was finishing a rather typical undergraduate education in architecture at this point (1996/7) and was about to begin graduate studies at Columbia University, where a lot of the formal busy-ness from deconstruction was being

channeled through new capabilities with software to start what seemed like a form of architecture not reliant on the past, or other things, to establish its own purpose.

At this point computers were coming along as much cheaper things people could own, and certainly universities could own better ones for the use of their students, and some universities, like Columbia University, were able to set up labs with UNIX workstations. Architects like Greg Lynn, Lise Anne Couture and Hani Rashid (of Asymptote), Evan Douglis and the school in general, along with external architects like Preston Scott Cohen, UNStudio, Zaha Hadid, and others were interested in using this accessible processing capability combined with some existing software packages (Alias and Soft Image and then Maya) as form-finding exercises. Using these surface modelers and finding philosophical motivation in the writings of Gilles Deleuze, a lot of the work of the time explored the shapes that resulted from identifying complicated biological patterns and then working with the results to make surfaces that then got corralled into forms which became identified as architecture. Deleuze published *A Thousand Plateaus: Capitalism and Schizophrenia* in 1980, but it was the 1988 English translation by Brian Massumi that allowed the work a wider audience. The book's nonlinear format along with its content focused on the explanation of Rhizome fit well with the newly available technologies of surface modeling, that did not necessarily require geometry to be of platonic origin to develop variations. The technologies of animation and simulation software created the hierarchy-free forms that were philosophically imagined by Deleuze.

It was a heady time. None of us in school really knew what was going on but it felt great, and with the materialist ideas of affect theory and the otherworldly aesthetic coming out of the computers it seemed like a rupture in the world. Architecture always seemed entirely built upon itself up to this point: its form, its organization, and its identity. It was difficult to ever understand a work without somehow understanding the work ahead of it. This was not that. The interest in the bottom-up rhizome and form realized through parametric software connecting shape to its component qualities and their interconnected relationships allowed for variations in geometric shape without relying on manipulations of platonic solids. This gave architecture a sort of alchemical moment. It also seemed wildly egalitarian, if expensive, since it no longer relied on an audience's deep disciplinary knowledge to relate to or evaluate the work. Deleuze built *A Thousand Plateaus* on a fascination with the idea of affect that was shared at the time by scholars in the humanities and social sciences. This theory relied on interest in the

neurosciences of emotion that was taking place at the time and six or eight or however many (it varied depending on the researcher) basic emotional states (affects) one might possess. The minimum "natural kinds" of emotions would probably include joy, sadness, anger, fear, disgust, and possibly surprise. This allowed people to assume that communication of architecture could occur exclusively within these primitive emotional states. Critical assessment of work was replaced with appraisal of its sensibilities. Digital formalism encouraged smoothness, interconnectivity, flatness, bottom-up growth (from top-down people), and lots of shiny-ness. Everything was shiny. It's difficult to tell what this had to do with much other than possibly being the one true aspect of affect theory, and since every baby loves shiny objects, it must somehow come from a place that is not intellect but just instinct, and therefore adults somehow would never ever be able to get over this. But it probably came more from the ability of computers to render reflection that earlier technologies of representation were difficult and time consuming. It was a previously expensive technique made cheap, and we were in love.

The project was aggressive and confident and worried some people, since it traded in a formalism that was animalistic, foreign, without easy reference, and dealt with the idea of big data in a way before big data became "Big Data™." This was all during the last few years of the twentieth century and the early ones of the twenty-first. This was the same period that saw the inflation and burst of the first Internet bubble, and, more importantly, the acceleration of the art market from novelty to full on commodity playground for those with wealth made in real estate resulting from the Internet bubble. This accounted for the domestic demand.

There were also the new buyers from the Middle East and China using their recent purchasing power. The appetite for new art had little end, and needed something adjacent to purchase. This new notion of architecture was wild enough to be uncomfortable to standard expectations, and still too confusing to those actually practicing it to make it into clear architecture, that it seemed a perfect fit for those looking to dump capital into something. Greg Lynn's interest in small design allowed for the production of things like chairs, flatware, rings, espresso cups, and tea sets to be produced in limited editions, and for lots of money. Such items were available for purchase for those who wanted to be certain they were purchasing something no one else had and was a bona fide "new" thing. Hadid, UN Studio, and others took fast advantage of this market for art by architects. In these later cases, and due to the full-flight nature of their

practice prior to this bonanza, architects were able to appropriate the style from parametric software coupled with the conventional notions of programming that architecture expected to begin the development of a full-throated architectural style. With projects commissioned by the government and interest in places like China, UAE, Azerbaijan, and other non-democratic resource-backed countries, these practices and others introduced an architectural style produced off the interests of software default curvature and a belief in the theory of affect and digital models of production. The results were a hit, and since all that was required for entrance was the adoption of tools (which meant purchase), it was a movement that spread easily. The idea was seductive: buildings modeled with the leading edge of software capabilities and produced with the collaborative partnership of design and manufacturing to allow for complicated custom parts to be easily, yet expensively, produced. No debt to anything other than computational history needed.

A lot of different parties signed on. Universities found it easy to fundraise and grant-raise around the purchase of computers, robots, and other advanced technology as the solution to architecture. Corporations found it to be pennies on the dollar to offer clients of any level of sophistication "the leading edge of design." What was initially a lever to depart from representation and historic reference quickly became a dominant ideology in the field and no longer a fringe interest. Architects who considered themselves art practices were now using the same tools and making the same proposals as larger, more business-oriented corporate practices. What began as an alternative project of architecture, founded on a philosophy that privileged an atomized emotional response in place of an intellectual one, began its conversion into convention. After a decade of work in the academy some significant built works were finishing construction as the result of this new ideology of shape. Projects like the Mercedes-Benz Museum (2001–2006) by UN Studio, and everything by Hadid since the turn of the millennium, removed all question of validity to a working practice that relied on the hunch that form and person have some sub-intellectual connection that finds meaning without a reliance on context. This was the 2000s, a time when hunches were privileged. The United States apparently relieved itself of obligations to intellect in its conduct across all spheres: political, social, and cultural. Architecture was ready to commit to the Id.

This combination of substantive technological inventions, easy money to fund its experimentation and the separation from stuffy notions of intellectual work—thanks to the liberation of meaning enabled by affect theory and

indulgence in experience, atmosphere, sensibility and some weird version of phenomenology—returned architecture to the realm of the immediate; architecture only needed itself to give both purpose and reception. Although, what was also becoming apparent at this moment, given the ubiquity of the tools (animation software, CNC tooling machines, 3D printing and other advanced methods of object fabrication, etc.), was how very pedestrian the work was. With the spatial and architectural effects of design now taking nearly its entire intellectual direction from the possibilities (and limitations) of fabrication, meaningful work (as it was) became available to anyone and was beginning to be used by everyone.

What resulted was the solidification of a style of work determined almost entirely by the aggressive advertisement of its tools of production within the final result. Computer designed work was of little use unless it was apparent that the shapes one was looking at were "from" the computer. Obvious patterns of panels, daring shapes of little more than sculptural effect, decorative surfaces and other complicated stylings were used to leave little doubt about their technological origin. This is where things started to leave the realm of post-critical inquiry to become yet another signaling project—not entirely unlike the preceding movements it sought to topple through its workmanlike approach to delicate forms. Curvy, shiny, complicated compositions and shapes found a better way to communicate than that of affect: commerce.

Much like postmodernism had before, parametricism, the architectural style of explicitly computer-designed form, became the adopted style of corporations and non-democratic states alike, and it served a near identical purpose for both: favorable public relations. Its contemporary (even if sometimes just implied) means of construction, and its computer-disciplined wilderness of shapes, signaled that this version of the future would be available for purchase in the present.

Parametricism involved an indifference to history and ideology alike, since it was the result of form and manufacture taken from the cool, impersonal world of the computer. Initially this worked quite well as a means of adopting and corralling the formal elements produced by the new software and fabrication technologies (3D printing, CNC manufacturing, etc.) into a clear alternative to past methods. Its distance to any ideology allowed it to be adopted by clients looking for work without baggage. Like the cinematic blockbuster, parametric architecture asked very little, offering in return spectacle and affect. This turned out to be a very difficult deal to refuse.

Part Two

Practice

6

Still in the Cage: Thoughts on "Two Undiscovered Amerindians," 20 Years Later

Coco Fusco

Fate should have it that I would make my most lasting mark on the art world as an ethno-freak in a grass skirt. From 1992 to 1994, I danced, somewhat pathetically, at numerous international festivals and biennials while my masked partner [Guillermo Gómez-Peña] wowed onlookers with his guttural mix of Nahuatl phonemes and global brand names. For hours on end, Guillermo and I paraded around the confines of a golden cage pretending to be hitherto "Undiscovered Amerindians," as people stared, grimaced, chuckled, and wept. We were taken to the bathroom on leashes by docents and fed by businessmen who paid for the honor of peeling bananas and stuffing them in our mouths. We were jeered at, burned with cigarettes, courted, and cheered. We remained expressionless as our visitors peppered docents with questions about our sexual habits and suspiciously light skin or expressed their outrage at the sight of caged human beings surrounded by a visibly enthralled public.

After each day's work, we'd shower down to wash the crowd away, collect stories from friendly witnesses, and read notes that viewers left behind. Together with friends, we would laugh about the strangeness of it all as we counted the change we had collected for telling tales in "native tongues" and selling Polaroids of ourselves posing with visitors. During the course of two years, our traveling show took us to Madrid, London, Sydney, Buenos Aires, Chicago, Minneapolis, Washington, New York, and Irvine, California. We performed in two public plazas, three natural history museums, and the Sydney (1992) and Whitney (1993) Biennials. We watched in wonder as myths were conjured about us that evoked classic anxieties about monsters, barbarians, and philistines—at various moments it was feared that we would spread disease, traumatize children, enrage

Republicans, or shock wealthy museum donors with noise and live nudity. We made news, lectured widely on our findings, and eventually made a movie. We got ill, and we got sued. Twenty years later, I can say without a doubt that our escapade changed our lives. I may have left the cage behind but it doesn't leave me.

From behind the bars of our gilded enclosure festooned with voodoo dolls, postmodern theory books, and a TV-topped altar, we confused some and angered many. At times we annoyed each other: Guillermo didn't like my face paint, and I found his rock en español grating. I preferred a minimalist approach to carrying out our actions, while he wanted to ham it up. But we both sensed that we had hit a nerve and reveled in private as the ghosts of history came alive. People we hardly knew sent us information about the history of the human display in their respective corners of the world, strengthening our premise that we were reviving a venerable performance tradition. Indigenous elders we met in America and Australia understood our message and gave their blessings to our endeavor as long as we agreed not to pose as members of an actual tribe. But many gatekeepers of the art world and performance studies frowned on us and wrung their hands while we toured. Jan Avgikos confessed in her *Artforum* review of the 1993 Whitney Biennial, for example, that she couldn't think about cultural genocide because she just kept thinking about how nice my body was. Doyenne of performance studies and New York University professor Diana Taylor complained that we were too heteronormative to be truly radical debunkers of stereotypes. Nonetheless, there was something exquisite about the feeling that we had become a "bad object" for the art world, and that even so, thanks to contractual arrangements that would have been embarrassing to renege on and public interest in our antics, we were not going to disappear with the wave of a curmudgeonly critic's wand.

We frustrated bourgeois ethnics who wanted multicultural art shows to be dignified celebrations of their peoples' triumphs over adversity or their talented tenths' greatness: Why, they would ask, did we want to show something so ugly? Our refusal to strive for authenticity short-circuited the efforts of curators who sought to overcome institutional racism with positive images of people that their institutions had largely ignored. Some responded by becoming allies and shepherded us through byzantine cultural bureaucracies while devising defense strategies for containing public outcries. Others who had equated multiculturalism with insipid family entertainment denounced our work as offensive, even shocking. I'm honored by their astute appraisals. Our detractors found themselves in strange company: Those very liberal but very uptight museum officials who

hated washing their dirty laundry in public had to share their irritation with *haut conceptuel* art cognoscenti who hated abject aesthetic interventions that make a point with humor and 1980s art sharks who hated sharing the spotlight with colored people they saw as party crashers. The last of the three remain unforgiving, while the others have, over time, begrudgingly conceded that the performance had unexpected staying power, even if they didn't like our message or our method.

In the wake of the culture wars, after serving time as whipping boys for anti-PC pundits, we became poster children for the academic Left. The video documentary about our performance became standard fare for the "Everything You Ever Wanted to Know About What's Wrong with Anthropology" unit in cultural studies courses around the country. As time passed and our audience changed from those who were present at the live act to those studying the original, the response to our performance shifted away from moralistic concerns about whether it was OK to lie to Joe Public (as if artists don't do that all the time!) toward more nuanced consideration of what our experiment had actually yielded. Since no one was on the hot seat once the show was over—no more audiences could be potentially duped and no more bureaucrats could get in trouble for hosting us—we lost our threatening edge. We slowly transformed from enfants terribles into postcolonial participant observers. Reflecting on the causes for this shift, I would attribute it largely to our many years of pounding the pavement—we gave dozens, if not hundreds, of public lectures to convince the academy that our "lies" had a greater purpose. We also benefited from the expansion of cultural studies in the 1990s, which provided us with a sympathetic audience at a time when many art historians were trashing multiculturalism and rediscovering beauty. Finally, credit is also due to the Whitney's and the Walker Art Center's publicity machines and their extraordinary capacity to disseminate our images on a global scale.

The undiscovered Amerindians still aren't included in "Janson's History of Art" but we did make it into quite a few other art history textbooks, much to my surprise. The records of our tumultuous adventure continue to be scrutinized by academic experts worldwide. Students who weren't even alive when we were frolicking behind bars now write me to ask in wonder how we did it. I still believe the audience did "it." They made the performance weirder than anything I could ever have imagined when I first stumbled upon Sander Gilman's account of Ashanti being asked to defecate in public while they were on display in the Prater in 1890s Vienna so that prurient European visitors could gawk at them.

I had read classic texts about the collective unconscious as a semiotics major at Brown University but I had no idea what it felt like until I performed the role of the savage in front of so-called civilized beings. I shall never forget the uncanny sensation that a cavalcade of Freudian slips about colonialism was springing forth each time our show began. Neither of us was convincing, but what we promised to be for others was enticing and familiar, even though the ethnographic display of human beings as curiosities was a defunct practice by the time we launched our tour. We offered forbidden fruit for a multicultural moment—a blatantly racist display—and elicited shudders of pain and pleasure. It even seemed at times that the pain we engendered was pleasurable to some, as if we were an antiracist Wailing Wall. The political implications of these ambiguous responses constituted a hot potato for museum bureaucrats and cultural theorists: While it was fine to acknowledge racist errors of the past, it was an entirely different matter to support art that elicited racist pleasure in the present. And so, those who believed that their professional integrity depended on distancing themselves from the pleasures offered by the display of racial difference publicly decried our experiment—even if they celebrated with us in private. Their feigned horror at the prospect that racial difference could not only be desirable but entertaining at the end of the 20th century was a magnificent charade. If only the psychic life of human beings were simple enough for anything racial to be equated with racism and swept under the rug with a legal injunction. After what I've seen in archives and real life, I'd stake my bets that even abolitionists got a kick out of gazing at their dark brethren.

The entire enterprise turned out to be a kind of exposé of the racial doublespeak of educated liberals in the so-called post-racial era. One particularly nasty critic called it a *piège à con*, or sucker bait, as if to say that you had to be stupid to fall for it. But what does it mean to "fall for it?" Does that mean that all responses could be divided neatly between those who believed we were real and those who didn't? What about those who didn't believe "it" but wanted to play the game, to mimic the Kiplingesque arrogance of a colonial? Why was the "lost tribe" script so familiar that anyone seemed able to pick it up and run with it? What explains the attraction to a lie? What about those who knew who we were and championed free speech and contemporary art but didn't want us to experiment with volatile subject matter in front of people who might not "get it"—did they not also believe that something "real," albeit inappropriate, was happening?

Twenty years later, I still think about an unanswered question that led me into the cage. Is there anyone who really believes that we could be "post-racial" in a

culture that fetishizes black athletes, equates black style with rebelliousness, pillages indigenous belief systems for pithy profundities to satisfy the spiritual cravings of secular materialists, and then depends on cheap immigrant labor, redlining, and mass incarceration to safeguard class hierarchies that are obviously racialized? It was the unspeakably grotesque irony of our imagining America as a multicultural paradise that inspired me to push the performance to its limits and to refuse to break character so as to assure the audience that we were not real, let them breathe a sigh of relief, and wander home. Uneasiness was a better response to the persistence of race as a social fact than disbelief or disinterest.

I continue to marvel at how much curiosity the "Undiscovered Amerindians" performance generates after the fact, especially when I contrast it to the fury the piece caused in its moment. Although I am frequently asked to talk about my experience with the work and often feel as though I live in its shadow, it's not something that I could ever re-perform, to use that awkward neologism that has been embraced of late by the art world. "Two Undiscovered Amerindians Visit the West" emerged from and belongs to another time, before webcams and reality TV normalized exhibitionism and turned popular media into a 24/7 hypersexed freak show. We are all in cages now, trying very hard to couple.

Parasitism and Contemporary Art

Adrian Anagnost

Since the 1990s, there has emerged a strain of art practices that could be characterized—somewhat polemically—as parasitic. Related to histories of performance art, relational aesthetics, and institutional critique, parasitic practices draw upon the social, financial, and political capital of large institutions to produce socially engaged artistic situations, processes, and events that are intended to effect a change in the material circumstances of some of the participants or viewers.[1] Like a certain strain of politicized performance art, these practices exist in the form of social relations (as, for example, performance works by Adrian Piper or, arguably, Tino Sehgal), and they emphasize process over product. Parasitic procedures overlap with relational aesthetics in their concern that art produce utopic or microtopic situations, in which the form of an artwork might materially address a social problem, or at least imagine a social challenge otherwise (Bourriaud 2002; Bishop 2004). Finally, like institutional critique, parasitic practices depend upon institutions for resources and validation, though the institutions being addressed are typically not restricted to an art world (Becker 1982).

These parasitic practices bear some resemblance to "relational" or social practice artistic modes that emerged around the same time in the context of Western European nations with strong social welfare states. However, parasitism is best understood in the context of public–private partnerships that have emerged in response to the particular conditions of contemporary US cities: economically and socially diverse urban agglomerations with limited art markets, a profusion of institutions of higher education, and tangible conditions of social inequality brushing up against intense concentrations of wealth. These are the conditions of possibility for a parasitic mode of art making, something like institutional critique operating beyond the bounds of the art world.

Of course, following Hal Foster, one might counter that, even before the 1990s, artists had already broadened the legacy of institutional critique beyond the bounds

of art institutions. Writing in the mid-1980s, Foster cited artists such as Martha Rosler, Sherrie Levine, Louise Lawler, and Krzysztof Wodiczko as "open[ing] up the conceptual critique of the art institution in order to intervene in ideological representations and languages of everyday life" (Foster 1985: 100). Yet Foster's 1980s examples are primarily concerned with *mediated* social interactions, particularly the ostensibly de-authored visual and linguistic tropes of advertising and corporate lingo. The newer generation of post-institutional critique, i.e., those artists engaged in parasitic procedures, is highly invested in face-to-face interactions, in the frictions of an urban setting, or in the unscripted potentialities of global circulation of goods and people; or, in recreating or instantiating those frictions in the setting of a museum or gallery. It is oftentimes such antagonism that distinguishes parasitism from relational aesthetics, the latter of which might be seen to evince a particularly 1990s optimism about the possible new modes of human cooperation effected by the "end of history" (Fukuyama 1992) and the intercultural mixing of globalized trade and labor markets (Friedman 1999), or fruitful local resistances to such shifts (Critical Art Ensemble 1994).[2] But these parasitic art practices are not always antagonistic. Instead, what is more characteristic of parasitism—what distinguishes it from institutional critique—is its complicity in the *economic* mechanisms that enable its very existence (Drucker 2006).[3]

One might also counter that parasitism is nothing new since "critical art" or institutional critique had already always been parasitic upon the institutions being criticized. With regards to works of institutional critique by artists such as Marcel Broodthaers, Hans Haacke, Michael Asher, and Daniel Buren, Hal Foster has argued that the:

> very attention to the institutional frame … determines its production no less for being exposed in doing so.… [T]his practice runs the risk of reduction in the gallery/museum from an act of subversion to a form of exposition, with the work less an attack on the separation of cultural and social practice than another example of it and the artist less a deconstructive delineator of the institution than its 'expert.'
>
> Foster 1985: 103

And Rosalind Krauss has posited that this has been a facet of modern art since its very beginning: the "constitution of the work of art as a representation of its own space of exhibition is in fact what we know as the history of modernism" (Krauss 1982: 313). Indeed, much art historical scholarship of the past four decades has foregrounded the physical spaces, institutional structures, and social networks providing the conditions of possibility for artistic production.

More recently, art historians Miwon Kwon and James Meyer have taken site specificity as a guiding principle for analyzing works of "relational aesthetics" and "social practice art" that have emerged since the 1990s (Meyer 1995 Kwon 2002; Keeler 2008; Thompson 2012; Quinn 2012). Writing in the mid-1990s, Meyer argued that recent works by artists such as Mark Dion, Andrea Fraser, and Renée Green "transformed the notion of site specificity as it emerged in the early years of institutional critique and earthworks, revising the assumptions implicit in this model to reflect upon the globalized, multicultural ambivalence of the present day" (Meyer 1996: 20). For her part, Kwon cited an almost identical roster of artists, explaining that their works "complicat[e] the site of art as not only a physical arena but one constituted through social, economic, and political processes" (Kwon 2002: 3). In this lineage, parasitic practices are simply the most recent iteration of a mode of artistic production that interrogates the grounds of artistic production and/or exhibition, practices that foreground the physical, social, or discursive spaces that provide the conditions of possibility for the artworks produced by a given art world.

However, parasitic practices fit uneasily within this narrative of site specificity, even given the notion of site reimagined as mobile or portable, as "a process, an operation occurring between sites, a mapping of institutional and textual affiliations and the bodies that move between them (the artist's above all)" (Meyer 1996: 21). Instead, parasitic practices are closer to the mobile and deterritorialized processes of global capital, and the corresponding "artificial, residual, archaic" reterritorializations (Deleuze and Guattari 1983). In this sense, parasitic practices take advantage of what Michel Serres has characterized as the power of the parasite, which is "founded on the theft of information" and "could be called bureaucratic" (Serres 1982: 37).[4] However, the parasitic practices of contemporary art do not simply interrupt and extract from a system, but purport to fulfill the system's workings, all the while diverting resources to *another* system. From one set of institutions, money and social capital flow to a new array of institutions, at first fictitious, summoned into being by the artist as parasite.[5] If the artist is bureaucrat, it is as the anti-Bartleby, as a successful factotum whose parasitism does not enrich self, but diverts nourishment to a new organism with structures paralleling the parasited organism; a new institution forms to serve a different, underserved clientele. In contrast to Serres' one-way loop of parasite upon parasite, these parasitic art practices double the circulation with a shadow institution.

Recently, artists such as Theaster Gates and Tania Bruguera have used parasitic procedures to redirect the resources of large, financially-solvent

institutions bound up in networks of global capital in order to materially enrich socially marginal figures. In Gates' urban development projects, the artist draws upon the financial and political might of institutions such as the University of Chicago, the Knight Foundation, or the City of Chicago to perform the role of real estate developer in low-income African American communities of the urban United States. Bruguera's *Cátedra Arte de Conducta* (roughly translatable as 'School of the Art of Behavior') (2002–2009) has employed the structures of international art biennials to propel her Cuban students from the peripheral locale of Havana to art world centers, or her New York City-based *Migrant People Party*, now *Immigrant Movement International* (2010–2015), in which the resources of art institutions are channeled to political activism on behalf of undocumented immigrants. In both cases, these artists do not—or do not only—create art objects to be sold at gallery shows, but create situations funded by a combination of private and public sources, potentially including the largesse of art collectors, personal income derived from teaching, and public funding for arts and cultural programs. And in both cases, parasitic practices combine a savvy deployment of institutional resources and power with a nostalgic affirmation of older—even archaic—notions of identity.

In drawing upon these alternatives to the art market, Gates and Bruguera deploy a certain legacy of relational aesthetics, that is, a romanticized notion of localized identity reinvigorated under the pressures of global migration. The persistence of localized identity is a trope of the contemporary art world that has proven particularly strategic for practitioners of relational aesthetics. For example, artist Rirkrit Tiravanija—ethnically Thai, born in Argentina, educated in Canada and the US, and currently dwelling in "New York, Berlin, and Chiang Mai"—came to international attention with relational works that foregrounded his ethnic identity. In his 1992 work *Untitled (Free)*, Tiravanija set up a kitchen in the gallery and gave away Thai curry with rice. A similarly self-mythologizing aspect of identity is represented in British artist Liam Gillick's 1997 *Discussion Island*, whose concept draws upon Gillick's Irish ethnicity: "Discussion Island" is rooted in a fabled Celtic mode of conflict resolution carried out on the neutral ground of an island collaboratively maintained by various clans (Gillick 2009; Avgikos 1997).[6]

Both Gates and Bruguera similarly root their practices in ethnic community. However, in lieu of the mobile ethnicities of Tiravanija or Gillick, able to be recreated in virtually any art space, Gates and Bruguera undertake a reterritorialization of identity by rooting it in the specific contexts of African American Chicago, or the parallel New York City occupied by immigrants *sans*

papiers. Parasitic works of Gates and Bruguera are dependent not only upon the artist's identity, but upon a mode of territorialized belonging that focuses on unequal distribution of resources according to the geographic inequalities, for example, among urban neighborhoods or nations. Finally, what is most notable about the parasitism of certain contemporary art practices is their investment in post-globalization reconfigurations of financial flows. As art historian Johanna Drucker points out: "The difficulty of mapping older art historical models onto contemporary activity comes because the conditions on which agency, opposition, and revolutionary activity were conceived within those earlier political models no longer exist.... [W]here is that *locus* of power in advanced, transnational capitalist economies?" (Drucker 2006: 24). It is precisely those dispersed and delocalized nodes of power that parasitic art practices regard as their material.

Rather than institutional or social critique, these contemporary practices ostensibly sidestep the art market, instead marshaling the resources of large, financially solvent institutions and foundations bound up in networks of global capital in order to materially enrich socially marginal figures.[7] Gates works to divert resources to African Americans living in low-income, urban communities in Chicago and other industrial cities of the Midwest. Bruguera works to propel young, politically-engaged artists working under repressive conditions in Havana, or undocumented immigrants in New York City, to the center of the art world. The dual nature of these procedures cannot be overemphasized: these practices do not simply make marginal populations visible, or call attention to social problems, but initiate processes that will—hopefully, eventually— *materially improve* the lives of individuals in marginalized communities. That is, these art practices are not simply discursive, but lay the foundations for future financial and social gains. Moreover, in drawing upon the unpredictable potentialities of market forces, these US-based practices distinguish themselves from many European practices that engage with the possibilities of a social welfare state (even weakened as in the past two decades). Ultimately, this combination of public good and private investment is driven precisely by these artists' positions as cultural creators rather than politicians or activists.

I. Theaster Gates, the face of Chicago's urban development

A key aspect of parasitic practices is that they welcome institutional support, as opposed to the ambivalent stance of prior generations of institutional critique;

still, commentators tend to attribute a critical stance to these artists (Drucker 2006). For Theaster Gates, support from the University of Chicago, where he also holds a position as the director of Arts and Public Life, affords him institutional backing at the same time that his work both celebrates and challenges the University's relationship to its urban surroundings. In his large-scale urban projects, Gates salvages derelict buildings in lower-income African American communities of Chicago in order to transform them into community cultural spaces. In addition, Gates originally incorporated "a work force training program … [with the goal of using] the opportunity of building the interior finish work … to train and teach skilled carpentry to … young men from the community" (ArtPlace 2012a; Viveros-Faune 2012). Part community space, part urban development project, Gates' practice might seem to side-step institutional settings, by generating new arts institutions in areas typically underserved by museums and galleries. However, Gates' "institutions" are embedded in local economies of public–private investment that take the arts and cultural programming as driving forces for urban development. In 2012, for example, Gates' practice benefited from a $400,000 "Creative Placemaking" grant to the University of Chicago from the philanthropic and banking conglomerate ArtPlace. ArtPlace awarded the University these funds to support Gates' Washington Park Arts Incubator, a new institution intended to "serve as a powerful catalyst for neighborhood revitalization by creating a new hub for artistic production and community engagement on Chicago's South Side" (ArtPlace 2012b). The funding for this project demonstrates the parasitic nature of Gates' practice, in which his affiliation with the University legitimizes his work and allows him to fund it through donations to an institution, at the same time that his practice validates the University as an incubator of arts and community development.

Himself African-American, and a resident of the predominantly African-American, lower-income neighborhood to the south of the University of Chicago, Gates can be seen as both a link between the university and the surrounding African-American neighborhoods, as well as a critical commentator on the possibilities for such involvement (Gates 2009a).[8] One should question, however, whether Gates' identity simply allows the university to displace some of the "local anxiety" facing its expansion by situating him as its public face. The University poured over $1.3 million into the Arts Incubator, and the investment has paid for itself beyond merely good publicity (City of Chicago 2012). For one, the University has used the Arts Incubator to generate public and private investment to materially beautify a particularly blighted avenue that had greeted many

visitors to the University: "Reviving the stretch of Garfield between King Drive and Prairie Avenue is important to the university because the boulevard is the first thing that many out-of-state and international students see when visiting campus," explained the Vice President of the University of Chicago's Commercial Real Estate Operations (CREO) (Matthews 2014). Moreover, the University's support for Gates' Arts Incubator has generated further financial gains. In addition to the ArtPlace funding for this project, its "success" spurred another large donation to Gates' work, again funneled through the University of Chicago. In spring 2014 the John S. and James L. Knight Foundation awarded the University of Chicago a $3.5 million grant for "The Place Project." Building on "pioneering work by Theaster Gates," this project is intended to "test a community development model that supports arts and culture to help transform communities and promote local growth and vibrancy," by expanding Gates' practice to cities such as Gary, Indiana; Akron, Ohio; and Detroit (Knight Foundation 2014). Finally, the University of Chicago publicized these collaborations with Gates at precisely the time when the institution was engaged in the fiercest bout of lobbying to house the future Barack Obama Presidential Library. Playing good neighbor to surrounding low income African-American communities may not have ensured that the University of Chicago succeeded in winning the Library, but it certainly bolstered the institution's bid. Even as the University of Chicago has faced criticism for its real estate ventures in nearby areas, it could point to its support of Gates' work as demonstrating efforts to engage its neighbors (Lacey 2015).

II. Tania Bruguera, art, migration and risk

Similarly, Tania Bruguera has capitalized on the resources available to her while treading a fine line between collaboration with and criticism of the sources of her power and influence. In the mid-2000s, Bruguera established an alternative art school, *Cátedra Arte de Conducta*, in Havana. The school emphasized conceptualism and performance art precisely in response to the regressive artistic training and lack of new media and performance curricula within Cuba's main art school, the state-run *Instituto Superior de Arte* (ISA). However, Bruguera often relied on ISA to obtain visas and sponsorship for international artists who lectured as part of her experimental curriculum, and she drew a number of her pupils from ISA's student body. In addition to Cuban institutions, Bruguera's *Arte de Conducta* project was also aimed at institutions of the

international art world. In fact, the parasitic nature of Tania Bruguera's work can be seen to crystallize the creative funding structures and ersatz institutional settings deployed by artists unable to support themselves through sales of artworks, and who are increasingly denied the stability of pedagogical positions as well. As Bruguera developed the parasitism of her *Arte de Conducta* project, it relied not only upon the Cuban national art school, but upon an extensive and financially flush web of international art biennials and fairs. Using her position within this social milieu, Bruguera advanced the careers of her students by exhibiting their artworks as her own participation in the Havana *Bienal*.

On the one hand, Bruguera's use of her own fame and connections to propel her students to the next level of artistic professionalization offers a trenchant criticism of those professionalizing processes and their inaccessibility to young artists without links to art world centers. At the same time, Bruguera's own ability to travel in and out of Cuba relatively freely is dependent upon her status within the international art world, while her status in the international art world is dependent upon her precarious position as a Cuban artist. During the 2009 Havana *Bienal*, Bruguera also presented *Whispers of Tatlin*, a work that challenged the Cuban government's censorship and repression of free speech even as her own position as an internationally renowned artist protected her from real reprisals.[9] Mounting a microphone in the Wifredo Lam Art Center, a venue for the *Bienal*, Bruguera invited audience members to speak freely, while two performers dressed in military uniforms placed a white dove on the shoulders of each speaker, in mimicry of a famed incident involving Fidel Castro. After taking Havana at the head of the victorious rebel forces on January 8, 1959, Castro gave a public speech during which a pair of white doves landed on his shoulders; this bit of political theater was repeated with a single dove during Castro's speech for the thirtieth anniversary of the Revolution in 1989. In response to Bruguera's 2009, the Cuban government threatened to prevent her from leaving the country, but there were no real repercussions for this artistic provocation. Some five years later, US President Barack Obama's late-2014 announcement of a thaw in relations between the US and Cuba spurred Bruguera to attempt a repeat of her *Bienal* microphone piece, this time on the Plaza of the Revolution in Havana. As authorities placed key dissidents under house arrest and briefly detained others, including Bruguera (Cuba Debate 2014; Archibodjan 2015), the effort proved Bruguera's ambivalent relationship with the institutions that both restrict her activities and provide the limitations that serve as the very material for her artworks (Mosquera 2009). It is in her simultaneously ambiguous status within

the institution of Cuban civil society and the institutions of the international art world that Bruguera's works can operate: she draws her legitimation from both.

Similarly, Bruguera's *Immigrant Movement International* (2010–2015) has drawn upon the resources of the arts institutions such as the Queens Museum, the New York public arts non-profit Creative Time, and the Van Abbe Museum, as well as political entities: in 2015, Bruguera was named the first artist-in-residence of New York City's Mayor's Office of Immigrant Affairs. In contrast to Gates' deployment of institutions' financial resources to propel economic gains, Bruguera's parasitism is oriented more towards the potential for artistic institutions to shield artists from legal repercussions. It is not only Bruguera's position as a Cuban immigrant, privileged among migrants in the US, that allows her the freedom to dabble in politics, but also her position as an artist whose international career affords a certain freedom of behavior (it is no accident that Bruguera titled her pedagogical project "*Arte de Conducta*," art of *behavior*). The license to be outrageous, to challenge social and political norms, has become largely defanged and meaningless in contemporary Western societies. But these strictures remain relevant for Bruguera, both because of her position as a citizen of authoritarian Cuba, and because she refuses the ease and privilege of US or European citizenship, which would invalidate the potential danger of her artistic risks. With her Immigrant Movement International, she has exacerbated this indeterminacy. Taking on the role of a successful entrepreneur—complete with a confident LinkedIn profile that states her role as "Initiator/Director at Arte Útil Association"—Bruguera directs cultural production as a political shield for individuals with little access to social capital or political reach.

III. Parasites and their hosts

Though both Gates and Bruguera initially developed their parasitic practices in the context of academic institutions, in both cases these artists have turned to a wider array of organizations. Parasitic strategies initially arose as a majority of mid-career working artists found themselves affiliated with large research universities in close proximity to lower income urban areas, *in the absence of a strong art market*. Artist Michelle Grabner in fact theorizes that the early instantiations of "social practice" in Chicago offered "refuge" for painters faced with an utter lack of a local market for painting (Grabner 2013). In such a context, not only have artists been driven to academic institutions for their bread

and butter, making a living (albeit increasingly in contingent positions as adjunct instructors), but artists have seized upon universities and other local institutions as sources of funding and institutional might that can be harnessed for their own purposes, artistic or otherwise.

The historical precedent that provides a roadmap for future parasitism is a project undertaken in New York City in the 1970s by Gordon Matta-Clark, entitled *A Resource Center and Environmental Youth Program for Loisaida* (1977). Situated in the largely Puerto Rican and predominantly lower-income Lower East Side, the *Resource Center* was to serve as a design program for youths and government-funded job trainees.[10] Drawing upon his explorations in "undoing a building" as a means of addressing urban social conditions, Matta-Clark intended the project to move beyond "metaphoric treatment" of abandoned buildings toward transformation of social spaces in a manner responsive to occupants (Matta-Clark 1976). The first stage of the project was to be "a combination of basic design workshops and small scale building designs that would introduce key skills," while the second stage moved to heating and electric utilities, followed by "attention not only to the internal needs of a building, but also to the surrounding areas and neighborhood interests" (Matta-Clark 1976). Participating along with extant "Sweat Equity" programs, *The Resource Center*'s "ultimate emphasis would be to educate able young members of the community to make their own decisions while expressing unique and practical alternatives to sub-standard housing" (Matta-Clark 1976). Like Theaster Gates, Matta-Clark's work would have deployed a combination of arts and non-arts funding to materially benefit a marginalized urban community. Matta-Clark's work emerged during a period when not only was the city's population reaching a nadir, from the industrial lofts of Soho to the depopulating lower-income residential housing of the Lower East Side where Matta-Clark wanted to situate his Resource Center. Moreover, New York's art market was stuck in a relatively fallow period. In bringing together a Guggenheim grant with government programs, Matta-Clark marshaled funds to carry out a social intervention couched as art. It was in the absence of a strong art market that Matta-Clark proposed to address a neighborhood facing the dual problems of reduced population and substandard housing, an area arguably at the margins of Manhattan both in locale and political agency.

What is interesting about parasitic practices is not—or not only—their foregrounding of alternative economies, but the way they seek to harness the financial excess of global capital as a way to critique that very system. For, despite

any claims to the contrary, large research universities are embedded in this system, from private donations (think of Michael R. Bloomberg's reported $1.1 billion in donations to Johns Hopkins University, or the $350 million donation by the family of a Hong Kong real estate developer to Harvard University), to endowments sunk in a variety of financial instruments and real estate (Barbaro 2013; Rooney 2014). And US artists seeking alternatives to the art market, whether by necessity or design, have seized upon the large research university as one way by which that system's largess can be funneled toward art and social practice. Gates and Bruguera merely take such efforts to their logical limits. These two artists have been extremely successful at seizing upon the financial and political resources of non-governmental, non-commercial institutions (universities, biennials, foundations), not simply for individual gain but to redistribute those resources. This strategy requires a peculiar—and savvy—balancing act between critique and immersion within a system.

This new artistic entrepreneurialism is not, then, the spectacular showmanship of Jeff Koons or Damien Hirst, but the shadow phenomenon of artists and educators whose mode of production is necessarily dependent on the new economic realities and their positions as factotums. Perhaps this puts this approach in closer resonance with models from Europe, where (historically, at least) financial support for the art has been more evenly balanced between private and public than the largely commercial driven US context (Sholette 2000; Enwezor 2002). For US artists outside New York and Los Angeles, the large urban research university and the growing commitment to "creative placemaking" (Florida 2002; Florida, Stolarik, and Knudson 2010) and the role of the arts as a part of responsible relations with "the community," now seems to offer the primary alternative (amidst a vastly shrunken field of financial support) for artists to propel their own projects. This is not to say that Bruguera and Gates have evaded traditional art world structures entirely: when I speak of them as the most visible practitioners of parasitism, this is due precisely to their financial successes and notoriety.

For example, not only has Gates been the beneficiary of a wealth of funding from private non-profits, but his work on behalf of the University has resulted in public investment as well: "So what did Mayor Rahm Emanuel do during his first weekend in office? He went to City Hall on Saturday morning in jeans and a dress shirt and met with top officials from the University of Chicago to hammer out an agreement on, of all things, zoning and construction permits" (Harris 2011).

To repeat, Rahm Emanuel's first official action upon taking office as Chicago mayor was to discuss urban development with the president of the University of Chicago. The implications are clear: future economic growth depends on productive relationships between cities and large, wealthy private institutions. And part of such relationships may be the ability for universities to vacillate between business enterprise and educational institution, offering the promise of the university as economic engine while benefitting from tax breaks afforded to educational institutions. In the years since this initial meeting between Mayor Emanuel and University of Chicago President Robert Zimmer, the city has eased the University's development efforts in the area, most notably through the intermediary of Theaster Gates, who has served on the City of Chicago's Cultural Advisory Council since 2011. In the end, it is not only the University of Chicago for which Theaster Gates serves as the public face of socially responsible urban development, but—more and more frequently—for the City of Chicago itself (Chicago Transit Authority 2012; City of Chicago 2014).[11]

These parasitic practices thus take the form of "relational" or "social" or "service" aesthetics purporting to serve the needs of a community without access to the channels of power and concomitant financial resources. Yet, just as corporations have sought to capitalize on consumers' desires for the local, the authentic, and the personally-crafted, parasitic procedures draw upon viewers' nostalgic desires for "community engagement" in the context of a passive digital age activism of purchasing power. As app-fueled urban lifestyles become ever more mediated, immanent "community" is often located in an older way of life, or in the seeming "authenticity" of ethnic minorities who are perceived to retain a more cohesive social life rooted in face-to-face encounters. Frederic Jameson has described the resulting "envy and *ressentiment* of the *Gesellschaft* for the older *Gemeinschaft* which it is simultaneously exploiting and liquidating" (Jameson 1979: 145; Foster 2015: 123).[12] This is "social practice" as delegated to—as embodied in—the artist and his or her manipulation of institutional finances and influence. The parasitic practices of contemporary art can thus best be understood as a romantic version of capitalist entrepreneurship in the global age.

Where institutional critique sought to challenge the structures of the art world's existing spaces, and relational aesthetics sought to carve out heterotopias within and around the art world's institutional systems, parasitism criticizes by diverting the resources of extant institutions elsewhere. The parasitic practices of Gates and Bruguera create shadow institutions, a city within a city. In the case of Gates, this is the black metropolis, as a parallel set of institutions and public spaces

interpolating the predominantly white and upper-class art world and urban bohemias (Gates 2009b).[13] In the case of Bruguera, the shadow lives of the undocumented in the United States are given voice in an impossible political visibility. For both artists, success might be measured in the extent to which their presence—performative though it is—becomes no longer necessary for the functioning of these parasitic practices, as parasitism endures without the parasite.

Notes

1　These parasitic practices are related to, but importantly diverge from, the notion of the parasite proposed by philosopher Michel Serres, see below.

2　Even as the more pessimistic opinions of anti-globalization activists became apparent during the 1999 "Battle in Seattle" protesting the World Trade Organization Ministerial Conference, and the protests at the joint meetings of the International Monetary Fund and the World Bank in Washington, DC, in 2000, there was also an optimistic strand of this movement that saw possibilities in pockets of "resistance" to corporate globalization. Many of these more optimistic activists highlighted the efforts of producers' cooperatives, such as the *Mondragón Corporación Cooperativa* in Spain, or the performative and media-savvy militancy of the Zapatista rebellion in Chiapas, which was initiated as the North American Free Trade Agreement (NAFTA) and implemented in 1994. Writing in the early 1990s, Critical Art Ensemble proclaimed that: "Treading water in the pool of liquid power need not be an image of acquiescence and complicity. In spite of their awkward situation, the political activist and the cultural activist (anachronistically known as the artist) can still produce disturbances. . . . By appropriating the legitimized authority of 'artistic creation,' and using it as a means to establish a public forum for speculation on a model of resistance within emerging techno-culture, the cultural producer can contribute to the perpetual fight against authoritarianism" (Critical Art Ensemble 1994: 12, 27).

3　Here, I mean something slightly different from Johanna Drucker's characterization of the complicity of contemporary art. As different as her approach is from the scholarship of art historians such as Benjamin Buchloh and Hal Foster, Drucker similarly defines her position in relation to an Adornian notion of the relationship between art and the culture industry or "mass culture values," even as she questions a knee-jerk opposition between the two.

4　Serres complicates an older Marxist paradigm of production and consumption (Lenin's "bloodsucking" kulaks enriching themselves at the expense of true producers, the peasants) with a media theory-inflected emphasis on communication, whereby the parasite takes the disruptive form of *static*. See Vladimir Lenin (1918).

5 One might understand this process in light of the fictitious doubling of an imaginary
 Eastern European city in China Mieville's novel *The City & the City* (Mieville 2008).
6 Gillick himself has noted that his recourse to Celtic legend was spurred by the
 particular context of the art department of Goldsmiths College and the emergence
 of the so-called Young British Artists (YBA), whose work in late-1980s and early
 1990s London at times adopted an aggressively identitarian mode of art production.
 Tracy Emin and Sarah Lucas, for example, took up a hyper-sexualized approach to
 form, style, and self-representation in congruence with third wave feminist stances,
 while Yinka Shonibare and Chris Ofili drew upon their Afro-British identities to
 combine forms and styles of Western art history (18th-century British and French
 genre scenes, the Madonna and child) with materials (Dutch-wax dyed fabrics,
 elephant dung, etc.) related to Africa's imbrication in colonial and imperial networks
 reaching to Western Europe and beyond. Gillick explicitly referenced debates on
 "difference and collectivity" among professors at his art college, and the legacy of
 feminist artists such as Mary Kelly, who was living in London until around 1987.
7 Of course these artists are not really evading the art market. Some of Gates' funding
 for his parasitic practices comes from sales of art objects, and he is represented by
 the unabashedly commercial gallery White Cube, in London. Bruguera has a more
 tangential relationship to the dealer-gallery-auction side of the art world.
8 In certain works, Gates has overtly addressed his own performance of blackness
 (Gates 2009c).
9 Bruguera's work references Tatlin's *Monument to the Third International*, which was
 intended to be topped with radio antennas. See Boym (2008).
10 Specifically, the job trainees were to be those funded by the Comprehensive
 Employment and Training Act (CETA), in which federal block grants were given to
 states and municipalities to deliver job training based on local needs. CETA was
 implemented in 1973 and replaced by the Job Training Partnership Act (JTPA) in
 1982.
11 Gates' recent commission for the redesign of a public transit station, for example,
 and his collaboration with the Chicago Housing Authority on a mixed income
 residential development put him in league with the big boys of commercial urban
 development. The arts component of the redesign of the 95th Street Red Line Station
 was budgeted at $1.3 million, while Gates drew upon $12 million of mixed private
 investment and government funding for the Dorchester Art + Housing Collaborative
 residential project.
12 Jameson asserts that, "In the United States, indeed, ethnic groups are not only the
 object of prejudice, they are also the object of envy; and these two impulses are
 deeply intermingled and reinforce each other mutually. The dominant white
 middle-class groups—already given over to *anomie* and social fragmentation and
 atomisation—find in the ethnic and racial groups which are the object of their social

repression and status contempt at one and the same time the image of some older collective ghetto or ethnic neighbourhood solidarity; they feel the envy and *ressentiment* of the *Gesellschaft* for the older *Gemeinschaft* which it is simultaneously exploiting and liquidating." Hal Foster discusses the compensatory nature of participatory art in the face of "the dissolution of the [Habermasian] public sphere."

13 As Gates describes, "Because I spend so much time moving between super formal institutions [museums, galleries, the City of Chicago's Department of Cultural, Affairs] and super informal ones, I wanted to . . . call attention to . . . the life that is lived between them. And often, the really formal ones are outside of my neighborhood, and the informal ones are often in my neighborhood. So I also wanted to . . . have those two things collide in the way they collide in my life. . . . One of the byproducts of [my] projects is that there would be this kind of spatial collision, or this social collision, that really conflates how my life looks every day."

References

Archibodjan, Randal C. (2015), "Cuba Again Arrests Artist Seeking Dissidents' Release," *The New York Times*, January 1, 2015. Available at: https://www.nytimes.com/2015/01/02/world/americas/cuba-again-arrests-artist-seeking-dissidents-release.html. Accessed January 10, 2015.

ArtPlace America (2012a), "Black Cinema House," *ArtPlace America*, March 27, 2012. Available at: http://www.artplaceamerica.org/funded-projects/black-cinema-house-live/blog/black-cinema-house. Accessed August 15, 2013.

ArtPlace America (2012b), "Washington Park Arts Incubator," *ArtPlace America*, September 22, 2012. Available at: http://www.artplaceamerica.org/funded-projects/washington-park-arts-incubator. Accessed February 25, 2013.

Avgikos, Jan (1997), "Liam Gillick," *Artforum* 35(10): 136.

Barbaro, Michael (2013), "$1.1 Billion in Thanks from Bloomberg to Johns Hopkins," *The New York Times*, January 26, 2013. Available at: https://www.nytimes.com/2013/01/27/nyregion/at-1-1-billion-bloomberg-is-top-university-donor-in-us.html. Accessed February 25, 2013.

Becker, Howard S. (1982), *Art Worlds*, Berkeley, CA: University of California Press.

Bishop, Claire (2004), "Antagonism and Relational Aesthetics," *October* 110: 50–79.

Bourriaud, Nicolas (2002), *Relational Aesthetics*, Dijon: Les Presses du Réel.

Boym, Svetlana (2008), *Architecture of the Off-Modern*, Princeton, NJ: Princeton Architectural Press.

Chicago Transit Authority (2012), "95th/Dan Ryan Station & Terminal Improvements," *Chicago Transit Authority*, August 27, 2012. Available at: http://www.transitchicago.com/95thTerminal. Accessed December 18, 2014.

City of Chicago (2012), Building permit #100419939. March 7, 2012.

City of Chicago (2014), "Mayor Emanuel, Chicago Housing Authority Announce the Grand Opening of the Dorchester Art + Housing Collaborative." *City of Chicago*, November 20, 2014. Available at: http://www.cityofchicago.org/city/en/depts/mayor/press_room/press_releases/2014/nov/mayor-emanuel--chicago-housing-authority-announce-the-grand-open.html. Accessed December 18, 2014.

Critical Art Ensemble (1994), "Nomadic Power and Cultural Resistance," *The Electronic Disturbance*, Brooklyn, NY: Autonomedia, pp. 11–33.

Cuba Debate (2014), "*Consejo Nacional de las Artes Plásticas: Inaceptable performance en la Plaza de la Revolución,*" *Cuba Debate*, December 30, 2014. Available at: http://www.cubadebate.cu/noticias/2014/12/30/consejo-nacional-de-las-artes-plasticas-inaceptable-performance-en-la-plaza-de-la-revolucion. Accessed January 10, 2015.

Deleuze, Gilles and Félix Guattari (1983), *Anti-Oedipus: Capitalism and Schizophrenia*, Minneapolis, MN: University of Minnesota Press.

Drucker, Johanna (2006), *Sweet Dreams: Contemporary Art and Complicity*, Chicago, IL: University of Chicago Press.

Enwezor, Okwui (2002), "What Is an Avant-Garde Today? The Postcolonial Aftermath of Globalization and the Terrible Nearness of Distant Places," *Documenta 11, Platform 5*. Ostfildern-Ruit, Germany: Hatje Cantz, pp. 44–48.

Florida, Richard (2002), *The Rise of the Creative Class: And How It's Transforming Work, Leisure, Community, and Everyday Life*, New York: Basic Books.

Florida, Richard, Kevin Stolarick, and Brian Knudsen (2010), "The University and the Creative Economy," *Education in the Creative Economy: Knowledge and Learning in the Age of Innovation*, New York: Peter Lang: 45–76.

Foster, Hal (1985), *Recodings: Art, Spectacle, Cultural Politics*, Seattle, WA: Bay Press.

Foster, Hal (2015), *New Bad Days: Art, Criticism, Emergency*, New York: Verso.

Friedman, Thomas (1999), *The Lexus and the Olive Tree*, New York: Farrar, Straus, Giroux.

Fukuyama, Francis (1992), *The End of History and the Last Man*, New York: Free Press.

Gates, Theaster (2009a), "To Be Pocket: Militaristic Effeminacy, the 'Hood' and Adorno's Last Sermon, or, It's Over When the Black Marching Band Goes Home," *Our Literal Speed*, Chicago, IL, May 2, 2009.

Gates, Theaster (2009b), "Interview with Kathryn Born," in *Bad at Sports* (Podcast) no. 205, August 2, 2009. Available at: http://badatsports.com/2009/episode-205-terry-scrogumtheaster-gates. Accessed January 23, 2015.

Gillick, Liam (2009), "Lecture," University of Chicago Franke Institute for the Humanities, Chicago, IL, October 7, 2009.

Grabner, Michelle (2013), Interview with Adrian Anagnost, Chicago, IL, January 17, 2013.

Harris, Melissa (2011), "Emanuel's in the Zone with Master Plan. Mayor Tackles U. of C. Permits in Bid to Streamline Process for Everyone," *The Chicago Tribune*, May 22, 2011. Available at: http://articles.chicagotribune.com/2011-05-22/business/

ct-biz-0523-confidential-emanuel-20110521_1_master-plan-rahm-emanuel-zoning. Accessed February 25, 2013.

Jameson, Frederic (1979), "Reification and Utopia in Mass Culture," *Social Text* 1 (Winter 1979): 130–48.

Keeler, Stuart (2008), "Community as Collaborator," *Public Art Review* 19(2): 32–33.

Knight Foundation (2014), "Knight Foundation Invests $3.5 Million to Help University of Chicago Expand a Model for Community Revitalization Led by Artist and Urban Planner Theaster Gates," *Knight Foundation*, May 8, 2014. Available at: http://www. knightfoundation.org/press-room/press-release/place-project-theaster-gates. Accessed December 18, 2014.

Krauss, Rosalind (1982), "Photography's Discursive Spaces: Landscape/View," *Art Journal* 42(4), *The Crisis in the Discipline* (Winter): 311–19.

Kwon, Miwon (2002), *One Place after Another: Site-Specific Art and Locational Identity*, Cambridge, MA: MIT Press.

Lacey, Annesa (2015), "University of Chicago Programs, Partnerships Boost Local Economy Block by Block," *The Examiner*, April 30, 2015. Available at: http://www. examiner.com/article/university-of-chicago-programs-partnerships-boost-local-economy-block-by-block. Accessed September 25, 2015.

Lenin, Vladimir (1918), "Speech at the Meeting of Delegates of the Committees of the Poor Central Provinces," *Byednota* 185, November 10, 1918.

Matta-Clark, Gordon (1976), *A Resource Center and Environmental Youth Program for Loisaida: A Proposal by Gordon Matta Clark* [Grant Proposal to the John Simon Guggenheim Memorial Foundation], Report in *Urban Alchemy: Gordon Matta-Clark*, ed. Francesca Consagra, St. Louis: Pulitzer Foundation for the Arts, 2009.

Matthews, David Lee (2014), "Meet the U of C Exec Who Wants to Revitalize Hyde Park," *Chicago Real Estate Daily*, October 2, 2014. Available at: http://www. chicagobusiness.com/realestate/20141002/CRED01/140939973/meet-the-u-of-c-exec-who-wants-to-revitalize-hyde-park. Accessed December 18, 2014.

Meyer, James (1995), "The Functional Site; or The Transformation of Site Specificity," in *Platzwechsel: Ursula Biemann, Tom Burr, Mark Dion, Christian Philipp Müller*, eds Bettina Marbach and Bernhard Bürgi, Zürich: Kunsthalle. Rpt. in *Documents* 7 (Fall 1996): 20–29.

Mieville, China (2009), *The City and the City*, New York: Del Rey Ballantine Books.

Mosquera, Gerardo (2009), "Cuba in Tania Bruguera's Work: The Body Is the Social Body," in *Tania Bruguera: On the Political Imaginary*, New York: Charta.

Quinn, Allison Peters (2012), "Exchange Rate," in *Service Media: Is It "Public Art" or Is It Art in Public Space? A Collection of Essays*, ed. Stuart Keeler, Chicago, IL: Green Lantern Press.

Rooney, Ben (2014), "Harvard Gets Record $350 Million Donation," *CNN Money*, September 8, 2014. Available at: http://money.cnn.com/2014/09/08/news/harvard-donation. Accessed December 18, 2014.

Serres, Michel (1982), *The Parasite*, translated by Lawrence R. Schehr. Baltimore, MD: The Johns Hopkins Press.

Sholette, Gregory (2000), "Some Call It Art: From Imaginary Autonomy to Autonomous Collectivity," "*Dürfen die das*?" OK Center for Contemporary Art, Linz, Austria, March 24–26.

Thompson, Nato (2012), *Living as Form: Socially Engaged Art from 1991–2011*, Cambridge, MA: MIT Press.

Viveros-Faune, Christian (2012), "Theaster Gates," *Art Review* 56: 66–71.

Time, Autonomy, and Criticality in Socially Engaged Art

Grant Kester

There is no surer way of evading the world than art, and no surer way of attaching oneself to it.

Goethe, *Elective Affinities* (1809)

One of the central questions in the discourse around contemporary socially engaged art practice concerns the determination of critical efficacy. I want to begin by noting that "criticality" has, for some time, functioned as the implicit criterion for the evaluation of artistic or aesthetic merit in contemporary art more generally. This is, of course, consistent with the earliest concept of the aesthetic as a form of critical self-reflection (on the harmony of the faculties or the free play of our formal and sensuous drives in the virtual realm of aesthetic semblance). It should also be noted that the essentially monological concept of the self that is assumed to engage in this reflective project continues to inform contemporary accounts of art's critical potential.

That all modernist art (not just the socially engaged variety) makes some claim to a critical efficacy is self-evident, as is the fact that this capacity rests on a set of explicitly ethical claims about art's relationship to dominant systems of power. It is equally axiomatic that the preponderance of what we know as modernist art is driven by variations of the same underlying impulse: to challenge the growing influence of (implicitly capitalistic) forms of materialism and possessive individualism. It takes no great hermeneutic effort to detect this orientation in the special privilege assigned by Kant to disinterest, in Schiller's assault on the "reign of material needs" or in Adorno's attack on "constitutive subjectivity" in *Aesthetic Theory*. At the same time, the source of art's power to challenge this regime was to be found in its monological autonomy from the same corrupt social and political system that it hoped to transform. For Schiller

the aesthetic re-invents the growing schism between works of art and the world of daily life—which would become a defining feature of modernity—as the precondition for art's capacity to effect a harmonious reconciliation of contending classes. One symptom of modernist fragmentation (the hierarchical segregation of fine art) thus became the antidote for another (class division).

In this model concrete social or political change is merely the mechanical or pragmatic extension of the real, creative work of social transformation, which only occurs through the cognitive reprogramming of individual subjects. Any direct social or collective action is premature, and even hazardous, until we have first learned how to respect, rather than instrumentalize, the other through a singular experience of aesthetic education (whether this occurs through exposure to elevating models of high art or the spectacle of economic abjection engineered to "force" the bourgeois viewer to admit his own complicity in class oppression). This deferral of praxis is re-articulated by Adorno as a prohibition on the premature reconciliation of subject and object, or self and other, in artistic experience, which would allow the bourgeois viewer an unearned experience of aesthetic transcendence. The necessary presumption in both cases, of course, is a hierarchical separation between artists, who possess an innate capacity for critical reflection, and individual viewers (always implicitly "bourgeois") whose consciousness remains mired in what Viktor Shklovsky famously termed "habitualization." It is only *after* the (inevitably deferred) revolution, when the aesthetic reconciliation of self and other is finally universalized and made real, that we can be allowed to indulge in all those emotions (friendship, love, sympathy) that "we revolutionists," as Trotsky once wrote, "feel apprehensive of naming" (Trotsky 1923). Until that time any artistic practice that traffics in the kinds of affirmative or solidarity-enhancing modes of affect necessary to actually work collectively does nothing more than provide an alibi for a fundamentally corrupt system.

As I've suggested, the ethical orientation of the avant-garde has historically been staged through this binary opposition between complicity and criticality, between those practices that can be seen to engage in an authentic form of (autonomous) critique, and those that can be shown to reinforce rather than challenge oppressive social or political systems. It would seem clear that these two operational modes can't be entirely disentangled, and that this tension, between salve and salvation, between agent of radical change and alibi for the status quo, is built into the very operation of the avant-garde as a discursive apparatus. As Paul Mann describes it, the avant-garde is "not a victim of recuperation but its agent, its proper technology" (Mann 1991: 92). Like Icarus,

just how closely do artists hew to the corrosive warmth of the social before their wings are melted and they plummet to earth? These issues are even more pronounced when we turn to the arena of socially engaged art, whose very self-definition assumes the problematic counterpoint of a socially *disengaged* art practice. Thus, one of the central discursive tropes evident in recent criticism of socially engaged art circulates around the efficacy of "merely" local or situational actions. While there are certainly valid reasons for being skeptical of practices grounded in local sites of resistance, this critique assumes that artists today actually have the option of developing their work in conjunction with a revolutionary movement operating at a global scale. More crucially, it ignores the fact that the future evolution of new, potentially global, forms of resistance must begin precisely with the creative and practical experience of local or situational action.

This fall I wrote a short piece for the *A Blade of Grass* website (http://www.abladeofgrass.org/fertile-ground/between-theory-and-practice/) that explores this same question, using Thomas Hirschhorn's widely celebrated *Gramsci Monument* (located in the Forest Houses complex in the South Bronx) as an example. I want to return to this project here, as it allows for a more detailed elaboration of the questions I've raised above. In particular, the *Gramsci Monument* offers a useful illustration of the complex ideological machinations necessary for an artist whose livelihood is dependent on the collecting habits of the 1 percent to retain the aura of autonomous criticality necessary to be simultaneously embraced by the validating mechanisms of academic art criticism. In addition, given the increasing appropriation of "social art" by museums, art fairs, and foundations, it also provides a revealing example of the specific modes of practice that are most congenial to the institutional and ideological demands of the mainstream art world. Typically these involve temporary and ephemeral gestures that entail no long-term commitment, responsibility or investment but, rather, provide highly mediagenic moments of immersion in "other" social and cultural contexts. Certainly they don't encourage anything as déclassé as a form of resistance or criticality that might raise troubling questions about the hegemonic function of the sponsoring institutions themselves.

For Hirschhorn, of course, the criticality of the *Gramsci Monument* is linked to its carefully regulated autonomy, evident in his insistence that this project is "no social work experiment, but pure art". The most obvious subtext for this insistence is what we might term the exculpatory critique, which I've alluded to above. It is familiar to us from several decades of critical theory, but I'll rehearse

its general outlines here. Given the repeated failures of the working class to rise up in revolutionary protest and overthrow the entire capitalist system, the artist or theorist has come to function as a kind of protective vessel (Adorno used the term "deputy") for a pure revolutionary spirit that must be held in trust until the proper historical moment allows for its return to the masses for final actualization. Until that time any concrete action (to improve the conditions of the oppressed, for example) only serves to compromise the exemplary freedom of artistic or intellectual production and exonerate the "system" itself from critique, by showing that some positive change is possible without a total revolution. Here the premature reconciliation of art and life replaces the premature reconciliation of self and other as the condition against which advanced art differentiates itself. The artist, in order to preserve his or her own (internalized) revolutionary purity, must abstain from concrete action and instead traffic only in various form of symbolic enactment (performances, the production of physical objects, etc.) designed to interpellate individual viewers.

One might be surprised to find a project that is so clearly indebted to the often-reviled traditions of community art presented as an exemplar of aesthetic purity. However, Hirschhorn's evocation of purity in this context deserves closer scrutiny, as it can reveal a great deal about the increasing institutional popularity of various forms of collaborative or participatory art. The result of this mainstreaming has been a tactical shift in the constitution of autonomy itself. We have moved from a model of spatial autonomy, in which art preserves its independent criticality by remaining sequestered in museums and galleries, to a model of temporal autonomy, in which the artist preserves his or her critical independence by retaining mastery over the unfolding of a given project through time. Here the artist alone determines the moment of both origination and cessation, and the complex choreographic markers that structure the processual rhythms (of creativity, of incipient resistance, of reinvention or reorientation) set in motion by their work.

In the absence of the institutional and spatial boundaries of the museum or gallery, time, and the structuring of time, becomes the primary form through which the artist exercises his or her autonomy. It is the realm of expectation and disappointment, realization and deferral, and completion and incompletion. The orientation to time in the structuring and planning of *Gramsci Monument* is symptomatic. It was exhaustively event-driven, rather than process driven, combining elements of both a museum education program and a biennial (complete with its own "pavilions"). This is museum time, institutional time,

teleological time, predicated on planned events and scheduled, highly programmatic, activities, and largely resistant to the improvisational emergence of new critical insight or the unforeseen social energies and antagonisms that can be generated by a messy, complex, creatively staged collaborative interaction (a process that is, more often than not, temporally disobedient). Not surprisingly, the *Gramsci Monument* appeared to have no real orientation to local nodes of practical resistance that might have allowed the residents of Forest Houses to integrate the ideas espoused by Antonio Gramsci, the intellectual figurehead of the project, with their own lived experience.

This sovereign relationship to temporality is clearly evident in Hirschhorn's insistence on the "time-limited" nature of the *Gramsci Monument*, which came in response to a critic's inquiry about its possible long-term effect on the Forest Houses community. Hirschhorn's response is symptomatic:

> First of all, I am happy to learn that residents want the Monument back, because this means that the project was not a failure. But I had been, since the very beginning, clear to everybody that the Gramsci Monument is a new kind of Monument, and it's a new form of art—concerning its dedication, its location, its output and its duration … It's not a Monument which understands eternity as a question of time; it's a Monument which understands eternity as 'here' and as 'now'.
>
> Kimball 2014

For Hirschhorn the purity of *Gramsci Monument*, and his own critical autonomy as an artist, rests on his singular ability to prescribe its temporal limits, and to refuse any responsibility for the actual effect the work might have on the Forest Houses community "after" the project is completed. Here the fundamentally monological orientation of his practice is evident. In order to instantiate and preserve his own autonomy Hirschhorn must refuse any reciprocal answerability to the site and to the unfolding social processes that might be catalyzed by his presence there. The effect of this temporal sovereignty on the community itself is apparent in the following observations; one made during the project's eleven-week run (by the then-director of the Dia Art Foundation, which commissioned the work) and the other about one year after its conclusion by Susie Farmer (the mother of one of Hirschhorn's chief contacts at Forest Hills).

> The seminars on Saturdays are packed. There are people coming every day: that's a sign that the residents are interested in the project. I remember I was there one morning just before it opened to the public and a group of kids was running toward the monument, screaming, "The monument is about to open. Let's go to

the computer room!" There is ownership. The *Gramsci Monument* is part of Forest Houses; it's part of their lives.

<div align="right">Vergne 2013</div>

Whitney Kimball: I remember the last time I talked to you, you were telling me about kids who were getting really inspired by the art there. Have you seen that [enthusiasm] grow at all over the year? [Note: Last year, Susie had told me a story about a little boy who'd been particularly inspired by the Monument, and had been thinking about going into an art program because of it.]

Susie Farmer: No. And one little boy who we particularly thought would be very good [with art], I don't even know if he's going to school now like we'd encouraged him to do. The children are asking every day if it's going to come back. No, they're not going to come back. It was a one-time thing. Every day they had something to look forward to. They would get up early and come to the monument. It was something they never had in their area before, and they may never have it again.

<div align="right">Kimball 2014[1]</div>

By refusing to use his considerable prestige (and the Dia's equally considerable financial resources) to create a more sustainable transformation in Forest Houses, Hirschhorn imagines that he is offering an indirect critique of the failure of existing public agencies to fulfill their own obligation to support the Forest Houses residents themselves, invoking what he somewhat cryptically terms the "non-necessity of the world as it is". This is a straightforward, and fairly predictable, reiteration of the exculpatory critique outlined above. For Hirschhorn, art's function is to provide a brief, symbolic anticipation of a different world, evoking the possibility of concrete change or political empowerment (in the case of the *Gramsci Monument*, via the staged consumption of Marxist philosophy or critical theory) but never seeking to realize it. The residents of Forest Houses can be employed, trained and lectured to, but never engaged in a process that entails their own agency in the development of new forms of resistance or criticality.[2] If the after-effect of this approach is some level of disillusionment that the unprecedented outpouring of resources and media attention devoted to the Forest Houses community had been abruptly withdrawn, it's preferable to a scenario in which the state could point to some more lasting improvement in the community to excuse its own inaction.

By leaving the community with no sustainable model of creative resistance Hirschhorn can preserve his own image as an uncompromising critic of capitalism while siphoning off the social capital generated by working-class residents, whose cultural and economic difference is a narcotic to arts institutions and funders

anxious to demonstrate their social commitment (so long as it remains short term), without calling into question their institutional privilege or their hegemonic function within the global art market (now valued at $54 billion dollars per-year). Of course one can't expect Hirschhorn, or any artist, to resolve the economic crisis of the working class in the South Bronx. But one can ask what it means for an artist to offer the hope of something different from "the world as it is," while using the frustration and disappointment produced by its failed realization to demonstrate his unwillingness to indulge in the "premature" reconciliation of art and practical action. Here the people of Forest Hills, their kindled enthusiasm, their aroused hopes, their participatory involvement, become the medium for a "critical" gesture intended primarily for art world consumption.

Notes

1 Erik Farmer, the Forest Hills Tenant Association President, and Susie Farmer's son, registered a similar concern: "Well I thought [the reactions] would be a little more mixed, but mostly, everyone misses it. They wish it was back. Everyone keeps asking me *Is it going to come back this year, is it going to come back* . . . I had to tell them, nope, that was it, not again this year. So there's nothing for the kids to do now, they're really bored. You can see how nobody's out here, when the monument was here last year, it was full of people outside."

2 The governing matrix for all of these processes remains the *a priori* plan devised by Hirschhorn before the event begins. Hirschhorn discusses the centrality of the plan in an interview with Benjamin Buchloh: ". . . my idea was that I wanted to make sculpture out of a *plan*, out of the second dimension. I said to myself, 'I want to make sculpture, but I don't want to create any volumes.' I only want to work in the third dimension—to conceive sculpture out of the plan, the idea, the sketch. That is what I want to make a sculpture with: the thinking and conceiving, the various plans the planning" (Buchloh 2005: 81).

References

Buchloh, Benjamin H.D. (2005), "An Interview with Thomas Hirschhorn," *October* 113: 77–100.

Goethe. Johann Wolfgang von ([1809] 1994), *Elective Affinities*, trans. David Constantine, Oxford: Oxford University Press.

Kimball, Whitney (2014), "How Do People Feel about the *Gramsci Monument* One Year Later?" *Artfcity*. August 20.

Mann, Paul (1991), *The Theory-Death of the Avant Garde*, Bloomington, IN: Indiana: University Press.

Trotsky, Leon (1923), "Communist Policy Toward Art," https://www.marxists.org/archive/trotsky/1923/art/tia23.htm

Vergne, Philippe (2013), "The Momentary Monument: Philippe Vergne on Thomas Hirschhorn's Ode to Gramsci," *Walker Art Museum Magazine*. September 12. http://www.walkerart.org/magazine/2013/philippe-vergne-interview-hirschhorn-gramsci.

Radical Proximity

Sofia Leiby

The crisis of value is happening beyond the art-making sphere: the democratization of "expertise," the constant cry of the "death of art criticism," and the shift towards populist methods of value accumulation via networks: from Yahoo Answers to Yelp to Medium to art critic Jerry Saltz's open-forum review/prompts on his Facebook page. This is partly thanks to the so-called "democratizing" tools provided by the Internet but also is related to the impact of a globalized, networked system of labor on creative producers and a general cultural trend towards "horizontality." There has been a trend of populist, radically democratic exhibitions in recent years and more have surfaced; one recent example is Hans Ulrich Obrist and Simon Castets' *89plus*, a utopian exploit which attempted to put forward a global, interdisciplinary zeitgeist of all artists born after the year 1989 through a massive open call.[1] Like Obrist, traditional gatekeepers such as critics, curators and galleries are making a show of what appears to be a dispersal of their agency. In terms of value production, the tally has largely replaced the weighted vote, the visible versus invisible over the plus versus minus, as theorist Boris Groys suggested in a roundtable in 2005 held at the School of the Art Institute of Chicago about the state of art criticism. He spoke of a change of codes in reaction to artworks. First there was a positive or negative code, but the digital age ushered in a new "digital code," where the option is either one or zero, either art is brought to exposure or withheld it (Elkins and Newman 2008: 154). But what is thinly veiled as some kind of populist paradigm shift in value accreditation that reaches towards consensus in art actually leaves art production exposed to the values of the market.

Globalization and the Euro accelerated the art world's international grip. Deregulation, the erasure of state-imposed bonds on corporations and big banks, privatization, austerity measures and the expansion of the free market post-2008 financial crisis in the US ushered in a new golden era in the art

market. The so-called return of the Gilded Age—as Thomas Piketty proposed in his bestselling book, *Capital in the Twenty-First Century*—resulted in auction prices flying their highest in the history of Christie's for any auction, a record-breaking gross of $852.9 million for contemporary art in 2014 (Duray 2014). According to data compiled by the European Fine Art Foundation, €47.4 billion, or about $64.6 billion, of art and antiques were sold by the world's auction houses and dealers, an increase of more than 150 percent over the last decade (Reyburn 2014). Speculative collectors inflated prices by young painters to reap the benefits of resale later.

Enabling this market recognition are a few high-powered gatekeepers, art collectors and hypermobile super-curators[2] who curate massive global biennials and in doing so, determine which artists will be propelled to stardom. This resultant fabric of validation is completely uprooted, unspecific to place or time, linked to abstract ideas of fractalized and monetized time-units of making, floating above everything, distinctly face-less and place-less, and bolstered by globalization and neoliberal capitalism. This new hierarchy of value for current art production is a flimsy, transient, mobile fabric, not unlike what Marx called "general intellect": a hazy combination of these few individual authors' consumerist relationships. Lamentably, this new criteria is well on its way to replacing what may have been called the old postmodern marker of worthwhile art, *criticality*.

So what are the ways to create methodologies for evaluation of art outside of the market? One place where artists know for sure the reason to occupy their time making art is within the pedagogical setting. Part of what is useful about art schools is that they foster a limited, clear-cut language for the artist to define her work, a criterion established by her professors that is fairly straightforward and developed largely on a case-by-case basis. Critiques can be enormously significant evaluations of success in artwork, and may be attributed to a student's proximity to her peers within the university. In a critique setting, thoughts are fired around a room informally, and in the best instances, an *embedded* understanding develops *between* subjects in a room. When people feel comfortable, critiques can be some of the most helpful experiences for an artist: feedback is honest and, if even momentarily, *suspended outside the market* (even though the professors are getting paid and the students are paying).

What if we took this method of value attribution and thought about how it might begin to apply to artistic production outside of a school? If we defined a value system *based on proximal relations between persons*, with whom we share,

at the very least, a location and that location's history, might we create a system not dependent on capital *and* one that runs *against* the current of globalization?[3] This would require a tiny bit of solidarity on the part of the artists, some kind of allegiance at least to one another or at least the place they are living in, something artists are largely resistant against. In his essay "Exhaustion and Subjectivity," in *After the Future,* Franco "Bifo" Berardi suggests that through a process of "collective subjectivization"—or social recombination—it's possible to escape global capitalist flows (Berardi 2011: 100). He defines collective subjectivization as the development of "a common language-affection." But for Berardi it is impossible, as late capitalism has fermented to the point where artists are freaking out about how they spend time; it is so implicated in a digital realm, fragmented by precarity, fractalized into little units: "abstract, depersonalized, fractal atoms of time available in the net-sphere." For Berardi, contemporary creative laborers "[have] become unrecomposable, unable to recognize itself as a community of sensible and sensitive beings who share the same social interests and cultural expectations" (Berardi 2011). We can look to artists producing in non-commercial centers, for example.

Michelle Grabner, writer, artist, gallerist, and curator of the 2014 Whitney Biennial, wrote in the Brooklyn Rail in March of 2012 about Chicago: "Great amounts of creative energy are still being wasted on promoting and reinforcing outdated cultural hierarchies or on criteria of success adapted from New York.... To maintain a rigorous art practice here, artists need to set their own criteria, continuously measuring and contextualizing their work" (Schwabsky and Grabner 2012). It is useful to look to smaller arts ecologies, i.e. not New York or LA, to find examples of this system based on *proximal relations* actually taking place. It is not a coincidence that in these areas, artistic production, like in the art university, takes place without the presence of a virile market for art. Happening in Chicago, as my examples below will note, is the creation of a value system not based on the market-dependent mobile fabric, but instead based on *individualized nodes of individual- and community-specific knowledge* that are *inexchangeable* and therefore *incommensurable*: not measurable in quantitative terms.[4]

One example of this value cultivation (development, say, of a "common language-affection") in practice in Chicago was the MDW Fair. The MDW (for Midwest, or Midway airport) Fair was co-founded by three of Chicago's influential arts organizers, both for- and non-profit, that took place in three iterations from 2011 to 2012. Despite the art fair epithet, the organizer's stated objective for the event deemphasized sales, even neglecting to mention them at all; it aimed to be

"a manifestation of the collective spirit behind the region's most innovative visual cultural organizers, focusing on the breadth of work done here by artists and arts-facilitators alike."[5] The MDW Fairs consisted of mainly Chicago exhibitors, with a few exceptions (St. Louis, Baltimore, and Milwaukee in 2011). The uniqueness of MDW was that its success, if it could be measured, wasn't how well its cultural output was *exported* (did New York pay attention?), *nor* how much work was sold. Rather, it pursued a new kind of criteria for evaluation, one not beholden to a market. To me—an exhibitor, attendee and volunteer—the platform allowed fairgoers the space to step back and get an overview of Chicago's artistic creation, from Bronzeville to Rogers Park, and to take a pause. James McAnally, himself a participant in the fair (and another triple-organizer: curator, writer, artist), hit the nail on the head in his essay for *Temporary Art Review* after the fair received negative press on a New York-based blog, writing: "The fact that dozens of artist-run and alternative spaces, curatorial projects, and independent publishers would converge in one place with several thousand attendees and essentially no competitive or commercial presence is remarkable for a zero profit startup venture" (McAnally 2012). Indeed, MDW seemed not to be about exporting Chicago's culture, but rather about celebrating and improving its own cultural activities. MDW, put on by the creative producers of Chicago for those producers and a general public, did not preempt the idea of criticality. Instead, it fostered a *new kind* of criticality, one that happened organically, at bars and in local weekly newspapers, in clucked tongues, and at intimate studio visits; in effect, it produced an environment not unlike that of the critique. In my view, MDW was in many ways an exercise in anti-commercial, locally produced value production.

In small arts ecologies there is a lot of overlap; in Chicago, many creative people are artists, critics, curators, collectors, and even donors, all at once. This is another form of proximity that begins to develop a local methodology for critical understanding and production. It may be time to banish the whole "critical distance" thing all together; sometimes rather than resulting in a form of cheerleading, the lack of distance between these roles actually results in devastating and tenacious critique. Perhaps in response, Chicago art critic and artist Lori Waxman, has proposed a form of art criticism she called "embedded." This form provocatively borrows the term from journalists working with a military unit during wartime. She argued that despite its negative and colonizing connotations, one positive aspect of the practice is the privileged level of access it affords, allowing for unique opportunities for in-depth analysis and criticality. Embedded units, though controversial, are arguably able to access indelible

reports from the war front. She cited a personal example: she is married to the artist Michael Rakowitz, and thus is "the best possible critic of his work" but of course, could never write about it, due to the constraints of traditional criticism (Chicago Artist Writers 2013). Were Waxman to write about his work, however, it may begin to develop a kind of incommensurable, intensely proximal measure for his work that is not dependent on global gatekeepers or capital flows.

One might argue that this closeness could work to negatively impact creative production, in that instead of advancing criticality, it would rely on nepotistic aims, or, the reverse, devolve into interpersonal squabbles. This is certainly a perspective relevant to a smaller arts ecology like that of Chicago. In "On Leaving the Building: Thoughts of the Outside," Dieter Roelstraete discussed what he calls the "everpresence" of the artist's uncritical position, "always-inside" the *Gesamtkunstwerk*. Roelstraete suggests, though, that this inside/outside does not have to be a binary; the artist instead locates herself "at an open door," where she can still maintain a "critical distance" (Roelstraete 2011). Perhaps this is a position we can attempt to occupy.

Chicago is not unique in this sense. In a panel discussion about Baltimore's art criticism in 2015 organized by the artist-run *Post-Office Arts Journal*, art writer Marcus Civin proposed a kind of "searchlight approach" to criticism, a kind that is "place-based." Since many of the artist-run activities in Baltimore take place in domestic spaces, Baltimore art is "personal—or interpersonal." One panelist related that rather than writing with an objective distance, in writing about friends he might pen a love letter or a poem instead. They questioned whether criticism could function to generate discourse and self-reflection within a community, or whether it was always entangled in a market context, and asked why art needed to speak beyond a small network (Post-Office Arts Journal 2015).

It seems that it might be useful for artists to use their unique subjective position, rather than stubbornly continue to pretend a position of "objective" critical distance. The role that criticism plays in a community is crucial in determining the post-critical agenda of current art (if we think about it as not entirely subsumed into capitalist market hierarchies and the discretion of globetrotting, nomadic curators). Proximal, embedded, regional criticism developed ground-up within communities is uniquely positioned to address and unearth that agenda. And perhaps most importantly, the kind of valuation structure that is produced in places like Chicago and Baltimore cannot be exchanged for its use value elsewhere; it does not play into a flimsy hyper-global higher value system of art, one that continues to enable a tiny number of individuals to triumph over the many.

Notes

1 See http://89plus.com/about/. From 2013 to the present, 89plus is "a long-term, international, multi-platform research project co-founded by Simon Castets and Hans Ulrich Obrist, investigating the generation of innovators born in or after 1989."

2 If some agency has left the critic, it certainly finds itself in the curator. Like critics, curators are purposefully and sometimes awkwardly dispersing their power—like *documenta 13* curator Carolyn Christov-Bakargiev's massive artist-led curatorial team.

3 While this essay focuses specifically on North American examples, there has been a strong current of anti-globalist activities on this topic, largely reacting against massive biennials and triennials that have no relationship to place. See *The Ghetto Biennale* and the general negative reception of *documenta 11*.

4 This is not to suggest that this kind of "collective subjectivization" cannot happen outside of those with a shared location—say, within intimate communities on the Web—but face-to-face interaction is a yet-to-be-explored x-factor.

5 See http://mdwfair.org. Compare this to the mission of Art Basel, on their website: "showing work of the highest merit, and attracting the world's leading gallerists and collectors, [making] Art Basel the place where the art world meets."

References

Berardi, Franco (2011), *After the Future*, Oakland, CA: AK Press.

Chicago Artist Writers (2013), "Art Criticism Today and Hopefully Also Tomorrow," *Bad at Sports*. Available at: http://badatsports.com/2013/chicago-artist-writers-lori-waxman/. Accessed June 1, 2013.

Duray, Dan (2014), "Christie's Contemporary Art Sale Nets $852.9 M., All-Time Auction Record," *ARTnews*, November 12, 2014. Available at: http://www.artnews.com/2014/11/12/christies-contemporary-art-sale-nets-853-9-m-all-time-auction-record/. Accessed February 1, 2016.

Elkins, James and Newman, Michael (2008), *The Art Seminar*, New York: Routledge.

McAnally, James (2012), "Plaster Dust and Polemics: The Other Public of the MDW Fair," *Temporary Art Review*, November 16, 2012. Available at: http://temporaryartreview.com/plaster-dust-and-polemics-the-other-public-of-the-mdw-fair/. Accessed December 1, 2012.

Post-Office Arts Journal (2015), "Arts Criticism and the Arts Outpost," Panel discussion, March 6, 2015, Baltimore Design School, Baltimore, MD.

Reyburn, Scott (2014), "For Art Collectors, the Risk Behind the High Returns," *The New York Times*, June 8, 2014. Available at: http://www.nytimes.com/2014/06/09/arts/

international/for-art-collectors-the-risk-behind-the-high-returns.html. Accessed February 1, 2016.

Roelstraete, Deiter (2011), "On Leaving the Building: Thoughts of the Outside." *e-flux*, Journal 24. March, 2011. Available at: http://www.e-flux.com/journal/24/67853/ on-leaving-the-building-thoughts-of-the-outside/. Accessed February 2, 2012.

Schwabsky, Barry and Michelle Grabner (2012), "Michelle Grabner with Barry Schwabsky," *The Brooklyn Rail*, March 2, 2012. Available at: http://www.brooklynrail. org/2012/03/art/michelle-grabner-with-barry-schwabsky. Accessed April 1, 2012.

Post-Critical Painting

Andreas Fischer

It seems that every conversation that mentions critique lately also identifies problems or limits with critique. Hal Foster's "Post Critical" is a convenient example in part because, although Foster wrote it as brief defense of criticism, it also serves as something of a quick reference guide to key "attacks" on criticism (Foster 2012). As a central figure of postmodern critique, Foster sits opposed to Jacques Rancière, who is a primary focus of Foster's defense in this and other writings. Rancière sees art as fundamentally intertwined in social operations and, as such, not capable of the "critical distance" necessary for a critical device to operate. Rancière has other concerns about critique as well. He describes the intent of criticism as setting out "to build awareness of the mechanisms of domination to turn the spectator into a conscious agent of world transformation" (Rancière 2009: 46–47). He is quick to add to the apparent didactic validity of criticality that "the exploited rarely require an explanation of the laws of exploitation" (Rancière 2009: 47). In another instance he cautions that "where one searches for the hidden beneath the apparent, a position of mastery is established" (Rancière 2004: 49). Mastery, of course, re-inscribes the same kinds of problematic power structures that criticism is supposed to expose. These examples sit alongside those of other thinkers and are part of a growing body of complaints that originate from a range of fields.

This chapter focuses on the question of what post-critical painting might look like. In order for it to do so, we first need to consider some relevant instances of skepticism toward criticism because certain dominant forms of painting are perceived to have emerged from criticality and to operate as critical devices. The focus here is ultimately on pointing towards kinds of painting that operate beyond the limits of critical painting. In part I will show that one of the problems of the legacy of historical critical painting is that what lives on from it today does not seem interested in any real function outside of market complicity. Many of the

sources that we will look at show that the kind of direct engagement historically attributed to painting has been purged, resulting in a perception that what is left for painting is only an empty attitude, tendency, or style. This examination is meant to highlight a less appreciated approach to painting today, within which painting engages and reflects immediate context deliberately. Where past uses of painting as a critical device, whether intensely aggressive (as in Niki De Saint Phalle's shooting paintings and Asger Jorn's denigration paintings), or cool and distant (as in works by Ad Reinhardt and On Kawara) have involved taking painting's own ontological stances apart, the kind of painting this essay will highlight in the end preserves and expands painting in ways that range from intimate and personal, to the poetic or the analytical or the self-reflexively questioning—all of which, one might argue, are orientations that critical painting of the past has pushed aside and that remain largely neglected within the dominant discourse around painting today. The hope in this is to advocate for direct engagement, dynamic relationships between multiple elements, and a desire for connection that all stay in perpetual motion, as opposed to a kind of engagement that is "backed off," cool, or distant.

In *The Painting of Modern Life*, art historian T. J. Clark points to a fundamental change to painting that takes place around the time of Manet. "Perhaps the change can be described as a kind of skepticism, or at least unsureness, as to the nature of representation in art" (Clark 1984: 10). Clark is not just talking about general attitude here, rather he means to refer to deliberate differences in the way that artists assert materialism relative to historical efforts to preserve illusionistic integrity. He explains that this shift leads to "stress on the material means by which illusions and likenesses were made" (Clark 1984: 10). This is reversal of sorts. It represented an interest in making apparent the materials and processes that artists had previously trained specifically to disguise. It is a deliberate form of resistance to illusionistic integrity and the historical givenness of painting's status as delivery system for a whole range of political idealisms. It is an effort to take images apart to reveal otherness beneath what had been the overt point of painting, which was to deliver a visually compelling and convincing narrative. This newer kind of painting shifts the emphasis of painting from noun to verb. Painting is no longer the presentation of an illusionistic thing, but an action toward that thing. Statement becomes the process of acting toward an object, specifically the process of acting to take that object's status apart. Painting reveals itself to be not an intact finished given, but an activity that makes available the tactics of its causation. This disruption to illusion establishes a new role for

painting as a device that critiques idealism. Clark's conceptualization points to a beginning for critical painting in its challenge to illusionistic representation, and others (Greenberg, of course, among them) have seen an extension of critical painting that would eventually grow to include abstraction. Because abstraction is often understood as a mode in which the act of taking apart has gone so far as to dismantle most if not all elements of traditional representation, it can be seen as a further extension of critical activity in ways that fit with Clark's understanding of art as critique. Framed in this way, critical painting can be understood to include any painting that challenges or dismantles representation, and thus, at least superficially, includes abstraction as a general category because of its implicit link to the history of taking images apart.

Limits of criticality

As a subcategory of critique at large, understanding the past and present of critical painting requires an examination of the past and present of critique. Among the various reflections on critique in general, Bruno Latour has been important because he sees our habit of using critique as capable of actual damage. Latour is concerned about what he sees as actual danger in the use of critique relative to his inquiries in science studies. He points to mindless habit in a changing context as a root concern. "It does not seem to me that we have been as quick, in academia, to prepare ourselves for new threats, new dangers, new tasks, new targets. Are we not like those mechanical toys that endlessly make the same gesture when everything else has changed around them?" (Latour 2004: 226). More specifically, Latour's concern is with the misapplication of critique. Because it is by now seen simply as an authoritative tool, critique is being used by those who wish, for whatever reason, to add persuasive weight to a position by dismantling another position. This includes cases where this act of taking apart might literally cause the life and death kind of harm.

According to Latour, criticality has been transformed from a productive tool for revealing the hidden behind the apparent in cases where the hidden might manipulate us, into a general signifier of supposedly justifiable suspicion. It is precisely because of past faith in critique in this sense that skepticism has become something of a shorthand for trustworthy authority and intellectual rigor. Our habit has made it possible to separate signifier from signified—to peel the function of revealing hidden manipulations away from its purpose and to apply

critique to any object. Where critique has supposedly been an important device for revealing problematic political motives and functions, it has turned into a tool for disguising new and often deceptive motives and functions.

An obvious example of this kind of purposeful misapplication is the case some continue to make against global warming. Latour recounts:

> What has become of critique, I wonder, when an editorial in the New York Times contains the following quote? "Most scientists believe that [global] warming is caused largely by man-made pollutants that require strict regulation. Mr. Luntz [a Republican strategist] seems to acknowledge as much when he says that 'the scientific debate is closing against us.' His advice, however, is to emphasize that the evidence is not complete. 'Should the public come to believe that the scientific issues are settled,' he writes, 'their views about global warming will change accordingly. Therefore, you need to continue to make the lack of scientific certainty a primary issue.' Fancy that? An artificially maintained scientific controversy.
>
> Latour 2004: 226

Once again, as Rancière has implied, critique re-inscribes what it sets out to undo.

Eve Kosofsky Sedgwick is less assertive in her assessment of criticism's problematic status, but her observations serve as useful contributions as well. Similar to Rancière's observation that the exploited rarely require an explanation of the laws of exploitation, Sedgwick argues that revealing hiddenness is simply not as valuable as has been assumed. Even in cases where criticality is not causing the kind of damage that Latour sees, dismantling may not be all that useful because it is not connected with ways to move beyond what it takes apart. "For someone to have an un-mystified, angry view of large and genuinely systematic oppressions does not intrinsically or necessarily enjoin that person to any specific train of epistemological or narrative consequences" (Sedgwick 2003: 226). The question underlying all of this for Sedgwick is, what does knowledge do? And assumptions or expectations that any expanded knowledge resulting from critique's taking apart will necessarily have consequences do not seem, after several decades of faith in this practice, to have yielded real change or growth.

The legacy of critical painting

Parallel to the growing concern over criticality's limits, is an expanding conversation about the limits of critical painting. Much of this focuses on a

perceived dominance of certain kinds of recent abstraction that have carried the legacy of critical painting forward by pushing the act of taking apart into a state where the socio-political functions that critical abstraction initially sought to carry out have been severed. This kind of painting has dismantled previous functions of painting so far that the only content left is either some clever version of an acknowledgement of painting's present lack of capability, or worse yet, complicity with what, in a recent article on *Artspace*, Andrew Goldstein calls "market driven" phenomena (Goldstein 2015).

A frequently referenced example that many believe initiated the conversation about the limits of critical painting on a wide scale is Raphael Rubinstein's "Provisional Painting," published in *Art in America* in 2009. In identifying this tendency, "Provisional Painting" takes a sympathetic stance. Rubinstein remarks, for example, that "provisional painting is major painting masquerading as minor painting" (Rubinstein 2009: 5). Following up on Rubinstein's claim, critic Lane Relyea argues that "being [an] artist in the Rubinstein mode, too unique and uncategorizable and ever-changing to be pinned down by a single, definitive visual statement, can often result in a romantic art, its template is the romantic hero's transcendent quest of leaving behind common social definitions and roles in search of unique paths and triumphs, fuller truths and a more authentic and rich existence" (Relyea 2015: 63). Both of these characterizations reflect Rubinstein's initial faith in the expansive potential of this kind of painting (even if Relyea goes on to express an amount of cynicism in his subsequent discussion of Rubinstein).

Proclamations like Rubinstein's are fairly frequent and typically evaporate soon after they emerge. "Provisional Painting" did not go away quickly, though. Instead, it provoked continued discussion and elaboration, as indicated by Sharon Butler's ongoing conversations on her blog *Two Coats of Paint* about what she has called "New Casualist Painting" and by Relyea's term "DIY Abstraction," among many other examples.

More recent extensions of the conversation, though, have been blunt in their identification of problems. This kind of characterization is typified by Walter Robinson's 2014 essay "Flipping and the Rise of Zombie Formalism." In it Robinson writes, "One thing I am hearing these days, loud and clear, is the hum of an art style that I like to call Zombie Formalism. 'Formalism' because this art involves a straightforward, reductivist, essentialist method of making a painting ... and Zombie because it brings back to life discarded aesthetics of Clement Greenberg" (Robinson 2014). The link to Greenberg here is important, of course, because of Greenberg's connection to critical painting. "Zombie

formalism" has become an active layer on top of the more sympathetic discourse tied to provisionalism. It has quickly become a familiar term of condemnation in internet conversations, art criticism, and university studios and critiques. By the time the term "zombie formalism" emerged, the perception of the dominance of provisionalism was already a half decade old and much of the early faith had given way to actual observation. What observation yielded was that this tendency was not holding up well.

Relyea's is perhaps the most provocative depiction of the legacy of critical painting because it goes beyond the accusation of simple market complicity. DIY abstraction, as Relyea calls it, is a kind of painting that "shares close quarters" with provisional painting. Similar to provisional painting, DIY abstraction operates "not as a foregrounding of personal gifts and one's unique endowments." Rather, DIY painters "uniquely manifest contemporary feeling—not despite their impersonality and anonymity but because of it" (Relyea 2015: 64). He explains that, "here painting stands as close as one can get to just doing stuff, purely making things" (Relyea 2015: 62). He continues, "painting today is just what an artist does, just filling time while sitting around the studio" (Relyea 2015: 62). The only possible way for artists to practice in this context, "is to act out in their daily material practice the society's reigning, terrifying belief in the short-term, the temporary, the moment to moment, the always on call, the get-it-while-you-can and enjoy-it-while-it-lasts." (Relyea 2015: 65). This is a mode of complicity in which art practice is reduced to passive symptom of larger and socioeconomic forces. As Relyea puts it: "here artistic labor becomes nearly indistinguishable from flex-time wage labor—anonymous, abstract, interchangeable and disposable. Painting as just doing stuff, like a hamster on its treadmill, as if in a perpetual feedback loop, over and over, with no other further objective in sight." (Relyea 2015: 65). To Relyea, painting not only embodies problematic characteristics of late capitalism, but any deliberate engagement with these characteristics (the kind of engagement that often gives art validity as an insightful device of reflection, for example) is rendered impossible. Painting today is helplessly and unselfconsciously washed along by context. It no longer challenges its context, tries to take it apart, or even to ironically play with it. Nor does it model a new way to engage. It is passively complicit to the extent that it is likely that the only ambition possible for it is the kind of brand building and financial "success" that is the illusory product of late capitalism.

Criticality in this sense has once again re-inscribed the things it set out to undo. The legacy of critical painting has, at least in terms of this recent discourse,

enabled market complicity and supported the social structures that historical critical painting set out to challenge. Painting's participation in the act of taking its object apart; that is, painting's criticality, has evolved to the point of undermining its ability to engage at all. Questions seem to follow. Is painting today incapable of playing any significant role outside of the market? Or, are there kinds of painting that are engaged with their contexts in ways that fit with emerging post-critical tendencies that fall outside of currently dominant discourse?

Beyond criticality

In the introduction to *Touching Feeling: Affect Pedagogy: Performativity*, Sedgwick describes her book as an attempt to think beyond the limits of engaging texts through the lens of critique. She explains that her project's aim is "to explore some ways around the topos of depth or hiddenness, typically followed by a drama of exposure, that has been such a staple of critical work of the past ..." (Sedgwick 2003: 8). She claims that past methods saddle us with problematic habits. "*Beneath* and *behind* are hard enough to let go of; what has been even more difficult is to get a little distance from *beyond*, in particular the bossy gesture of 'calling for' an immanently perfected critical or revolutionary practice" (Sedgwick 2003: 8).

What she offers instead is the preposition "beside." "Invoking a Deleuzian interest in planar relations, the irreducibly spatial positionality of *beside* also seems to offer some useful resistance to the ease with which *beneath* and *beyond* turn from spatial descriptors into implicit narratives of, respectively, origin and telos" (Sedgwick 2003: 8). "Beneath" and "beyond" operate in this case as reductive designators of specific functions rather than as expansions of their objects. She explains, "Beside is an interesting preposition also because there's nothing very dualistic about it; a number of elements may lie alongside one another, though not an infinity of them. Beside permits a spacious agnosticism about several of the linear logics that enforce dualistic thinking" (Sedgwick 2003: 8). "Beside" is not pure analysis; it is relational. "*Beside* comprises a wide range of desiring, identifying, representing, repelling, paralleling, differentiating, rivaling, learning, twisting, mimicking, withdrawing, attracting, aggressing, warping, and other relations" (Sedgwick 2003: 8). Although Sedgwick discusses "beside" at some length as an indicator of relations in literal space, there are, of course, important implications beyond literal spatial relationships. And these have significant implications for contemporary painting.

Similar to Sedgwick's consideration of beside, Craig Owens points in a conversation about "the Third World" to important differences between talking "about" or talking "for" on the one hand and talking "to" on the other (Owens et al. 1989: 89). Talking "about" or "for" are analogous with the discussion of conventional critique in that both terms reductively position an other as an object of mastery. "About" and "for" are not just complicit with, but also reinforce "beneath" and "beyond." Getting "beneath" and "beyond" might allow a speaker to speak "about" or "for." All four of these prepositions contribute to the representation of objects as reductive snapshots of larger meaning. As Owens points out the term "the Third World" is in itself a signifier of reductively speaking "about" or "for." Owens explains, "in order to construct the monolithic entity 'the Third World,' differences within that world must be reduced and, whenever possible, eliminated" (Owens et al. 1989: 89). Complex affect must be reduced to particular signifier. Owens reminds us that "what unifies the Third World, makes it a 'world,' is its common experience of colonialism." (Owens et al. 1989: 89). The term "the Third World" becomes reflexive and characterizes the inventor of the term (the colonizer). The apparent object of critique here is not allowed even discursive autonomy.

Owens begins to respond to this problem by suggesting that "we in the increasingly routinized metropolitan centers might ask the question of what (or who) cannot be assimilated by the global tendencies of capital and its culture." In other words we ought to step outside of the assumption of reductive mastery. He suggests, "perhaps it is in this project of learning how to represent ourselves—how to speak to, rather than for or about, others—that the possibility of a 'global' culture resides" (Owens et al. 1989: 89).

With these orientational relationships rather than subject–object assertions in mind, we can consider examples of painting that lay process, materials, and depiction beside each other in order to emphasize their orientation. This kind of painting might be said to enact something of a collapse of the distinction between subject and object. Such painting considers the position or relationship between the action of painting and the ontological status of painting in affirmational and empathetic ways. It is interested in sustaining moving and changing relationships between painting activity and the overall status of painting, which is directly oppositional to any effort to use the action of painting to cynically reduce the ranges of functions painting can have (never mind how clever). The painting under consideration here does not ultimately land in a place of trying to take apart, get behind, or beneath. Rather it attempts to consider ways that things can relate. It forgoes critical distance for closeness, even if actors

in its relationships seem to not fit together. Painting of this sort uses depiction as a process for indicating proximities. It indexes touch and, by extension, attitudes, thought processes, and even social contexts of its makers, and situates these beside what is being depicted (the ways its signifiers link iconically to content). It tries to talk to painting's potential by adding to a history in which it finds value. Painting of this sort involves a range of materials, applications and deliberately manipulates levels of fidelity and distortion. It mixes collections of ideas and orientations with its subject matter, some of which might be at times richly opposed, and it tries to situate the world inside the painting beside issues of the world outside of painting.

There are many artists who we could use as examples. Painters as diverse in age, location and attitude, who practice in ways that fit post-criticality in terms of the ideas under consideration here, include Sarah McEneany in Philadelphia, Henry Taylor and Charles Garabedian in Los Angeles, Phil Hanson and Margot Bergman in Chicago, and Kyle Staver, Todd Bienvenu, Lois Dodd, Angela Dufresne, and Lisa Sanditz in New York, to name just a few. In order to keep the conversation brief and because they are more widely familiar, we will focus on only two painters: Merlin James and Nicole Eisenman. It is worth mentioning that these painters have received a fair amount of attention in the form of writing and discussion. This fact may seem to contradict issues raised here about the state of painting discourse, however, both Eisenman and James are frequently identified as under-appreciated or as outliers. These perceptions in effect actually strengthen current assumptions and protect current discourse from a real responsibility to expand beyond its tendency to operate within dominant trends. While it has been common to discuss provisionalism or zombie formalism as indicative of the larger state of painting, that kind of association does not happen with Eisenman or James, even though they are both widely collected, and significant numbers of younger artists acknowledge them as important models. They continue to be identified as exceptions, rather than as representative of an expansion in our ways of thinking and practicing.

In addition to being widely known, both Eisenman and James practice modes of painting that combine a number of different approaches to the post-critical. They both emphasize material evidence of the structural elements of painting in combination with various kinds of representational rendering typical of the way Clark discusses early modernism in ways that are perhaps more deliberate than other painters. They both use these tactics of early modernist critical painting that Clark identifies, but they invert the original skeptical purpose in using these

tactics to create orientational relationships rather than critique. In assertively acknowledging characteristics of painting that have been typical of historical critical abstraction and in preserving the role of representation (something that critical abstraction pushes aside), Eisenman and James re-orient critical painting from a project of taking apart into a project of willful affirmational construction. The mixture of ingredients and images in these artists' work creates an expansive view of a particular kind of virtual synthesis and both artists model ideas that relate to those that Sedgwick and Owens suggest.

For years, Merlin James has been creating work that relies on a tension between assertive materiality and the representation of familiar painting subjects. In a recent series, which he calls "Frame Paintings," James uses exposed painting stretchers and transparent painting surfaces, among other structural elements, as points of consideration. As is the case in his earlier work, these paintings point back to the history of representational painting both as precedent (historically familiar genres, for example) and self-reflexive indexes of materials and processes, and in so doing connect past and present. In using transparent surfaces, the "Frame Paintings" recall the idea of painting-as-window, which has, of course, been a way of describing what illusion seemingly does to transform surface into space. Given the curiously seductive quality of these same surfaces in the "Frame Paintings," these works simultaneously point to the potential of surface to be attractive, curious, or interesting as material in itself. One of things that James consistently does well is to place things in productive relationships to unlikely others, which one might see as something of a model for a kind of ongoing engagement that moves beyond the act of taking apart, despite apparent unlikeliness or resistance among potential participants. James is not interested in using any single element of painting's past or present in order to isolate and critique it; nor is he interested in dismantling painting as a whole. Rather, he aims to lay material and representation beside each other in order to underscore the role these elements of painting play as parts of a larger and ongoing set of relationships. James uses painting, itself an all-too-familiar entity, to complicate what can easily be taken for granted. As John Yau has put it, James "can take a familiar, almost hackneyed subject—a plant on a table or a footbridge over a river—and by using muted colors and different viscosities of paint instill it with both a materiality and a sense of the ephemeral, which seem commemorative and mournful, special and ordinary, strange and curiously familiar" (Yau 2015).

Consider, for example, James's *Silver Birch* (2014–2015), a depiction of what seems to be a tree in a landscape, possibly with a human-made structure or two

in the background. Here, material characteristics of painting and basic representation intertwine and gently wrestle with each other. In a playfully witty gesture that he repeats in other paintings, James has bowed inward the side stretcher bars that make up the painting's physical support, an exaggeration of the mistake commonly made by painters of stretching a small canvas too tightly. This mixes the potential for idiosyncratic imperfection with the very structure that holds the surface of the painting, that is, it adds emphasis character to a part of the painting that is supposed to be inert.

Silver Birch also exhibits a curious mixture of characteristics of representation and abstraction. The tree trunk shape in the center of the painting seems representationally clear enough, except that James has reduced parts of it to flat ovals of opaque paint with no illusionistic texture (only the texture of the actual paint is apparent). These ovals flirt with being representations of flat stubs where branches have been sawn off, but clearly violate the texture and color scheme of the tree. Their flat, relatively intense colors cause them to lift off the surface of the canvas and drift away from the trunk and toward the viewer. As a result of this these forms waffle back and forth between description (being parts of the tree) and abstraction (being simple flat oval forms). A similar mixture of representation and material factuality occurs in the background behind what might be distant rows of trees in the upper right third of the painting. Here, James stops the representational background information abruptly with a crisp hard edge line that suddenly changes into an elongated vertical rectangular grayscale smear that both makes no sense in the representational context and, oddly, fits rather harmoniously into the overall formal scheme of the painting. One could continue to describe seemingly contradictory, but also curiously harmonious relationships in this and other of James's paintings, but the important point is that the experience of this painting is rooted in the way that it keeps its laying beside of references, thoughts and actions of the artist, and immediate material facts moving in relationship to each other whether they seem as though they fit together or not. James engages the viewer by productively orienting things to each other in ways that use similar material tactics to the early modernist critical painting that Clark describes, but James's work uses these mechanics in ways that are distinctly at odds with the sort of skepticism that Clark ascribes to early modernist critical painting.

Though more straightforwardly representational than James's work, Eisenman's paintings also use similar elements and techniques as those that Clark describes, and also substitutes orientational relationships for early modernist critical skepticism. Eisenman uses scraping, globbing of paint, bits of collage,

distortion, and other anti-representational strategies, but simultaneously skillfully preserves representation in a number of different stylistic modes. She regularly combines the stylistic characteristics of cartoons, art historical paintings, advertising, and idiosyncratically personal rendering. Though she uses similar technical procedures to James, her interest in directly addressing social issues distinguishes her work from James's more poetic manipulations. Eisenman includes some critical impulses in her work here and there, particularly in the doses of irony and satire in her often aggressive, yet humorously exaggerated human figures. When she does this, though, she mixes it with an adventurous and expansive mixture of movement and pleasure in the painting process. She uses the act of painting to re-characterize criticality. It often seems as if she is enacting a playful view of the very device of critique in order to suggest that it is just one part of the range of relationships that make up life, and that it would be ineffectual to focus on it alone. Overall, though, putting different stylistic tendencies next to one another is the most insistent tactic in her work. Critic Holland Cotter describes one of her paintings as, "Sistine Chapel meets Thomas Hart Benton meets Classic Comics" (Cotter 2014). The result is a kind of picture that re-enacts the child-like pleasure of discovery by curiously situating things in relationships with each other. Her paintings seem to argue that she has learned from experience that engagement rooted in the creation of moving and changing relationships, even among elements that seem as if they could not or should not relate, is more effective than old fashioned criticality alone. Her work stands as an example of the orientational extensions beyond criticism for which Sedgwick and Owens argue.

In Eisenman's *Achilles Heel* (2014) for example, the excitement in the challenging of bringing a range of characteristics together is apparent. The image is something like a bar scene located somewhere along the east river in Brooklyn, judging from the water and skyline pictured out the window. In this painting it seems as if Eisenman has humorously brought the activities of a bar—some segregated figures preoccupied with their own activities, a bartender pouring from a tap, and a figure sleeping or perhaps passed out on a table in the background—together with the idea of a ceramics studio. The bar is covered with a high viscosity earthy gray goo that resembles something between slip and fuller-bodied clay, and the figures are manipulating blobs of this goo with their hands. Perhaps in order to enact a playful satirical metaphor for an art teacher, Eisenman renders the bartender as unhappy and bored with the task of serving the patrons (pupils), although she also stylistically gives him some of the

child-like lovability of a muppet or similar children's character, which mixes a kind of pleasantness into her characterization and pulls the whole operation of inventing this character away from anything as clear or reductive as the device of satire. There are few basic vessels present in the painting, slippery signifiers that could fit into either a bar or ceramics classroom. These vessels are ambivalently shaped so that they could be interpreted as either containers for drinks or one of the basic vessels that students of ceramics learn to make early in their training. Behind the bartender hangs a portrait that can be read as either be a blob of clay amateurishly shaped into a face or an Expressionist painting.

Although Eisenman's painting is full of representational description, the way that she inventively switches between a variety of types of rendering and seems to move back and forth between investing in description and inviting us to enjoy the feel and movement of the paint, brings another equally, if not more compelling, narrative to life, that of the painter working, thinking, and performing her multiple journeys across the surface. She paints the bartender's apron in thick white paint, then scrapes away the top layer to reveal a much thinner light gray layer underneath where a stained canvas both depicts and literally is a set of stains. She uses the pointed wooden end of the paintbrush (or some similar tool) to scrape something resembling generalized and playfully sloppy pin stripes into the thick wet blue paint on one of the figure's pants. In depicting the goo, her meandering and almost distracted marks both describe a high viscosity substance and simultaneously index someone playing in that same substance. She seems to be happily participating in the activities of her characters alongside of them even as she renders them—a witty conundrum that reinforces the invitation to actively participate in both the material and iconic relationships of the painting. The list of these playfully inventive gestures goes on, and they perform a physical narrative that is a bit like watching the artist's hand perform tiny dance maneuvers across the surface. Paintings like this function much differently than more typical images that direct a viewer to specific points of emphasis. The variety of images and technical approaches in Eisenman's painting in addition to the deliberately disjunctive transitions from one passage to another result in a surface made up of many independently curious parts that each ask for attention for their own reasons (they provide many different kinds of experience). Because many areas of the painting simultaneously ask for attention, paintings like this pass the power to decide where to direct one's attention on to the viewer, instead of relying on predetermined compositional hierarchies that direct the viewer as many other kinds of images do. They encourage a viewer to choose where to

look, what to think about, and when to do each of these, each time she or he looks at the painting, so that viewers can combine different areas of the painting to create new experiences upon each engagement in a way that might relate to the varieties of experiences that the on-demand nature upon which other imagery and narrative devices depend presently as well.

In *Achilles Heel* Eisenman seems to both embrace boredom and assert a more positive complacency. In her images everyone seems to be getting through her or his day without too much excitement, but without any real problem either, and there is everywhere evidence of human presence in ways that oppose the distance that painters like Edward Hopper depict in similar kinds of urban interiors. Even though the interior has been taken over by goo, the people inhabiting it at the moment continue to carry out their activities. No one is panicked. The people in the space are not interacting much, but they are there together and seem to have the kind of ease that suggests that they are comfortably familiar with each other and the context. One gets the sense that there is some positive energy connected to whatever kind of boredom might also be present, or at least that there is a possibility that boredom is the only problem these characters face, which of course suggests that life cannot be all that bad. With the exception of the bartender, figures sit alongside of each other, some with fairly contented expressions, shaping the goo. As all of the parts and activities of this painting move around next to each other, the painting seems gradually to sway back and forth between a kind of subtle negativity and a lazy contentedness. It roams around though signifiers of "real" daily life: service industry existence, leisure time, familiarity, boredom, complacency, and joy in action and making. Through her use of painting activity as performativity, Eisenman pulls the viewer into a silent, but conversational meditation on how we inhabit everyday existence. The painting does not insist on a position or make an argument about its subject though. Instead, it invites the viewer take it in her or his own experiential and interpretive direction. It does not, as historical criticism might, try to create a heightened version of the everyday by taking illusion apart in order to expose its true nature as symptomatic of the spectacle. Rather, it warmly lays complicated depictions and processes together to entice the viewer to activate the range of relationships and characterizations to which it points as possibilities.

James and Eisenman—along with many other contemporary painters—engage the medium of painting with a faith in its ability to function in meaningful ways by bringing ranges of characteristics and activities together into kinds of visual and experiential conversations. Both use their work to talk to painting and to get the

parts of painting to talk to each other and the viewer instead of talking analytically about it. They lay characteristics of painting, its maker, and the viewer beside each other instead of engaging painting and its subjects by trying to dismantle them in an effort to get to some other sort of knowing. The artists here engage by building relationships of moving parts that reflect a belief in the ability of painting to function and interact as a form of direct engagement with any number of issues and concerns. They see painting as a vital platform for engagement.

In collapsing the distinction between author, viewer, subject and object, both painters transform established distinctions between subject and object into a sequence of prepositional relations, where instead of creating an actor to act masterfully toward an object, all the participants in the relationship interact with each other in a kind of evenly weighted exchange. It may be that this fracturing and transforming of dominant critical action into a plurality of actor/receivers that operate beside each other and talk to each other better reflects present social circumstances and has a stronger potential to encourage what we might once have thought of as the best hope for progress. Perhaps, as Rancière and others seem to imply in their complaints against criticality, aggressive actions are incapable of accomplishing more than scenes of destruction.

Conversations about the limits of criticism (regardless of expansive ambition) and the legacy of critical painting (regardless of how clever) both underscore the need for ways of thinking and practicing that move beyond the critical act of taking apart. Sedgwick and Owens have proposed acts of re-orientation instead. For each of them putting things next to each other, in relational and conversational interactions promises more than critique seems to have delivered. Similarly, James and Eisenman (and others like them) trade critical dismantling for careful arrangements of new relationships. Their work models active engagement and expansive adaptive experience in the place of what we previously expected from the urge to take apart.

In suggesting that critique is essentially a question of what knowledge does, Sedgwick underscores observations and experiences that seem to be telling us that simply understanding hidden meanings does not guarantee a better or more equitable state of existence. As both Sedgwick and Owens imply, it may be that the question is not one of objective results of some sort, but one of stronger, more active relationships that foster ongoing proximities and encourage growing awareness of the ever-evolving negotiations required to navigate our changing contexts. And although tendencies such as those described by provisionalism, zombie formalism, and DIY abstraction seem to argue for the apparent inability

of painting to play an active role in how we structure and negotiate our world today, at least some contemporary painting argues that the engagement of painting in meaningful ways continues to be both possible and necessary.

References

Clark, T.J. (1984), *The Painting of Modern Life: Paris in the Art of Manet and His Followers*, Princeton, NJ: Princeton University Press.

Cotter, Holland (2014), "A Career of Toasting Rebellions," *The New York Times*, September 25. Available at: http://www.nytimes.com/2014/09/26/arts/design/a-nicole-eisenman-midcareer-survey-in-philadelphia.html. Accessed January 14, 2016.

Foster, Hal (2012), "Post-Critical," *October* 139: 3–8.

Goldstein, Andrew (2015), "CAM Houston Director Bill Arning on Why the Return of Figuration in Painting Was Inevitable," *ArtSpace.com*, October 13 Available at: http://www.artspace.com/magazine/interviews_features/body-of-art/bill-arning-body-of-art-interview-53186. Accessed January 14, 2016.

Latour, Bruno (2004), "Why Has Critique Run Out of Steam? From Matters of Fact to Matters of Concern," *Critical Inquiry* 30(2): 225–48.

Owens, Craig, Martha Rosler, James Clifford, Boris Groys, Robert Storr, and Michele Wallace (1989), "The Global Issue: A Symposium," *Art in America*. July: 86.

Rancière, Jacques (2004), *The Politics of the Aesthetics*, trans. Gabriel Rockhill, London: Continuum.

Rancière, Jacques (2009), *Aesthetics and Its Discontents*, trans. Steven Cochran, Cambridge: Polity Press.

Relyea, Lane (2015), "DIY Abstraction," *Painter's Table*, Wow-Huh archives. Available at: http://www.painters-table.com/link/wow-huh/diy-abstraction. Accessed October 19, 2016.

Robinson, Walter (2014), "Flipping and the Rise of Zombie Formalism," *ArtSpace.com*. 3 April. Available at: http://www.artspace.com/magazine/contributors/see_here/the_rise_of_zombie_formalism-52184. Accessed January 14, 2016.

Rubinstein, Raphael (2009), "Provisional Painting," *Art in America*, May: 122–35.

Sedgwick, Eve Kosofsky (2003), *Touching Feeling: Affect, Pedagogy, Performativity*, Durham, NC: Duke University Press.

Yau, John (2015), "What Does It Mean To Be a Grown Up Painter?" *Hyperallergic.com*, February 22. Available at: http://hyperallergic.com/184132/what-does-it-mean-to-be-a-grown-up-painter/. Accessed January 14, 2016.

Intimate Bureaucracies: A [Sweetened and Condensed] Manifesto

dj readies [Craig Saper]

Participatory decentralization, a mantra of art and political networks, expresses a peculiarly intimate bureaucratic form. These forms of organization represent a paradoxical mix of artisanal production, mass-distribution techniques, and a belief in the democratizing potential of electronic and mechanical reproduction techniques. Borrowing from mass-culture image banks, these intimate bureaucracies play on forms of publicity common in societies of spectacles and public relations. Intimate bureaucracies have no demands, no singular ideology, nor righteous path.

Intimate bureaucracies monitor the pulse of the society of the spectacle and the corporatized bureaucracies: economics, as in Big Business; culture, as in Museums and Art Markets; mass media, as in Studio Systems and Telecommunication Networks; and politics, as in Big Government. Rather than simply mounting a campaign against big conglomerations of business, government, and culture, these intimate bureaucracies and their works use the forms of corporate bureaucracies for intimate ends. Rather than reach the lowest common denominator, they seek to construct what those in the business world would call niche marketing to specific, narrowly defined demographics. Ironically, the model these artists developed has now become the new mantra of businesses interested in utilizing the World Wide Web and the Internet, as these technologies allow for very specific niche marketing. Intimate bureaucracies emulate, and resist, the very systems of the new business model used in Internet marketing.

The apparent oxymoron, intimate bureaucracies, is a set of strategically subversive maneuvers and also the very basis for the new productive mythology surrounding the World Wide Web. Electronic networks combine a bureaucracy with its codes, passwords, links, and so on with niche marketing, intimate personal contacts, and the like, creating a hybrid situation or performance. It's a

mix of cold impersonal systems and intimate social connections; it scales up whispering down the lane games. The earlier projects of Anna Freud Banana, Guy Bleus, Randall Packer, Geof Huth, and many others all used the trappings of bureaucracies, like canceling stamps, systems of organizing information, and alternative publication networks, to create similar hybrid performances. The Madison, Wisconsin artists mIEKAL aND & Lyx Ish even started a Dreamtime Village (www.dreamtimevillage.org). It is not merely business or governmental performance masquerading as performance art. It is not even performance art mocking business and government procedures, but the emergence of an alternative politics.

Early in his career, Roland Barthes used the image of a car trip through history to describe how mythology works. When a driver looks out of a car's windshield, she sees the landscape as full and present, and, at the same time, she sees the windshield. Myths function as windows framing and mediating our view of the world around us. The slightest change in focus allows the driver to notice the window. A broken window makes the myth too obvious, and we seek new myths. To focus only on the window would cause the car to crash. Barthes suggests a third option besides naïveté or cynical nihilism. Focusing on window and view separately goes against myth's dynamic of both window and scenery taken in together. Barthes explains that when he counters this dynamic, he morphs from a reader to that of mythologist. The mythologist takes advantage of the vacillation between noticing the windowpane and seeing the landscape to create what he calls an artificial mythology. This counter-myth of "naïveté looked at" neither replaces the window nor transcends it to direct access (Barthes 1972: 136). It simply changes the driver's focus.

Barthes does not tell us much more about this phrase, nor does he allude to it ever again in his other works throughout his career. From this little detail, this little thrown-away gem—or as the Spanish refer to a diamond in a lemon, a *sapates*—springs the possibility of a methodology for the study of cultural and media invention.

That Barthes chose a drive in a car as the model for ideology seems particularly fitting for citizens of the United States because the American Dream depends so much on the mobility of the family car, the destruction of downtown city neighborhoods, and the disruption of walkable communities. Even e-mail and the Internet have failed to dent the car's hold. Bicycles, important means of transportation in many economies remain a recreational vehicle or, in congested urban areas, a way for speedy messengers to get around the car traffic. These

daring bike-messengers are the exception that proves the rule: all of our cultural myths seem to circulate around the car, and quite literally. The car is not just an apt metaphor for mythologies; it is the epitome of American mythologies. The familiarity of the car makes it not only Barthes's vehicle for the metaphor to describe the interactions of myth, artificial myth, and material history, but also an image used in popular culture to describe progress through history.

Intimate bureaucracies may exist on a different scale than the large systems that determine ideologies. One view of the conflict involving the Occupy Wall Street movement (OWS) might suggest a conflict against the large-ideological fossil fuel-burning car (and the socio-political industry) as well as the rapid transport system's corollaries in the instant flows of capital among investment banks. The endless rapid cartel system (pun intended) involves a series of objectionable results, including the flows of capital away from slowly declining red-lined areas.

In response to the OWS protests, the society of the instant produces 24/7 news flashes, rapid summaries and counter-arguments, all clamoring for an instantly available definitive set of "demands" or a "program." The system does not merely demand the attention of the viewers, as in the society of the spectacle, but now also demands instant response. OWS's most profound politics may have less to do with the injustices of the current tax codes, wealth disparity, or even economic collapse, and more to do with its systems and practices of organization and communication.

My book *Networked Art* uses the neologism 'sociopoetic' to describe how artists performed, manipulated, and scored (as in musical scores) social situations (Saper 2001). These social situations function as part of an artwork. The networking over, and on, boundaries (national, geographic, political, technological, organizational, cultural, and aesthetic) became, in these works, a canvas. In Randall Packer's "United States Department of Art & Technology," his invented department, complete with signage, photographs of a governmental building with the department's name engraved in stone over the doors, logos, memos, and other trappings of the USDA&T (www.usdat.us), opens on to many other questions. Who owns the right to use the term United States? Should the United States have a cabinet-level department that examines the key component (technology) of our future? How would such a department function? Who determines what departments we need? Why not have a USDA&T? What other departments do we need? Perhaps a US Department of Intimate Bureaucracies (USDIB)?

The term sociopoetic describes the use of social situations or social networks as a canvas. The term sociopoetic does not define my methodology. Instead, the term describes the works studied here. My theoretical approach studies how situations function poetically (or sociopoetically). Although I do present contextual information (the history, the participants, the politics, and the like) as entangled in the artwork, my focus remains on how these works manipulate and score situations. In many of the artworks I have studied previously, the artists created "intimate bureaucracies" that "sought to project intimacy onto otherwise impersonal systems" (Saper 2001: 24). One might argue that this project seeks to do the same for social action theory. By highlighting the existing aesthetic relationships as well as performance settings, distribution systems, measurement machinery, or the social apparatus, my project does not demythologize, but displaces the frame to focus on the sociopoetic dimension. Scholars usually describe that dimension as a mechanism of social control and manipulation. Whether one agrees or disagrees with the justification or results of that social apparatus, it is commonly considered only in social scientific terms rather than as a poetic and artistic practice or a social poetry. Bureaucracy, as a mode of governmental or corporate organization, depends on officials rather than elected representatives or charismatic leaders. It usually connotes a cold, faceless, and excessively complicated system of administration. It epitomizes the distance between a governing body's procedures and the needs and desires of its citizens, subjects, or customers. Of course, much of the term's descriptive power depends on its connotations rather than on its specific meaning and definitions. It also suggests a large-scale mechanism familiar to anyone who has lived through modernity in the twentieth century. In tragic situations, it has Kafkaesque overtones and the markings of fascism—what Hannah Arendt called the "banality of evil." In happier situations, it appears in the administration of postal systems, the protocols of the Internet, and even IKEA's distribution systems. It never finds itself describing radical forms of social organization.

Intimacy, the close familiarity of friendship or love, by definition depends on a small-scale system of communication. Its warmth, face-to-face contact, and fleeting impact has often been the subject of art and literature. It usually appears in administration situations as either an insincere ornamentation of a political campaign ("pressing the flesh" or kissing babies) or as inappropriate office behavior (affairs, gossip, etc.), but rarely as the center of a political system. The "small is beautiful" movement did suggest the possibility of an intimacy in politics, but did not provide a blueprint for how to scale the system to the size of a government.

The pseudonymously written *bolo'bolo*, published by Semiotext(e) in their conspiratorial-sounding Foreign Agents series, describes the practical steps toward a utopian international social system (p.m. 1985). The author known only as "p.m." (at least before post-publication interviews revealed the author's identity) explains how small groups gathering outside the functions of an economy will form the foundation of this new social system. Instead of impersonal production and consumption, in which people's work, for an abstract economy, defines the social system, people join together only in groups of common enthusiasms. No group, or "bolo," forces anyone to stay, and individuals move from group to group depending on their current enthusiasm. The examples of common enthusiasms listed by p.m. include a very wide, and endlessly elastic, range of interests: garli-bolo, blue-bolo, coca-bolo, no-bolo, retro-bolo, les-bolo, etc.

The bolo depends on limiting social organizations to groups of between five hundred and one thousand persons so that they do not become dependent on higher authorities. In traditional governments or other organizations, a separate larger administrative group is a "structurally necessitated bureaucracy" (p.m. 2004). In that governing system, any administrative and governing body probably works to assure the citizens that they can meet the specific group's needs. Functioning government seeks to serve the needs of its citizens. The bolos seek to avoid these well-meaning "control organs" that become "susceptible to corruption," and require constant vigilance and work for an abstract labor market. p.m. also argues that bolos do not use "the large communes of the 1970s" as models. Instead, bolos function as "civil member organizations" in which you can "bring your wealth in with you" and "take it out with you when you leave. They are not communes" (p.m. 2004).

For the purposes of this manifesto, the current role of technology in society suggests that intimate networks may have unwittingly initiated a reconfiguration of sociopolitical systems that looks much like a bolo. Although p.m. insists that bolo'bolo will "not be an electronic civilization" because "computers are typical for centralized, depersonalized systems," s/he goes on to explain that "the existing material and hardware could also be used by the bolos for certain purposes" because "networks are energy-efficient and permit a better horizontal contact between users than other media" (p.m. 1985: 124). Written before the implications of online communication were at all apparent, p.m. thinks of a network "connected with regional or planetary processors or data-banks" (p.m. 1985: 123). Once the transportation system slows and centralized systems of control fail, electronic networks will allow for communication to continue. In a

description that could easily apply to social media, p.m. explains the impact of this type of network:

> Such a network of horizontal communication could be an ideal complement to self-sufficiency. Independence doesn't have to become synonymous with isolation. For the bolos there's little risk of becoming dependent upon technology and specialists—they can always fall back on their own expertise and personal contacts. (Without bolos and relative autarky, computer technology is just a means of control by the centralized machine.)
>
> p.m. 1985: 125

These radical systems already exist in OWS and in online communities and interest groups; and, just as p.m. suspected, they would begin without regard to economics, but rather in terms of shared enthusiasms. The impact, though, transcends an art project or a collective activity. It has become the foundation of much more broad platforms for cultural invention and social action.

Intimate bureaucracies, and other distributed weaves of networks online, unwittingly move toward appreciating even the most powerful government's lack of power as a threat, rather than as a revolutionary's ultimate dream-come-true. Lack of power (or power to attack only), rather than the ability to defend, preserve, and protect, may define contemporary culture's greatest threat. If, as the Fascists say, the trains always ran on time in Mussolini's Italy, then, one might answer, they ran only for the Fascists. In the contemporary version of that tautology, the escape plans and contingencies worked in the flooding of New Orleans by Hurricane Katrina, for example, but only for those that escaped. Intimate networks respond by setting up online networks, and even the most frivolous enthusiasms, like knitting or craft sites, prepare the participants.

Media studies, as a discipline, seeks to demonstrate how media forms and messages position, manipulate, and delude subjects. The networked sociopoetic experiments do not celebrate this absence as some kind of resistance; rather, they suggest an alternative to exposés, de-mythologies, and revelations. Those alternatives do not replace readings that find effaced politics lurking behind simple presentations, but focus instead on incompetence masquerading as power and authority, rather than on ideological power masquerading as entertainment, culture, and media. Intimate networks offer connectedness and shared responsibility in the face of a lack of power. They often explicitly discuss their collective efforts as "underground" alternatives to corporate power.

The aesthetics of connectedness, the focus on concrete enthusiasms, the links and movement among the enthusiasts' groups, and the willing manipulation of desires (not for productive economic ends) make the networked art experiments into a model for, and demonstration of, cultural invention and social action. The aesthetics, or sociopoetics, of tribe-making activities has subtle and very specific qualities. Looking only at the quantitative, or explicit, will miss appreciating the torque, frisson, and mood of those links. Although the databases of these hyper-linked tribal forms are limited and relatively small, and the actual links usually number less than one thousand at any given time, the cognitive map—the imagined—unfolds as an infinity of possibilities. Preparing the mind for that type of imagination is an ongoing project.

> *Some people think they might weave themselves in the rug and they put that line in so they can get out.*
>
> anonymous Navajo weaver

> *... spoof their communications.*
>
> Gen. McCaffery (ret.)

> *The parodic principle of deconstruction is to hoist the target on its own petard in a kind of mime of the host terminology.*
>
> Greg Ulmer

The use of the oxymoronic phrase, intimate bureaucracy, corrects the residue of Romanticism found in the bolo'bolo manifesto. It does demand a paradoxical epistemology for use in the usually binary forms of social organization and politics (a mix of the trappings of faceless bureaucracies and systems of organizations with intimate artisanal DIY production). We cannot merely think about the paradox of the social organization that allows for the trappings of bureaucracy and the intimate pleasures of the inside joke. We must think paradoxically about the situation. The distinction is crucial. If we do not understand the difference between a positivism of paradoxes and paradoxical thinking, then we will fall prey to formalism and turn sociopoetic theory into an empirical method for only reading texts.

This manifesto investigates how to produce counter- or artificial communication. As soon as artificial, or infidel, borrowing starts, parody appears. After the mid-1960s, critical theory gained a new importance for a diverse audience of students and scholars. Among scholars in the humanities the

conglomeration of linguistics, psychoanalysis, sociology, and philosophy became known simply as "theory." Something about the spectacle and drama of theory began attracting not just attention but love and repulsion. These theories examined how twentieth-century spectacles reinforced social control through a system of self-surveillance. Scholarship on spectacle emerged as an interdisciplinary field after the publication of Guy Debord's *Society of the Spectacle* in 1967.

Many scholars and critics, before Debord, had criticized mass media's hegemonic influence over the modern citizenry. Debord's achievement was to coin phrases for his provocative title and many other sound bites and slogans suitable for graffiti during the 1968 student rebellions in France. He produced a theory not only about how the world of mass media exerts social control, but also about how to intervene in the society of the spectacle using strategies similar to graffiti. He produced a manual on producing counter-spectacles opposed to the usually one-way state or corporate sanctioned spectacles. His phrases and slogans (e.g., "In societies where modern conditions of production prevail, all of life presents itself as an immense accumulation of spectacles" and "Everything that was directly lived has moved away into a representation") soon became vulgarized in media reports just as he would implicitly predict in his work. In that sense he initiated the spectacularization of critical analysis. That strategic side of his Situationist politics remained dormant in critical theory until the last decade of the twentieth century. Before that shift occurred, media theorists shared only his suspicions and distrust of media spectacles.

Debord's severe critical apprehension of mass media's spectacles reached a pinnacle in the work of contemporary film and cultural theorists writing from the late 1960s to the late 1980s. In the 1990s, as the century came to a close, those interested in code systems began more explicitly employing the mechanisms of spectacle. They combined Pop artists' attitudes toward mass media and popular culture with the Situationists' pragmatic approach (detourned media communications that twisted the intended meaning of advertisements, TV programs, and news reports).

At least since the 1960s, the two scholarly approaches, critical apprehension versus spectacularization as a theoretical strategy, overlapped and intertwined. The theories that sought to unmask the spectacle created their own spectacular controversies and resulted in theorists-as-stars (Lacan, Althusser, Mulvey, Metz, to name just a few). By the close of the twentieth century, scholars began investigating how to use strategies borrowed from popular culture, like narrative, in their analyses of media codes. By the mid-1980s, theory began examining problems and

solutions and also formed new disciplines, like "cultural studies." Theorists did not merely want to extend ideology-criticism's scope of explanation beyond cinema studies. They wanted to find a more stable and powerful institutional home in American universities. Film scholars often legitimated their discipline by reference to the theoretical foundation of their criticism. In doing so, they inadvertently made the value of cinema studies depend on the relevance of foundational theories (for example, Lacanian psychoanalysis). Once scholars re-evaluated and criticized how theorists *applied* psychoanalysis and poststructuralism, some scholars merely abandoned any effort to theorize film, while others sought to patch up the obvious problems. Film studies, threatened institutionally by its offspring, cultural and television studies, and imperiled theoretically by widespread dissatisfaction with its methodologies, also had to contend with conservative attacks on its supposed lack of importance for college students.

For media and cultural theorists themselves, the productive enthusiasm surrounding ideology-criticism had faded by the early 1990s. Indeed, as the right-wing politicians began their dated attacks on leftist cultural studies, many media scholars had already moved on to other theoretical approaches. Media theorists began writing about the cracks in the edifice of ideology criticism. In spite of the corrections, vulgarized versions of media theory spread throughout the humanities, into museums and public schools, and thence into the angry minds of conservative critics. The theory had become conventionalized to the point of stultifying cinema studies. The situation was so predictable that an influential cultural critic half-jokingly fantasized that a *computer* in some publisher's office was covertly responsible for churning out these formulaic articles and books on contemporary media and culture. One could easily guess the outcome of a cine-semiotic analysis: "the representations of gender, race, or class are naturalized by an invisible style and conventional narratives." The problem was not that critical speculations increasingly lacked progressive political positions, but that their predictability muted their message. Theory had finally lived up to its worst critics' claims: it was boring—boring in the sense that it neither highlighted the otherwise unnoticed, nor allowed for new connections. It was a cliché.

Even in this apparently moribund state, media theories have to answer ever-increasing demands to explain a wider set of cultural-historical phenomena, including the events of September 11th. This situation created a pressing need for work that continued to highlight the pitfalls of previous theories and applications, and many Parisian theories imported into American media studies

had as much authenticity and accuracy in this state of affairs as a Pepperidge Farm croissant. David Rodowick, Joan Copjec, Slavoj Žižek, Mary Ann Doane and others would take film theory to task for its inaccurate (and misleading) use of Parisian theories (Rodowick 1988, Copjec 1989, Žižek 1991, Doane 1991). In the 1970s and 1980s, film theorists sought to analyze the relation between cinema and ideology. Many film scholars initially greeted what was known as "apparatus theory" (the ideological analysis of the cinematic apparatus—both the literal and figurative positioning of audience members with the techniques, themes, styles, forms, and machines used to make and project movies) with productive enthusiasm. Times have changed. Studying contemporary film theory as a way to understand media-cultural sociopoetics may look to some like flogging a dead horse. There is increasing agreement about the inadequacies of contemporary media theory. Even Laura Mulvey, discussing the future of cinema studies, writes that the great challenge for film theorists is "to move to something new, from creative confrontation to creativity" (Mulvey 1989: 162).

The best of the social scientific studies of organizational structures do offer many important insights on electronic networks, but they (by definition) avoid the sociopoetic elements or aesthetics involved in networking as a practice (see Boetcher, Duggan and White 2002, Matei and Ball-Rokeach 2002, Wilson 2002, and Gibbs et al. 2004,). How does an intimate bureaucracy create the impression of intense productivity and (almost) conspiratorial connections among an elastic group of participants (even including those just visiting)? How do these works manipulate participants to celebrate a type of group cohesion without the rules, restrictions, or enforced (or at least, fixed) identities required in cults, cells, cadres, and corporations?

The political practice of intimate bureaucracies, such as the OWS movement, both seduced and repulsed by centralized-planned cultural production as well as the exclusive coding of knowledge and practical skills as specialized and professional, seeks to build a collaborative exchange economy with a manipulative twist.

Call to (f)action

1. You form contingent, mobile, and other distributed weaves of networks as forms of autonomous intimate bureaucracies.

2. You answer and protest any evacuation of centralized governments' role and ability to defend, preserve, and protect. You spring to action whenever, wherever, and in whatever form state failure occurs, whether in its inability to respond to absolutely particular desires or in its inability to protect against its own brutal militarized police-actions and murderous demands to "tow the line."

3. You challenge incompetence masquerading as power, authority, and accountability by offering connectedness and shared autonomous responsibility to your networks' needs, desires, and happiness. You gotta live!

4. You celebrate underground alternatives to standardized solutions.

5. You use inside jokes and intimate poetics as a serious model for social organization.

6. You compose.

7. You embrace enthusiasms, links, movements, and the willing manipulation of desires (not for productive economic ends) to allow for tribe-making activities.

8. You notice the torque, *frisson*, and mood of those links and enthusiasms to prepare the mind for that type of imagination and intelligence.

References

Barthes, Roland (1972), *Mythologies*, trans. Annette Lavers, New York: Farrar, Straus and Giroux.

Boetcher, Sue, Heather Duggan, and Nancy White (2002), "What Is a Virtual Community and Why Would You Ever Need One?" *Full Circle Associates*. Available at: http://www.full circ.com/comm unitywhatwhy.htm. Accessed October 6, 2016.

Copjec, Joan (1989), "The Orthopsychic Subject: Film Theory and the Reception of Lacan," *October* 49: 1–28.

Debord, Guy ([1967] 1995), *The Society of the Spectacle*, trans. Donald Nicholson-Smith, New York: Zone Books.

Doane, Mary Ann (1991), *Femmes Fatales: Feminism, Film Theory, Psychoanalysis*, New York: Routledge.

Gibbs, Jennifer L., Sandra J. Ball-Rokeach, Joo Jung, Yong-Chan Kim, and Jack Linchuan Qiu. (2004), "The Globalization of Everyday Life: Visions and Reality," in *Technological Visions: The Hopes and Fears that Shape New Technologies*, ed. Marita Sturken, Douglas Thomas, and Sandra J. Ball-Rokeach, Philadelphia, PA: Temple University Press: 339–58.

Matei, S and S.J. Ball-Rokeach (2002), "Belonging Across Geographic and Internet Spaces: Ethnic Area Variations," in *The Internet in Everyday Life*, ed. Barry Wellman and Caroline Haythornthwaite, Oxford: Blackwell Publishing, pp. 404–30.

Mulvey, Laura (1989), *Visual and Other Pleasures*. Bloomington, IN: University of Indiana Press.

p.m. [pseudonym] (1985), "Bolo'bolo," *Foreign Agents Series*, ed. Jim Fleming and Sylvere Lotringer. Cambridge, MA: Semiotext(e)/MIT Press.

p.m. [pseudonym] (2004), "bolo'bolo" [transcription of a video], trans. Lisa Rosenblatt, Available at: republicart.net: http://www.republicart.net/disc/aeas/pm01_en.htm. Accessed October 6, 2016.

Rodowick, David (1988), *The Crisis of Political Modernism: Criticism and Ideology in Contemporary Film Theory*, Urbana, IL: University of Illinois Press.

Saper, Craig J. (2001), *Networked Art*, Minneapolis, MN: University of Minnesota Press, 2001.

Wilson, M. (2002), "Does a Networked Society Foster Participatory Democracy, or, Commitment to Place-Based Community Still a Necessity for Civic Engagement?" in *Citizenship and Participation in the Information Age*, ed. Manjunath Pendakur and Roma M. Harris, Aurora, ON: Garamond Press, pp. 372–87.

Žižek, Slavoj (1991), *Looking Awry: An Introduction to Jacques Lacan Through Popular Culture*, Cambridge, MA: MIT Press.

Part Three

Instruction

On Performing the Critical

Billie Lee

Critique must also be seen as a search for alternative forms of living, different from the martial dominance, clerical and patriarchal order, and as a battle for education, as a battle over language, as a battle for broader knowledge production.

Gerald Raunig, "What is Critique?" (Raunig 2008)

The "critical" has become an unexceptional adjective in the field of art.[1] In today's neoliberal capitalist environment where everything is at risk of becoming absorbed as an image, an attitude, or a marketable style, critique is no less innocent. One goes to art school to become more "critical," to acquire "critical" skills, and to develop a more "critical" practice. What is heralded by the "critical"? How does something qualify as "critical"? Who gets to practice it, and in what locations? What does it have to do with the *other* "critical" as in urgent, dire, and precarious—*a critical condition, a critical matter, a critical time*?[2]

Choosing art as a vocation is a contested negotiation of various intersecting factors that include race, class, gender, culture, family, support systems, and mental health. Poet and activist Audre Lorde spoke presciently about the stakes of creative labor not only for the poor and disenfranchised, but in the age of late capitalism. Lorde connects the material demands of art and survival and the unacknowledged class and race differences that separate those who can and cannot labor as "artists" with the larger societal structures that delineate who gets to engage in "rigorous" or "serious" art forms. Poetry is the "voice of the poor, working class, and Colored women" because it is the most economical of art forms in time, energy, and material; it can be executed between shifts, on napkins, and while working exhausting hours (Lorde 1984: 116). In the end, she asks: "In this day of inflated prices of material, who are our sculptors, our painters, our photographers?" (Lorde 1984: 116). In *this* day

of inflated prices, who gets to go to art school and what does art school teach?

With the recent proliferation of masters and doctoral degrees in the fine arts, critique as a defining pedagogical module has become a naturalized mode of transaction and performance. The production of more art degrees and artists has resulted in an impoverished notion of critique that has failed to uphold a self-critical stance towards a radical repositioning of its own inequalities within. Unfortunately, art schools neither adequately address nor sufficiently prepare students for the asymmetrical relations of power and social hierarchies of the art industry, let alone of the art school itself. With more artists being produced as subjects of and through critique than ever before, we might ask what is being replicated in the name of critique.

This chapter proposes that critique must be in reference to a specific object of critique that is against normative, hegemonic, and oppressive value systems. For Judith Butler, critique is "always a critique *of* some instituted practice, discourse, episteme, institution, and it loses its character the moment in which it is abstracted from its operation and made to stand alone as a purely generalized practice" (Butler 2001). In this regard, this essay is based on the premise that we live in a time of multiple critical conditions and art education is an important site of struggle. In what is to follow, I reflect on what I see is critical for art and art education in this current moment and how we might understand and/or recognize the forms of critique that can materialize from fraught locations. I draw from my own experiences both as a student and as an educator, as well as from recent events that support my impressions. In doing so, I hope to make some gestures towards a reengagement with critique in its productive capacity.

Critical pedagogies: Art, education, and subjectivity

A semester into my MFA program at Yale University, I began to feel a sense of disenchantment.[3] I felt like my program, and other elite spaces of the art world, had been drained of their potential to be rich spaces of dialogue and exchange. Although these were rarefied spaces where those invested in the effusive project of contemporary art gathered to participate in and witness the making and unmaking of its meanings, I felt a disconnect. This demoralized sense was shared amongst many of my peers although it wasn't explicitly talked about. This disconnect was evident in group critiques, or "crits" for short, where our shared

language for working through issues of political and cultural difference were not as developed as our language for discussing formalism. The different frames of reference from with which we look and engage were rarely questioned. Discussions around artwork that dealt with more culturally specific contexts were not met with the same level of nuance and sophistication to take the conversation into productive directions. Also, the more challenging and controversial content too frequently went unquestioned or was left hanging at the ends of conversations. What were the conditions for these misfires and senses of disconnect?

Although the art school is often a site of critique—producing critical artists who challenge normative ways of seeing and making—it has historically been blind and recalcitrant to the ways it forecloses opportunities for critical engagement aligned with forms of liberatory antiracist pedagogy. Despite the success of artists of color in the last few decades, the dominant art world (in which the art school is undeniably a part) is still a scene of whiteness and white privilege. Pulitzer Prize-winning author Junot Díaz described his MFA experience as a traumatic space of white privilege for persons of color.[4] He reflects that the workshops silenced writers of color who wrote from their experiences and accused them of focusing too much on race. Díaz writes: "In my workshop we never explored our racial identities or how they impacted our writing ... we never talked about race except on the rare occasion when someone wanted to argue that 'race discussions' were exactly the discussion a serious writer should *not* be having" (Díaz 2014). In response, writer Matthew Salesses recounts: "For a writer of color, the defense of one's work quickly becomes a defense of the self" (Salesses 2014). In this way, these spaces meant for feedback function as unsafe spaces for many students whose race, ethnicity, class, gender, or sexual preference have been historically excluded from dominant frames of analysis. The types of questions asked, the way particular signifiers are read, what is said and not said—the silences or lack of comments—are correlative to forms of oppression and marking the "other."

As an artist of color working with themes of race, subjectivity, and diaspora, I often felt that I had to avoid all references to race or identity for a white audience allergic to them. I often resorted to speaking about my work more abstractly and formally to avoid the confrontation of a racist response. In turn, this impacted the kinds of discussions that took place around my work and the feedback I received. Ultimately, these self-censoring impulses were not helpful for my own growth or for connecting with others about the underlying political issues around our work. Coco Fusco, a visiting critic at Yale during my time, has long stood as a much needed contrarian voice. She has pointed out that students who

refer to identity politics in their work "would either be socially excluded by peers, reminded that identity politics are 'over,' or admonished by mentors for not realizing that such concerns fall outside the boundaries of the aesthetic appreciation" (Fusco 2014). As she has put it, "the message being driven home [is] that for artists of color to succeed" they have to "avoid talking about racial politics and concede that their presence at the school [is] sufficient evidence of a post-racial art world." In order to have the conversations that I found missing in my program, I sought out visiting critics like Fusco for support.[5]

To be clear, this essay is not about assessing debates on identity politics. Rather, I am interested in questioning the ways that the management of race and subjectivity go unchecked in spaces relegated for critical discourse. "Crits" and workshops, the staples of fine arts and writing programs, are part of larger sociopolitical arenas that regulate whose experiences are made legible and illegible. They manage and reproduce what can be said, heard, and made intelligible as acceptable discourses within the regimes of the avant-garde. In *Feminism Without Borders: Decolonizing Theory, Practicing Solidarity,* Chandra Talpade Mohanty argues that teachers and students need to "develop a critical analysis of how experience itself is named, constructed, and legitimated in the academy" (Mohanty 2003: 204). "The very act of knowing is related to the power of self-definition" (Mohanty 2003: 195). For historically marginalized peoples, their very location in the academy or the art world is about realizing a space of opposition alongside the dominant episteme that misrecognizes them. These struggles are not new, but are grounded in the civil rights and Third World liberation movements of the 1960s that led to the formation of women's, black, and ethnic studies departments where new critical knowledges were given space to manifest. Yet, since the backlash against identity politics and multiculturalism in the1980s, these struggles have become increasingly delegitimized through uncritical cultural relativist and post-racial viewpoints.

In this vein, it is not uncommon in studio "crits" and elsewhere for someone to insist that an artwork is not racist because it was not intended as such. More often than not, racist or sexist statements by white artists are perceived to be socially acceptable. While artists of color are admonished for working with notions of race, white artists who deal with race do not undergo the same scrutiny. For example, when artist Howardena Pindell reported allegations of racism in art institutions to the Volunteer Lawyers for the Arts in 1987 she was told, "artists are independent contractors and have no right under Title 7. You cannot prove racism when it comes to 'artistic choice'" (Pindell 1988: 158).

Moreover, white artists typically view confrontations of racism as "censorship" or "political correctness," as was the case with artist Donald Newman whose 1979 exhibition *Nigger Drawings* at Artists Space in New York City garnered much protest the same year. Pindell proclaims, "They have their First Amendment right to express their racism. (We did not, on the other hand, have the First Amendment right to express our outrage)...We should encourage the upcoming generation not to turn away from the visual arts because so many doors are now closed" (Pindell 1988: 161).[6]

In ways that recall the reaction to Newman's exhibition at Artists Space, nearly thirty years later at the 2014 Whitney Biennial, Joe Scanlan appropriated the identity of an African-American female artist in a project that resulted in the protest and withdrawal by the collective HowDoYouSayYaminAfrican, also a part of that year's exhibit.[7] In response, Fusco writes:

> Yams Collective's rupture with the Whitney is symptomatic of the lack of other discursive means within studio art practice for addressing social issues that implicate the institutions that sustain the practice of art in broader practices of exploitation and oppression ... Unfortunately, artists are often at a disadvantage when it comes to debating the cultural politics and historical legacies that inform the gestures they make—because they've been educated in the formalist hothouse of the art school crit.

Fusco locates the deficiency of critical discourse in art school training. As she makes known, the "formalist hothouse" does not adequately teach artists to understand or take active responsibility for the cultural and social implications of their work.

Indeed, the art world has yet to fully address the ghettoization of race in its educational and exhibition spaces as well as the ways in which art schools function as key sites where these discourses are put into practice. Dominant frameworks of critique work to privilege stable Euro-American heteronormative cultural subjectivity and aesthetics, while simultaneously displacing and misrepresenting those that are other. Cultural theorist Lisa Lowe has expounded that aesthetics works as a type of subject formation that is codified and organized through material histories and processes of racialization (Lowe 1996). Aesthetics is a conduit for the various registers on which political agency can be sublimated or reconstituted for racialized subjects in a given moment. In this way, she has insisted that we must acknowledge the "epistemological or evaluative boundaries" on which aesthetics are interpreted and regulated (Lowe 1996: 157). Upholding

critique entails questioning whose agency is enacted or constituted by the critical frameworks at play and what modes of feeling/being/doing fall outside of the margins.

As an educator, I have come to see that these issues are not only specific to dominant art world spaces. At my current institution, the University of Hawaiʻi at Mānoa, the university is a particularly contested site of knowledge and cultural production with ongoing legacies of settler colonialism, as is on the mainland. For students of Native Hawaiian, Asian, Pacific Islander, European, and mixed ancestry who are interested in exploring cultural issues specific to Hawaiʻi and the Pacific, having supportive and knowledgeable faculty who can speak to the specificity of this location *is critical* for a counterhegemonic and decolonial education. Students who examine Indigenous identities repeatedly state that they do not feel safe sharing their work with the mostly haole (Caucasian) faculty. One of the students in my art theory seminar at the University of Hawaiʻi at Mānoa commented: "I haven't found a single Hawaiian faculty in the art department . . . lots of white faculty teaching art to brown and yellow students." In her examination of Eurocentric art education in Hawaiʻi , visual studies scholar Karen Kosasa writes: "Art students are educated to misrecognize these very spaces and their visual representation as democratic terrains and to associate them with freedom of speech, equality of opportunity, and the sites of almost unlimited artistic creativity" (Kosasa 1998: 47).

Reflecting back to my own MFA education, by the last year of my program, I had come to see the art school as a failed site—not only of possibility, but also of solidarity among artists. This was also during the global economic crisis that illuminated the precarious material conditions of many lives, particularly devastating for marginalized communities already living in conditions of precarity. The lack of social engagement between the students and the school in a time of crisis tacitly reinforced the notion that all of this—the lack of diversity, the economic crisis, the stratified art world—was a problem of individuals. It was not the responsibility of the institution to *actively* confront and support the students in transforming these matters to look towards a more equitable future. If one of the most well-endowed universities in the United States could not provide a space for artists to imagine a more sustainable and ethical practice, the future of art was not here nor was it in the dominant spaces of art. Nearing graduation, the chair of the department held a meeting for the graduating class to see if we had any questions or concerns as we were getting ready for post-MFA life amidst the economic crisis. Although the gesture was welcomed by the

twenty students in the room, hardly anyone spoke or asked questions. This was not because no one had questions or concerns, but because we had not spent the last two years of our time together developing the language or safe spaces to be able to have difficult conversations such as this one. We had failed each other as well.

Graduating with my MFA during a period of global economic crisis, I was at a loss for what I had in fact earned through this degree. What this experience had crystallized for me however was that I was no longer invested in an (art) world that could not seriously engage in the deep intersectional commitment that artists like Lorde had exemplified for us in decades past. These matters are all the more pressing today. In an era of debt, uncertain job markets, uncontrolled gun violence, police brutality, and global crises, for artists to be able to have difficult conversations across difference is crucial for building coalitions towards a different kind of (art) world.

Reengaging critique

"Let's be clear about one thing. This is not an empty academic exercise. This is real. And it has everything to do with you."

Adrian Piper, *Cornered* (1988)

A reengagement with critique in artistic practice must question the constitutive violence of dominant histories and practices in the spaces of art and art education in order for any vision of social transformation to materialize. "The primary task of critique," according to Butler, "will not be to evaluate whether its objects— social conditions, practices, forms of knowledge, power and discourse—are good or bad, valued highly or demeaned, but to bring into relief the very framework of evaluation itself." A deployment of Western art training demands a serious consideration of its pedagogical implications and what it ostensibly renders normative. We need to draw attention to what is left out of dominant pedagogical frames so that we can engage with power, privilege, and agency in all of its elusive and complicit forms.

For art schools to engage in an ethical and critical praxis, they need to redefine the project of critique in relation to its situated communities, not displace it. This entails a retooling of Eurocentric critical paradigms with decolonial, feminist, queer, and antiracist frameworks that enable alternative forms of participation

in the critique of oppressive and normative practices. Critique is a practice guided by a desire to feel and know why these practices matter, as well as to acknowledge that these are matters of concern for all of us. These reflections on the state of art education today reaffirm that to question the critical efficacy of art education at any level, one must consider the vectors of power not only in society at large, but also within the disciplinary structures that inform how artists learn to become artists. It is a practice that, as Gerald Raunig says, must be "in search for alternative forms of living" within and through the embattled sites of education, language, and knowledge production. It is a process of interrogating the limitations and assumptions of normative critical paradigms shaped by historical and social forces in order to imagine new forms of the social. We all have a part to play in performing and transforming the critical.

To be sure, the reengagement with critique being outlined here cannot be achieved through the mere presence of marginalized bodies or through the recognition of "difference." A reengagement with critique that I am proposing takes seriously the historical, ideological, and material effects of Euro-American aesthetic and pedagogical practices and its privileges. Therefore, what some may propose as a post-critical paradigm risks further obscuring of power and hierarchies of these practices. The professionalization of art poses greater dangers for critical art education as it puts pressure on art schools to produce gallery-ready artists rather than socially responsible artist-citizens. We must work against art schools as signifiers of empty cultural capital and pathways for upward mobility and instead, work towards a counterhegemonic humanities-centered education.

The transformation of critique is an embodied practice of recognizing our own complicity in systems of oppression and power. Thus, cultivating discourses of opposition are important to linking what happens in the academy to spaces elsewhere in order to work towards broad-based political organization and consciousness raising. These modes of critique are alive in current day oppositional movements such as #BlackLivesMatter, student race protests on campuses of the University of Missouri, Yale, and others, as well as Indigenous solidarity movements. As such, critique, as defined in this essay, calls for a renewed insistence on oppositional analytic and cultural spaces in contemporary art. This not only requires adjusting pedagogical priorities, but shifting how we engage with issues of race in spaces of private and public culture as well as through our knowledge production. Only then might the critical be performed in ways that shape new coalitions across difference and color lines.

Notes

1 Special thanks to Karen Kosasa, Jonna Eagle, and colleagues near and far for their thoughtful and incisive comments on earlier drafts of this chapter.
2 I particularly gesture to the #BlackLivesMatter movement and the reported acts of racialized violence that had reached critical conditions during the time I was writing this essay.
3 I draw on my experiences in the Yale painting department from 2007 to 2009.
4 Díaz further elaborates that not much has changed since his MFA years in the 1990s: "I've worked in two MFA programs and visited at least 30 others . . . I can't tell you how often students of color seek me out during my visits or approach me after readings in order to share with me the racist nonsense they're facing in their programs." For recent responses incited by Díaz's article, see "Speak No Evil Forum" in *The Asian American Literary Review* 2(5).
5 Although visiting critic programs are valuable to an MFA curriculum and can often fill much needed gaps, visiting critics are often juggling several short-term contract positions at different schools where their transient presence in each student community can often work against building sustained engagements or lasting structural change.
6 See also Chang 2014.
7 For an astute response, see Wong 2014; for relevant resonances in the poetry context, see Friedersdorf 2015 and Hong 2015.

References

Butler, Judith (2001), "What is Critique? An Essay on Foucault's Virtue," *Transversal*, May. Available at: http://eipcp.net/transversal/0806/butler/en. Accessed October 19, 2016.

Chang, Jeff (2014), "Color Theory: Race Trouble in the Avant-Garde," in *Who We Be: The Colorization of America*, New York: St. Martin's Press: 79–99.

Díaz, Junot (2014), "MFA vs. POC," *The New Yorker*, April 30.

Friedersdorf, Conor (2015), "When a Poem by a White, Male Author Smells Less Sweet," *The Atlantic*, September 8.

Fusco, Coco (2014), "One Step Forward, Two Steps Back? Thoughts about the Donelle Woolford Debate," *Brooklyn Rail*, May 6.

Hong, Cathy Park (2015), "There's a New Movement in American Poetry and It's Not Kenneth Goldsmith," *New Republic*, October 1.

Kosasa, Karen (1998), "Pedagogical Sights/Sites: Producing Colonialism and Practicing Art in the Pacific," *Art Journal* 57(3): 46–54.

Lorde, Audre (1984), "Age, Race, Class, and Sex: Women Redefining Difference," in *Sister Outsider: Essays and Speeches*, Freedom: The Crossing Press, pp. 114–23.

Lowe, Lisa (1996), *Immigrant Acts: On Asian American Cultural Politics*, Durham, NC: Duke University Press.

Mohanty, Chandra Talpade (2003), *Feminism Without Borders: Decolonizing Theory, Practicing Solidarity*, Durham, NC: Duke University Press.

Pindell, Howardena (1988), "Art (World) & Racism: Testimony, Documentation, and Statistics," *Third Text* 2(3–4): 157–62.

Piper, Adrian (1988), *Cornered,* video installation with birth certificates, videotape, monitor, table, ten chairs, Museum of Contemporary Art, Chicago, IL.

Raunig, Gerald (2008), "What is Critique? Suspension and Recomposition in Textual and Social Machines," trans. Aileen Derieg, *Transversal*, April. Available at: http://eipcp.net/transversal/0808/raunig/en. Accessed October 19, 2016.

Salesses, Matthew (2014), "When Defending Your Writing Becomes Defending Yourself," *Code Switch: Frontiers of Race, Culture, and Ethnicity* (blog), National Public Radio, July 20.

Wong, Ryan (2014), "I am Joe Scanlan," *Hyperallergic*, June 14. Available at: http://hyperallergic.com/131687/i-am-joe-scanlan/. Accessed October 19, 2016.

Consideration (As an Antidote to Critique)

Karen Schiff

When I returned to art school in 2003, after training and teaching in literature departments for more than a decade, I noticed negative undercurrents that I didn't remember from studio classrooms in the 1980s.[1] The corrosiveness felt familiar from critical studies classes in the humanities. My school was indeed hastily developing theory-oriented curricula, along with a flavor of discourse that has come to be associated with theory: sharp-witted, sociopolitically disgruntled, and summarily righteous. After one critique session, a student depicted the theory-heavy dynamic in a cartoon: all the students were baby-pacifiers ganging up on one pacifier-avatar who was backed into a corner. Over the decade since then, protests about the tone of critique have expanded into public, online venues. In January 2016, bellwether art critic Jerry Saltz posted medieval images of taunting and torture on Facebook and captioned them with phrases such as "Art student in the center of a group-crit." Students at the Rhode Island School of Design document studio humiliations on a blog started in Fall 2015, "Tales from the Critkeeper: Allegories of 'Constructive' Criticism and other Academic Cruelties."

In literary studies, the discourse of criticism has also been, well, subject to criticism. Since the 1970s rise of "theory" in America, cultural critics have lamented the combative, "suspicious" tone of critique.[2] Strenuous objections, as well as strategies for reform, are now circulating in literary studies.[3] While this phenomenon promises to filter into visual studies, as did theoretical discourse itself, I will deliberately bridge the two disciplines, drawing on my experience in both. As I proceed to unpack the negativity in criticism, to construct consideration-based theoretical models, and to offer pedagogical strategies, my main concern is the relational structure underlying encounters between the observer and the observed. Oppositional structures establish conditions for an ontological negation of the artwork, and enable more war-like antagonisms that are commonly recognized as "criticism." The most troubling consequence of this chain of events

is a choked creativity. "Consideration" will counteract this, to open up both artists' inventiveness and writers' diverse interpretations, and to spell an ever-widening potential for Art within and beyond the academy.

Antagonistic critique

My experience teaching an upper-level undergraduate literary theory/criticism course in the mid-2000s first compelled me to seek fundamental, structural obstacles in critical discourse.[4] Every semester, the class broke into two groups: those who were already accustomed to a theoretical language and those who were not. Those in the first group tended to enjoy the class. As the semester progressed, however, someone from the latter group always protested, saying something like: "I love the works we're talking about. But the way we're talking about them here sounds so negative—it's ruining the experience for me!" These students assumed that "criticism" meant "negative criticism" (as in, "Stop criticizing me!"), and they extended this narrow, colloquial meaning to suggest that a work of art could be "wrong." They worried that if they developed critical skills, they would become meaner people and enjoy art less. I talked about learning to see works through diverse "critical" lenses—like putting on and taking off different kinds of glasses— to develop new perspectives and even to expand our appreciation for the texts. My pep talk worked temporarily, but discomfort returned; some students tuned out from the class completely. Distressed about "losing the 'magic,'" they couldn't identify any causal mechanisms for their conviction that critical discourse was "negative."

An underlying negativity in critique discourages students across the arts and humanities, as others have noticed as well. Some graduate students in English fall into "despair" (Ruddick 2011: 30) when instructor training programs exclude pedagogical goals aside from "critical thinking" (Ruddick 2011:29). Though they believe their work is useful, they find their contributions constrained; they lose confidence. A related "professionalization" denies a "home" to students who enter literary programs with an intense love for books and reading (Fleming 2008). In Studio Art, students who enroll with a love of drawing, for instance, quickly learn that "this is not enough; something else has to happen" for them to become regarded as viable student-artists.[5] The "something else" is "critique"—not just in studio "crit" sessions, but in sustained critical discourse and commentary. Some students eagerly absorb the subject; others become paralyzed.

I appreciate the intellectual thrills of theory and criticism, which have their own "magic," and I share the aspirations toward sociopolitical improvement and clear-eyed analysis. Yet my students' repeated grievances have compelled me to seek fundamental obstacles in these discourses. In the 1970s, when deconstructive theory began promoting a radically "open," "affirmative" search for multiple meanings and plural paradigms, critical pedagogy could be so sharply witty that students at Yale (the seedbed for the method) monitored each other for signs of psychosis and power politics plagued the faculty.[6] In other words, theory or criticism can be generous while its deployment can be cruel. Some students are profoundly unsettled by the questioning of their most basic navigational assumptions, but I believe that many students suffer more from the tone of critical treatments works of art, or from their experiences of encounters with critics.

I have come to understand these negative critical undercurrents as unnecessary effects of "critical distance." An ontological separation between the observer and the observed is a condition for independent thought: "Criticism is a matter of correct distancing," wrote cultural critic Walter Benjamin in 1928 (Benjamin 1978: 85). But this strategic separation can also occasion an opposition which can devolve into a hierarchical relation: the critic regards the work as a deadened, inferior object. Antagonism then can manifest in common "critical" techniques that preserve the critic's domination: looking for omissions, biases, oversights, or "silences," and imposing a predetermined set of standards. Swiftly subjecting a work to an authoritative agenda—critical antagonism is often marked by "smart" speed—subordinates the work and denies it any role outside that of an accessory to the critic's heroic exercise.[7] The critic's stance of superiority over the work implies, as my students sensed, that the work has somehow "failed."

While concerns about negativity in criticism have become entrenched, negativity has rarely been tied to the mechanisms of critique itself: the stakes are enormous. We may refrain from looking too closely at critique because commentary and dissent are essential elements of democratic, civil society. Or, to question socially utopian methods is to risk jeopardizing political progress. Plus "suspicion"—that emotional hallmark of the critical attitude—may be an ancient, biologically ingrained survival mechanism, as Rita Felski observes in *The Limits of Critique*.[8]

The paradigm of criticality indeed contains echoes of primal conflict and potential violence; its practice, by extension, teaches students to wage war. Bruno Latour notes the language of weaponry in the teaching of critique: "at first we [students of criticism] tried . . . to use the armaments handed to us by our betters

and elders to crack open—one of their favorite expressions, meaning to destroy—religion, power, discourse, hegemony" (Latour 2004: 242). British psychologist Alexander Shand, writing during World War I, suggests a connection between a critical attitude and literal conflict: "suspicion ... become[s] prominent" during "times of war and social disorder" (Shand 1922: 195).

Actual war also lurks in Benjamin's ideas about critical distance. In 1928, he had been calling for a clear and autonomous perspective for viewing art, one that would not be overwhelmed and undermined by the dangerously speedy, "insistent, jerky nearness" of advertisements that were already flooding daily culture (Benjamin 1978: 85). By 1936, when Benjamin returned to the topic of cultural speed in his canonical essay "The Work of Art in the Age of Mechanical Reproduction," he now connected it with war in this essay's epilogue on fascism. Earlier in the essay he associates speed—as well as its vehicle, film—with "the contemporary mass movements" (read: Nazism) that used film to incite loyalty (Benjamin 1968: 221).

Yet for Benjamin, a reparative critical activity depends not just on distance between the observer and the observed, but on "*correct* distancing" (Benjamin 1978: 85, emphasis added). "Distancing" can be an activity—a verb—and not just the static noun, "distance." The structure of relation sets up a mode of engagement. We can find structures of problematic distancing: in suspicion, "We remain physically close while psychically removed" (Felski 2015: 38). This relation enables various critical operations, but as a reflex it is psychologically corrosive, as we have observed in the classroom accounts.[9]

The search for more constructive critical paradigms can be examined in terms of the interaction between the critic and the work. Annette Federico, in her 2016 book, *Engagements with Close Reading,* reports that literary scholars are inquiring into "what we should *do* with the literary work. Should we accept its invitations, or hold it at arm's length? Become immersed in the author's world, or rationally dissect it?" (Federico 2016: 3; see also Ruddick 2011: 31). "Close engagement" is a common suggestion.[10] Ironically, though, it shares strategies with both an outmoded, formalist New Criticism and a maligned, suspicious deconstruction.[11] And on what structural basis can "close engagement" occur so the closeness does not prevent independent thought, as Benjamin warned?[12] Some critics, see a more "distant reading" as congruent with contemporary trends of internet literacy and world literature: reading online prioritizes skimming (Hayles 2010), and global interconnectivity demands a literary history that is "a patchwork of other people's research, *without a single direct textual*

reading" (Moretti 2013: 48, original emphasis). The essential variable, I believe, is not proximity or distance, but rather the "correctness" or artfulness of the encounter's dynamic. Ideally, in a "correct" distancing, independence of mind can be a countermeasure to war instead of an unwitting perpetuator of it.

No matter which structural model obtains, the vocabulary of "critique" remains an obstacle. As Latour writes, "The practical problem we face, if we try to go that new route, is to associate the word *criticism* with a whole set of new positive metaphors, gestures, attitudes, knee-jerk reactions, habits of thoughts" (Latour 2004: 247). But texts as far back as the 1700s maintain that "We are never safe in the company of a critic" who is "no more than a Fault finder" (*OED* 1984: 1180). Given the long history of associating criticism with negativity, which is so powerful that even students poorly acquainted with critique feel burdened by it, we cannot simply assign new meanings to "criticism." Better to take a fresh start with a new word, and a new paradigm.

Analytic consideration

As an antidote to "critique," I propose "consideration."[13] I do not mean this as just "a kinder and gentler critique," to appropriate George H. W. Bush's 1988 presidential campaign phrase. While "consideration" indicates concern for others' well-being, which would improve the tone of academic exchange, I aim to engage different mechanisms and to serve different goals. The difference between "critique" and "consideration" is encoded in the etymological histories of the two words: "criticism" comes from *krinein*, indicating separation and judgment, while the root of "consideration"—sidereal, from *sidus* or *sider*—has to do with observing the stars.

The perspective of "critique" is not observation but rather scrutiny. It involves separating a work from the observer—and sometimes also into its constituent parts—so its scope is precise and focused. A Greek root of the word "critic" became the Italian *critica*, the late-sixteenth-century "arte of cutting of stones," which also implies that the critic's approach must be strong and sharp. In this lapidary allusion the work becomes impenetrable, obdurate. A stone must be cut with a swift blow, like the pace of thought and the "incisive" comments in many critiques and critical studies classrooms. But Latour notes that critical swiftness leads to weak conclusions: "What's the real difference between conspiracists and a popularized, that is a teachable version of social critique inspired by a too quick

reading...?" (Latour 2004: 228). When critique proceeds like stonecutting, insight, accuracy, and complexity become secondary to performances of brilliance.

Consideration is more broadly inclusive, opening a perspective as wide as the sky. Gazing at the night sky creates feelings of both humility and embodied mortality, yet smallness in relation to the stars can be paired with a feeling of being contiguous with the cosmos. In terms of art, consideration implies a sense of curiosity, of almost awestruck mystification in trying to fathom the work, instead of an adoption of an ontologically antagonistic detachment from the work (and from curiosity itself). The separation between human and constellation/artwork blurs, and the pace slows in accord with the stars whose light is so many years away.[14] The longer time frame required for this fathoming is encoded in the Latin *considerare,* which means "to look at closely, examine, contemplate"—"contemplate" is from roots meaning to "spend time together." The root *desiderare* itself means "to miss, desire," and again derives from the Latin for those distant stars. Desire suggests a longing for a lost, former connection with the work, or for a connection that has not yet been forged. In the encounter with a great work, that connection might never be completely forged. Artworks, like stars, remain bright yet slightly out of reach.

It is not clear whether this starry association signals astronomical science or astrological fortune-telling, but in medieval times, astronomy and astrology intertwined. So, this historical layer of "consideration" hovers between secular and religious realms. I explore this below.

If we change "criticism" to "consideration," the title—and role—of the "critic" can also change: I propose "analyst." Again, many "critical" processes pertain, but the psychoanalytic context implies a conversation between critic and work. The work now seems almost alive—or personified. Psychoanalyst-artist Gabriela Goldstein writes that "the object acquires autonomy. We might say that it is an encounter with the Other in its radical otherness" (Goldstein 2013: 174). In psychoanalysis, "otherness," or individuation, establishes opportunities for mutual acquaintance. Silences are respected as evocative aporias. The analyst endeavors to contribute to an ongoing, long conversation, with nothing to prove.

The analyst sees self-encounter as a never-ending process, just as encountering an artwork can yield ever-changing impressions. Art critic Nancy Princenthal champions an inherent, positive "failure" in any attempt to fathom art: the work's visuality functions like the unconscious. "What matters most about visual art," she insists, "is that it's visual, that it always involves an essential quality that exceeds written accounts" (Princenthal 2006: 45). I partly attribute the work's ultimate

intractability to the fact that it was made, or at least conceived, by a human being, whose motives are always multiple and at least somewhat mysterious.[15]

Finally, "consideration" opens a space of engagement that cannot be attached wholly to either the observer or the observed. Fiction writer Guy Davenport imagines this space as a mechanical, optical illusion: a critic and a work represent two figures which intersect to materialize as a third figure like a "ghostly triangle in the stereopticon." Davenport's ghostliness, which is an effect of biophysics, dissolves the oppositional quality of a viewer looking at an objectified work. The effect is comparable to poet Charles Bernstein's "close listening": the poet, the listener, and the act of speaking/listening act in concert, so the performance emerges in a non-localized, in-between space, constitutes the "work," and shapes its reception (Bernstein 1998). It also recalls Louise Rosenblatt's "transactional" idea of "the poem . . . as an event in time. It is not an object. . . . It happens during a coming together, a compenetration, of a reader and a text" (Rosenblatt 1978: 12). Because consideration happens in specific moments, and people (and works) involved morph over time, "opposition" is unsustainable.

(Religious) reconsiderations

The etymology of consideration, in signaling the firmament, underscores the latent religious dimension, which fleshes out critique's origin story, welcomes complexity, and suggests resources for theoretical models.[16] Though today's professors tend toward secularism, I focus here not on the sociopolitical problems created by religion but on its visionary utopianism: when critical commentaries try to redress social ills, critics function like clerics or even missionaries.[17] Critical discourse is situated within the academy, but universities began as medieval training grounds for clergy. Critics can see their efforts as righteous work, trying to heal the culture: in my PhD program, graduate students joked that the critical theorists among the faculty tended to dress in black (like clerics) and talk like demi-gods.[18]

Black shows no sweat. The critic-cleric's body, cloaked in black, can circulate abstract ideas without physical distractions. The black-clad critic thus performs historical Christian dogmas about the "profanity" of the body. Or, to tie this interpretation of the critic's wardrobe to a more secularized academic context, the posture of quasi-divine authority could be gained by sidestepping the body's unruly complexity—black shows fewer contours and irregularities. Either way, if

the physical body can be bracketed and ignored, it can also be repressed and denigrated, akin to how an artwork can be bracketed and denigrated by the critic's paradigms. Incorporeality bolsters the critic's intellectual power. Then the work becomes profane, errant material, in contrast to the critic's sacred, unimpeachable ideas.[19]

A religious history of critical discourse substantiates my associative speculations and my reflections on unfathomability. In the time of early universities, sermon-writing guides formulated rhetorical strategies that resemble current non-religious critique. Rhetorical historian James J. Murphy focuses on Alain de Lille, an influential Cistercian monk who introduced preachers to an "analytic spirit" in his groundbreaking guide from the late twelfth century, *On the Preacher's Art* (*De arte praedicatoria*) (Murphy 1974: 309). Murphy says that this critical distance "may be his most significant contribution",[20] locating criticality in the clergy rather than the academy (Murphy 1974: 309). Alain included the use of *divisio*, dividing complex ideas into discrete topics (cf. cutting the stone).[21] His guide was also notable for its "overwhelming" use of quotations—just as it is common in contemporary critique (Murphy 1974: 305). Murphy cites these aspects of Alain's text as evidence that the university's rhetorical idea of a "truly 'critical' ... form (as distinct from the subject matter)" has ecclesiastical roots (Murphy 1974: 311). The sermon writer's "moral instruction" in the fight against sin and vice has certainly foreshadowed today's critical appetite for social correction (Murphy 1974: 308).

Michel Foucault locates a religious origin for the antagonistic "critical attitude" later, in Renaissance Europe, as a wariness in response to overbearing ecclesiastical authority. A critical muscle "specific to modern civilization" develops because "the Christian church ... from the 15th century on" created "a veritable explosion of the art of governing men" (Foucault 2007: 43). Criticality became a psychic survival strategy, an individual (resi)stance against being completely circumscribed by prelates "to whom [subjects were] bound by a total, meticulous, detailed relationship of obedience"—religious strictures, understandably, could be stifling (Foucault 2007: 43).[22]

While I agree that one must be savvy about governors' intentions, it is dangerous to assume that they will always be unhelpful. Felski agrees: "Excessive suspicion, [Alexander] Shand declares, has catastrophic consequences for communial and collective life ... it fractures the body politic" (Felski 2015: 43).[23] And while resistance to the total rule of ecclesiastic authorities in post-15th-century Europe might carry into contemporary critique as a residue, it need not totalize into

"reflexive suspicion." This is like approaching a text—or an artwork—with the presumption that it will be automatically insufficient. How is it possible to move from a dismissively critical rigidity to a cautiously considerate openness? After all, ministers or other governing figures—like texts or artworks—can be productively visionary. The unpredictability that must be allowed by this perspective—any circumstance can have repressive or generative impact—requires independent, cogent assessments, not an always-already-critical attitude of simmering resistance, eager for discharge.

A positive model for analytical relations with a work comes from theologian Martin Buber, a religious humanist who derived ethics from Hasidism and Taoism.[24] In his "I-Thou" dialogism, the "Other" is a fully formed subject, and the encounter is a respectful, non-hierarchical relation. Buber contrasts this desirable structure with an "I-It" relation, in which the "Other" is regarded mechanistically and instrumentally. The "I" does not exist outside of either relation: selfhood takes shape according to how one regards the Other. Further, Buber's "dialogue" includes the encounter with a seemingly unresponsive person or inanimate work of art or literature: "The object of our perception does not need to know of us, of our being there" (Buber 1968: 8). As Buber commentator Maurice Friedman sums up the idea:

> I-Thou is a relationship of openness, directness, mutuality, and presence. It may be between man and man, but it may also take place with a tree, a cat, a fragment of mica, a work of art—and through all of these with God, the 'eternal Thou' in whom the parallel lines of relations meet. I-It, in contrast, is the typical subject–object relationship in which one knows and uses other persons or things without allowing them to exist for oneself in their uniqueness.
>
> Friedman 1968: xiv

When Buber himself addresses the religious backdrop of his theory, he defines "God" more expansively than Friedman. In a passage entitled "A Conversion," Buber reveals that his failure to save a young man from suicide convinced him to have "given up the 'religious'" in favor of responding fully to "the everyday out of which I am never taken" (Buber 1968: 14). In other words, "God" becomes a shorthand for the enormously complex web of reality, which is as inscrutably amazing as any sidereal panorama.[25] Buber's structural relation, while marketed as theological ethics, applies beyond religion.[26]

Buber's "I-Thou" analog for the encounter of the observer and observed is structured as a binary encounter that does not lead to hierarchical antagonism.

Rather, recognition of otherness admits wonder about variety and uniqueness. But the "I-Thou" relation is categorical and abstract; it glosses over the specific identities of the interlocutors and therefore could benefit from supplementation.[27] Still, like the ideas of Davenport, Bernstein, and Rosenblatt, Buber's encounter comes to life in the circumstances of direct, physical contact: "[Dialogue] is completed not in some 'mystical' event," but within the contingencies of "the common human world and the concrete time-sequence" (Buber 1968: 4). Because the "Thou" and "I" are always changing, an "I-Thou" relation with the work, marked by curiosity and an ongoing awareness of the work's inherent otherness, yields a plural, ever-expanding richness of meaning. This is the hallmark of living with a great work. It also models a peaceful strategy for changing minds and societies.

Classroom considerations

In a paradigm of consideration, the object of study functions as a source of new information for continual learning. Any creative practitioner can produce a vision that has not yet been imagined, so initial approaches are best seen as the beginning stages of an inquiry. As theory professor Diana Fuss writes, "My own best experiences in the classroom have come when a class has collectively worked through their resistance to reach the point of inventing something unusual, unexpected, or even uncanny" (Fuss 2012: 166). The "something" invented could be an interpretation, a theory, an artwork ...

I do not mean simply for students to seek new or multiple conclusions. I aim for them also to "mine" the work for what it can offer: the word "mining" connotes deep and difficult digging to encounter the work on its own terms—How does a work function? What are the underlying ideas, motivations, or influences? How has the maker composed the work, and what might we gain anew from it?—then owning the results (making conclusions that are "mine"). In other words, in addition to researching anyone else's responses, students can explore both the "I" and the "Thou" in their encounters with art. These perspectives are especially important for studio artists learning to evaluate their work's originality. By reflecting on other artists' unique motivations, techniques, and results—not just to show how existing artworks refract trends in art or discourse—students might better locate their own. This outcome is summed up by Nancy Princenthal as "the joys of the unfamiliar that are among the highest pleasures of compelling

new art" (Princenthal 2006: 45). The following examples of classroom processes—in Visual Studies, studio critique, Art History, and a studio-based lesson in visual perception—all aim to stimulate this radical novelty, and they are intended as adjustable processes rather than prescriptive exercises.

A major example of an investigative, consideration-based curriculum is W. J. T. Mitchell's classroom exercise "Showing Seeing" (Mitchell 2002: 176–79). Mitchell asks students to perform experiences (or discuss objects) that involve visuality, while explicating the performer's thoughts and any implications about seeing and culture. This lesson asks students to unpack experiences they might not have regarded as visual or cultural. Students engage "critical skills," but the goal is to generate new theories based on their experiences, not to apply existing paradigms to new phenomena. Structurally, students articulate visual experience from their place within it; they cannot maintain a habitual critical distance.[28]

In dancer Liz Lerner's Critical Response Process, studio "critique" becomes a slow, ritualized conversation that does not corner the artist. Though the name of this approach uses a "critical" vocabulary, its mechanisms are considerate: observers must ask the artist's permission before offering feedback, and this offer can happen only at the end of a four-stepped procedure that unpacks the work's unique aims and manifestations. The ritual quality of the process slows the pace, allowing time for thought. A facilitator (not necessarily the teacher) guides the dialogue, revising critical barbs—or opinionated questions that would suppress exchange—into helpful, "neutral" questions to draw out realizations. The process "allows both student and teacher to clarify their artistic perspectives" (Lerner and Borstel 2003: 49); its mutuality evokes Buber's "I-Thou" relation.

I collaborated with Art History students as a Writing-Across-the-Curriculum Fellow at the Pratt Institute (2008–2009), to create thesis statements based on new considerations of famous paintings. I assured them that even tentative hypotheses, if original, would impress their professors more than "proofs" of established generalities, and I dared to demonstrate in real time. For a "compare and contrast" assignment, we projected two paintings of *The Last Supper*, by Leonardo da Vinci (1498) and by Tintoretto (1594). Students began describing the differences: earth tones versus primary colors; diagonal composition versus rectilinearity. We agreed that they already had been trained to see these "easy" details; we pressed on. Christ was not at the center of Tintoretto's table; might this reveal a shift in humanistic philosophy? (Better.) At last, someone remarked that Tintoretto's painting had animals, while Leonardo's didn't. We traced how the eye was directed to notice these animals, and speculated about their inclusion

at this Last Supper. Might a late Renaissance theology or worldview have included dogs and cats?

As these questions became the basis for constructing viable thesis claims, the students grew palpably engaged in the class, in the construction of ideas, and in the enterprise of art history. By considering the images in front of them, instead of proceeding as if the images had been thoroughly exhausted by others, they experienced a fresh encounter with artwork and were stimulated by the process as well as its results.[29] Buber helps to account for their rapid animation: upon seeing the painting by Tintoretto as a ("Thou") locus for new meanings, the students' contributions gave them agency and palpable presence ("I"). (There is no "I" outside of the relation.)

In a seminar for graduate students from different studio departments at the Rhode Island School of Design, in 2016, I led an even more basic exercise—retrospectively titled "What do you see?"—to strengthen visual perception and verbal description. I pushed my plain laptop into the center of the seminar table and asked the students to say what they saw, challenging them to mention only visual details (not brand names or models, for instance, which required external knowledge), and not to repeat each other. Initial skepticism waned during the second round, as students found unexpected nicks and optical reflections. One student had done a similar exercise, in which students were challenged to describe an object so that an alien could visualize it; the point here, however, was that we could expand our visual capacities from within our own limitations. In the third round, students became so engaged that some were reaching out to touch the laptop, to verify their perceptions or investigate further. At one point, we gathered near a window to see a sublime visual effect in the interaction of the laptop with the table.

While these classroom activities exercise critical processes, they proceed according to creative logic. Our work was not relying on others' commentaries; we created fresh, new observations. When students realized that they had to "perform" their "critique," they maintained a subtle dismissiveness—of the classroom activity, of the field, of the artwork or visual material in front of them, and of themselves as creative agents. When the students' engagement sparked new ways of seeing (a rainbow under the laptop?) and about worldviews that challenged their own (theology with housepets?), their interest in the field was confirmed—or kindled—and art(works) became fascinating.

Whether using a codified method like Lerner's, or a less systematic exercise like mine or Mitchell's, art education can promote more productive encounters with creative works. Instead of holding art at a stereotypical "critical distance," these

processes create what I hope Benjamin would call a more "correct distancing"—proximity marked by a consciousness of unfamiliarity/alterity, uniqueness, and mystery. If we approach the works that we study and make with patient consideration, instead of subjecting them to our brisk critical attacks, we will invite students' intellectual and creative expansion. This more "sidereal" approach can also reinscribe a sense of wonder about the visionary possibilities for Art.

Notes

1 Many thanks to Jennifer Liese (Rhode Island School of Design) and Lisa Ruddick (University of Chicago) for their attention to these ideas and their suggestions for this text.

2 In 1970, Paul Ricoeur identified the founders of "the school of suspicion" as Marx, Freud, and Nietzsche in the early twentieth century (Ricoeur 1970: 32). Raymond Williams, in his 1976 compendium of *Keywords* in cultural studies, worried that the "predominant general sense [of "criticism"] is of fault-finding" (Williams 1983: 84). Diana Fuss wrote that by the 1980s, she and her graduate school colleagues believed that "if you were not resisting something . . . then you were not theorizing" (Fuss 2012: 164). In an influential 1997 essay, Eve Kosovsky Sedgwick wrote about "the prestige that now attaches to a hermeneutics of suspicion in critical theory as a whole" (Sedgwick 2003: 126). And science-culture theorist Bruno Latour, in a 2004 essay on critique, noted that an overemphasis on the destruction of dominant narratives has led to doubt even in the scientific method that is supposedly prized by modernity: we can no longer uphold a narrative, for instance, of climate change (Latour 2004: 242). In 2009, Stephen Best and Sharon Marcus interrogated the aggressive, "symptomatic reading" strategy of looking in texts for "symptoms" of hidden ideologies by "constru[ing] [elements present in the text] as symbolic of something latent or concealed" (Best and Marcus 2009: 3). And in 2012, Diana Fuss wrote that "even today, the reigning approach to theory tends to privilege resistance and . . . refusal, subversion, reversal, and displacement" (Fuss 2012: 165).

3 Rita Felski's 2015 book *The Limits of Critique* was discussed feverishly at the 2016 annual conference of the Modern Language Association, where many panels focused on rethinking humanism (Felski 2015). Lisa Ruddick's online article "When Nothing Is Cool," on "the thrill of destruction" in criticism which manifests as "malaise" and "immorality," got more than 64,000 hits within six weeks of its December 2015 publication (Ruddick 2015).

4 I use the terms "theory" and "criticism" almost interchangeably, as often happens in literary and visual studies.

5 This observation was made by a professor who attended the College Art Association panel, "Critiquing Criticality" (February 14, 2013), where this essay began as a presentation.

6 See Marc Redfield's *Theory at Yale: The Strange Case of Deconstruction in America*. Redfield thoroughly chronicles the media's "distortion" of deconstruction—which came to be synonymous with theory and criticism—as "an effort to 'destroy literary studies'" (Redfield 2016: 4). At a discussion of Redfield's book at Cooper Union (February 24, 2016), Susanne Wofford and Emily Apter described deconstructive methods as "affirmative" and "open," though the goal of intellectual subversion could feel constructive or destructive. Testimonies about the effects of deconstruction on the students and faculty were gathered in informal, post-event discussion.

7 See Ruddick 2011: 30–31 for an explanation of the speed and truncation of the inquiry.

8 Felski draws on the work of British psychologist Alexander Shand to note that the attitude of suspicion may have "originally served a biological function" of helping us to stay alert to "lurking predators and other dangers" (Felski 2015: 37).

9 Or perhaps unsafe, difficult psychological conditions (such as in war) *create* this dysfunctional stance of physical proximity and psychic distance.

10 Federico, Ruddick, and Latour all call for a common-sensical return to close engagement with works; they avoid hierarchical negations because an initial critical distance dissolves into an existential "inward dimension" (Ruddick 2011: 32) or a larger factual "reality" (Latour 2004: 244). Jean Kennard's "polar reading" begins with complete immersion in the text, which soon leads to its opposite when the reader encounters foreign textual details (Kennard 1984). Stephen Best and Sharon Marcus devote a special issue of *Representations* to "surface reading," an emphasis on a text's manifest details, in contrast to "symptomatic reading" (Best and Marcus 2009). Both "symptomatic" and "surface" reading demand close engagement.

11 See Paul de Man's discussion of Reuben Brower's pedagogy of New Criticism (de Man 1986: 23–24).

12 James Elkins resolves this by finding it impossible to "read" objects closely: any attempt leads to "a moment of incomplete awareness, built on self-contradiction and the resurgent hope of intimacy with the object" (Elkins 1996: 186). While he finds this troubling, I discuss it below as an excellent aspect of "consideration."

13 Felski briefly suggests "composition rather than critique" (Felski 2015: 182), but "composition" lacks dynamic power.

14 See David Mikics (Mikics 2013).

15 Though Roland Barthes's "The Death of the Author" essay famously identifies the reader and not the author as the generator ("writer") of meaning, this shifts attention away from the author; it does not deny the physical existence of that person (Barthes 1977). And a reader-analyst can generate infinite inscriptions of meaning, as Barthes demonstrates in *S/Z* (Barthes 1975).

16 Contemporary reading theorists support this connection—Moretti notes that "close reading" is, "[a]t bottom, a theological exercise" (Moretti 2013: 48), and Felski writes that "secular interpretation—even in the guise of critique—has not stripped itself of its sacred residues and that reason cannot be purified of all traces of enchantment" (Felski 2015: 174).

17 This is a different sense of ministry from what Fleming describes as students consulting the "priestly caste" of the literary professoriate to unlock textual secrets. It is also distinct from Ruddick's aspiring "teacher-healers", who can regard teaching literature as an act of humanist ministry, in a New Age key (Ruddick 2011: 29).

18 Also, while "righteousness" can be defined secularly, in terms of impeccable behavior, it is also often associated with religious arrogance, or something in-between—a "holier than thou" attitude.

19 This framework refers back to Platonic philosophy, where ideas represented (divine) perfection, and material phenomena—especially artworks—were seen as inferior to philosophical (critical) thought.

20 "It has long been the opinion of scholars that this new preaching mode originated in the medieval university", writes Murphy, but he identifies Alain's treatise as the spark for "a homiletic revolution" in Europe (Murphy 1974: 310). "[W]ithin twenty years of 1200 a whole new rhetoric of preaching leaped into prominence, unleashing hundreds of theoretical manuals written all over Europe during the next three centuries", in extreme contrast to "only four writers who could by any stretch of the imagination be called theorists of preaching" before 1200 (Murphy 1974: 309–10).

21 Alain "never discusses the principle of division [as a mode of exposition], but every section contains examples of its use. The typical division is into three", which is also (coincidentally?) the typical number of examples or body paragraphs in college-level expository essays (Murphy 1974: 308).

22 See also Judith Butler, "What Is Critique? An Essay on Foucault's Virtue" (Butler 2001).

23 Shand, a British psychologist, had monitored the psychosocial effects of World War I.

24 Buber does not reveal Taoism as a source; it was not well known at the time, and might have been perceived as heretical in rabbinical circles. Instead, he weaves Taoist ideas into his philosophical discourse. See Friedman 1976.

25 Latour similarly calls for us to "get *closer* to [facts]" so we can "see through them the reality" in which we exist (Latour 2004: 244).

26 Buber does not discount the word "God" or avoid using the paradigm of God; he simply obviates dualistic concepts of divine versus worldly, religious versus secular.

27 Jean Kennard's theory of "polar" reading, which she calls "A Theory for Lesbian Readers", gives greater attention to identity (Kennard 1984). Her model, initially adapted from Joseph Zinker's Gestalt psychology, complements Buber's dialogism:

both the reader and the text can be seen, productively, as "other." The theory uses minority identity to construct a framework that can apply to any reader (or viewer). Kennard later constructs a more flexible vision of shifting identity, drawing on psychoanalysis in her essay on "Teaching Gay and Lesbian Texts" (Kennard 1998).

28 For an analogous exercise from the humanities, see Diana Fuss's "gender diary" (Fuss 2012: 170–71).

29 Theorizing from observations resembles the strategy of Leo Steinberg, whose creative and revolutionary 1983 book, *The Sexuality of Christ in Renaissance Art and in Modern Oblivion*, makes general theological claims based on his having analyzed the portrayals (or concealments) of Christ's genitals in countless Renaissance paintings (Steinberg 1983).

References

Barthes, Roland (1975), *S/Z: An Essay*, trans. Richard Miller, New York: Hill and Wang.

Barthes, Roland (1977), "The Death of the Author," *Image/Music/Text*, trans. Stephen Heath, New York: Hill and Wang: 142–48.

Benjamin, Walter (1968), "The Work of Art in the Age of Mechanical Reproduction," in *Illuminations*, trans. Harry Zohn, New York: Harcourt Brace Jovanovich, pp. 217–52.

Benjamin, Walter (1978), "One-Way Street," in *One-Way Street and Other Writings*, trans. Edmond Jephcott and Kingsley Shorter, New York: Harcourt Brace Jovanovich, pp. 44–104.

Bernstein, Charles, ed. (1998), "Introduction," *Close Listening: Poetry and the Performed Word*, New York: Oxford University Press, pp. 3–26.

Best, Stephen and Sharon Marcus (2009), "Surface Reading: An Introduction," *Representations* 108: 1–21.

Buber, Martin ([1947] 1968), *Between Man and Man*, New York: Macmillan.

Butler, Judith (2001), "What is Critique? An Essay on Foucault's Virtue," European Institute for Progressive Cultural Policies, May. Available at: http://eipcp.net/transversal/0806/butler/en. Accessed September 1, 2015.

Davenport, Guy (2015), *Every Force Evolves a Form: Twenty Essays*, New York: Open Road Integrated Media.

de Man, Paul (1986), *The Resistance to Theory*, Minneapolis, MN: University of Minnesota Press.

Elkins, James (1996), "On the Impossibility of Close Reading: The Case of Alexander Marshack," *Current Anthropology* 37(2): 185–226.

Federico, Annette (2016), *Engagements with Close Reading*, New York: Routledge.

Felski, Rita (2015), *The Limits of Critique*, Chicago, IL: University of Chicago Press.

Fleming, Bruce (2008), "Leaving Literature Behind," *The Chronicle of Higher Education*,

19 December. Available at: http://www.chronicle.com/article/Leaving-Literature-Behind/24699. Accessed August 30, 2016.

Foucault, Michel ([1997] 2007), "What is Critique?" *The Politics of Truth*, ed. Sylvère Lotringer, trans. Lysa Hochroth and Catherine Porter, Los Angeles, CA: Semiotext(e), 2007.

Friedman, Maurice (1968), "Introduction," in Martin Buber, *Between Man and Man*, New York: Macmillan, pp. xiii–xxi.

Friedman, Maurice (1976), "Martin Buber and Asia," *Philosophy East and West* 26(4): 411–26.

Fuss, Diana (2012), "Teaching Theory," in *The Critical Pulse: Thirty-Six Credos by Contemporary Critics*, ed. Jeffrey J. Williams and Heather Steffen, New York: Columbia University Press, pp. 164–72.

Goldstein, Gabriela (2013), "The Greatest Love of All," in *Art in Psychoanalysis: A Contemporary Approach to Creativity and Analytic Practice*, ed. Gabriela Goldstein, London: Karnac Books, pp. 171–88.

Hayles, N. Katherine (2010), "How We Read: Close, Hyper, Machine," *ADE Bulletin* 150: 62–79.

Kennard, Jean (1984), "Ourself behind Ourself: A Theory for Lesbian Readers," *The Lesbian Issue*, special issue of *Signs* 9(4): 647–62.

Kennard, Jean (1998), "False Analogies: Teaching Gay and Lesbian Texts," *Modern Language Studies* 28(3/4): 173–86.

Latour, Bruno (2004), "Why Has Critique Run Out of Steam? From Matters of Fact to Matters of Concern," *Critical Inquiry* 30: 225–48.

Lerner, Liz and John Borstel (2003), *Critical Response Process: A Method for Getting Useful Feedback on Anything You Make, from Dance to Dessert*, Takoma Park, MD: Dance Exchange, Inc.

Mikics, David (2013), *Slow Reading in a Hurried Age*, New York: Belknap.

Mitchell, W.J.T. (2002), "Showing Seeing: A Critique of Visual Culture," *Journal of Visual Culture* 1(2): 165–81.

Moretti, Franco (2013), *Distant Reading*, London and New York: Verso.

Murphy, James J. (1974), *Rhetoric in the Middle Ages: A History of Rhetorical Theory from St. Augustine to the Renaissance*, Berkeley, CA: University of California Press.

Oxford English Dictionary, Compact Edition (1984), New York: Oxford University Press.

Princenthal, Nancy (2006), "Art Criticism, Bound to Fail," *Art In America* 94(1): 43–45.

Redfield, Marc (2016), *Theory at Yale: The Strange Case of Deconstruction in America*, New York: Fordham University Press.

Ricoeur, Paul (1970), *Freud and Philosophy*, trans. D. Savage, New Haven, CT: Yale University Press.

Rosenblatt, Louise (1978), *The Reader, the Text, the Poem: The Transactional Theory of the Literary Work*, Carbondale, IL: Southern Illinois University.

Ruddick, Lisa (2011), "The Unnamed Work of English," *ADE Bulletin* 151: 29–35.

Ruddick, Lisa (2015), "When Nothing Is Cool," *The Point*, December. Available at: http://thepointmag.com/2015/criticism/when-nothing-is-cool. Accessed December 10, 2015.

Sedgwick, Eve Kosofsky ([1997] 2003), "Paranoid Reading and Reparative Reading, Or, You're So Paranoid, You Probably Think This Essay Is About You," in *Touching Feeling: Affect, Pedagogy, Performativity*, eds Michèle Aina Barale, Jonathan Goldberg, Michael Moon, and Eve Kosofsky Sedgwick, Durham, NC: Duke University Press, pp. 123–51.

Shand, Alexander (1922), "Suspicion." *British Journal of Psychology* 13(2): 195–214. Available at: http://onlinelibrary.wiley.com/doi/10.1111/j.2044-8295.1922.tb00093.x/full. Accessed February 26, 2016.

Steinberg, Leo (1983), *The Sexuality of Christ in Renaissance Art and Modern Oblivion*, Chicago, IL: University of Chicago Press.

Williams, Raymond ([1976] 1983), *Keywords: A Vocabulary of Culture and Society*, New York: Oxford University Press.

Re-Thinking Art Education (Revisited), or How I Learned to Love Art Schools Again

Jen Delos Reyes

I was first invited to contribute to this publication on rethinking critique in education in the summer of 2013, before Cooper Union announced it would begin to charge tuition, and before the entire 2014 incoming class of the USC Roski School of Art and Design's MFA program dropped out "based on the faculty, curriculum, program structure, and funding packages," inviting us all to deeply pause and reconsider the current structures and institutions, and move beyond amelioration and towards "new spaces for collective weirdness and joy" (BFAMFAPhD 2015).

This call to "keep it weird" was one that I was more than familiar with as a resident of Portland, Oregon for eight years. I worked within Portland State University from 2008 to 2014—I was the co-director and Chair of the MFA in Art and Social Practice for most of that time. The mantra of the program could easily have been that art and social practice starts and ends not in rarefied spaces, but out in the world. Our classroom could look like a walk through the woods mushroom hunting, blindfolded soccer, or a pipe organ demonstration. We worked with the Portland Art Museum to create a series of programs and integrated systems that allowed for artists to rethink what can happen in a museum, and reinvigorate the idea of the museum as a public space. Dowsing the museum, orienteering the museum, serenading the museum all became forms and possibilities through our collaboration.

Unfortunately, the weirdness I experienced while at Portland State University was not always positive, as often is the case in academia. After years of working as a full-time, fixed term assistant professor with the constant promise of a tenure track line opening up to potentially secure my position in 2013, I went from full-time to half-time, and then adjunct all while at one institution.

During this time, I was invited to give a talk on the theme of Education as part of a national series of breakfast lectures for creative communities. I was at a crossroads and felt like I was in a position where I had nothing to lose, and took this lecture opportunity as a way of really laying bare my current thinking on art schools and art education. What follows is a transcript of the lecture I delivered on December 19, 2014 at Museum of Contemporary Craft, Portland, Oregon. This talk on rethinking arts education was prepared for Creative Mornings PDX. The text appears in full with notes in track changes that are my additional reflections as of October 14, 2015. These sidebars trace my coming back around to the promise of public institutions, and once again falling in love with the idea and potential of a radical school of art and art history for the twenty-first century.

This is about options: Education, art school, and other ways

I know that for myself a large part of my education came from participating in the local Winnipeg music scene of the mid-90's—infused with the energy of Riot grrrl and DIY. How I work today is rooted in what I learned during these formative years as a show organizer, listener, creator of zines, and band member. I place a high value on what many might dismiss as incidental education.

I have had many other teachers in my life, some of which have come in the form of challenging experiences, or people. These are usually the lessons we never ask for but, if we are open to learning from them, can be immensely powerful for personal growth.

For this talk today I am going to tackle the following questions [1]:

1. How does teaching change when it is done with compassion?

Comment [1]: One of the things I asked myself while writing this talk was would any art school want to hire me after I give this lecture?

I sent a copy of the transcript of this talk to the Director of the School of Art and Art History at UIC, and then less than a year later I am now working directly with her with the goal to create the most impactful, relevant School of Art and Art History of the twenty-first century.

2. What should an arts education look like today? [2]
3. Can education change the role of artists and designers in society?
4. How does one navigate and resist the often emotionally toxic world of academia?
5. With the rising cost of post-secondary education in this country what can we do differently?
6. I think it is worth starting at the beginning. What is the impetus behind education? Where did it come from? What is education for?

> Comment [2]: This question has taken on a new significance for me as my new role as the associate director of a School of Art and Art History and working for the first time in the administration of an entire school.

The standardized education system that we know today comes from a historical, societal base of industrialization and militarization. Since its formalization, society also turns to the school system to provide its citizens with critical lessons in socialization. As education critic Edgar Friedenberg wrote, "What is taught isn't as important as learning how you have to act in society, how other people will treat you, how they will respond to you, what the limits of respect that will be accorded really are" (Repo 1971: 400).

Radical approaches to education fundamentally believe that learning can teach us so much more. These schools of thought believe education can liberate, empower, and assist in the creation of a more just world. I personally believe that formal education must serve in the creation of thoughtful, caring, and compassionate members of society [3].

Is art school a state of temporary delusion? In Dan Clowes' 1991 *Art School Confidential*, he illustrates the rarity of the art school instructor who is willing to "level with students about their bleak prospects", stating that, "only one student out of one hundred will find work in her/his chosen field. The rest of you are essentially wasting your time learning a useless hobby" (Clowes 1991). The sad reality is, as

> Comment [3]: What would be the measures of assessment for this? I am currently in the process of doing program assessments for a university and am thinking about how different things would look if this was one of the outcomes we were expected to measure.

Clowes puts forward, that many students who are in the system believe they will be the exception. That art school really will work for them. The New York based collective of artists, designers, makers, technologists, curators, architects, educators, and analysts BFAMFAPhD's research findings show of all of the people in the United States who identify as making their living working as an artist, only 15.8 percent of them are fine arts degree holders.

A primary problem with art school is often the perpetuation of the cult of originality; trying to do it "first." Students becoming paralyzed creatively because—everything—has already been done. This is a mistaken interpretation of the avant-garde— constant originality and innovation. Without delving too deep, I believe that the historical avant-garde was really about the quotidian, and making sure that art does not make the mistake of divorcing itself from life (Delos Reyes 2014). In the system as it stands, students often become closed off and feel restricted from freely sharing their ideas or thoughts out of fear that someone else will steal their precious "original" ideas. I think that this unhealthy emphasis on originality often makes students move in the direction of the frivolous, which is miles away from how philosopher and education reformer John Dewey beautifully described how the everyday can be the birthplace of meaningful originality: "Originality does not lie in the extraordinary and fanciful, but in putting everyday things to uses which had not occurred to others" (Freire 2008: 51).

The next point I want to take issue with is the violence of critique. I have experienced almost every possible manner of viciousness and self-importance in art school critiques. It is a bizarre and often cruel forum. This is likely where the majority of any given students' art school damage happens! Often instructors

are the worst perpetrators in critiques. Seldom do they place any rules of engagement for their students, and this is where the cycle of violence is perpetuated. Instructors often foster these unhealthy and destructive environments of power and dominance, instead of creating space for growth and deep understanding.

Another fundamental problem is outdated curriculum. I often got flak from the art school professors I would challenge during my BFA about assignments and approaches I thought were irrelevant. I did not want to draw nudes and still-lifes. I didn't want to make a color wheel. When I pushed back for more applicable work I could be doing in my art education I was once aggressively yelled at by a male professor, "If you don't want to do what I tell you, why are you even in art school?" Never thinking to ask himself—why was he teaching this way in an art school? My belief is best summarized by Canadian Artist Ken Lum: "What students need to be taught is that art is about making everything in the world relevant" (Madoff 2009: 339).

My next issue is the lack of critical care [4]. When I say lack of critical care I am talking about two separate, but equally problematic deficits. First is a social deficit. The lack of a real emphasis on community building, as well as what I feel is an epidemic of teachers who lack a real investment and care in their students and the creation of a learning community. Second is a widespread lack of care in whether or not the curriculum has real value and application outside of an art school or art world context.

Currently most of the art programs that focus on socially engaged art are Masters of Fine Arts programs [5]. I believe that an artist's relationship to and placement in society should not be an area of specialization, or afterthought, but instead a core

Comment [4]: One of my first tasks at UIC was to take on thinking about what self-care could look like in a twenty-first century art and art history school and to find ways to foster and model the daily implementation of self-care into the lives of artists/students. My name for this initiative is Critical Care—this endeavor will emphasize notions of care and wellness centered on collective courage, emotional fierceness, and embodiment and joy. Holding the space in our creative practices to maintain our personal well-being, give in to public exuberance, maintain relationships, face our emotions head on, and build community is what makes it possible for us to continue to do the important work of artists in the twenty-first century.

Comment [5]: In 2007 Portland State University became one of the first MFA programs in the country with a focus on socially engaged art. While it is now one of a handful of emerging and established programs with this focus, there are many aspects that differentiate an education in this program not only from similar programs, but as a critical departure from the professionalized MFA system.

component of the education of all artists (Delos Reyes 2013: 56). But can education actually change the role of artists and designers in society? Yes, but that means changing how and what we teach. I believe that this change needs to happen first at the foundations level. This Fall Carnegie Mellon University [6] will be the first art school to make this kind of approach to art making a foundations level requirement [7]. Another new and incredibly promising and relevant undergraduate program is the newly formed Art and Social Justice Cluster at the University of Illinois in Chicago [8].

You don't need the creation of an entire program to foster these ideas in how you teach art and design. How I teach is social. It is from a de-centered position of power. It is about respecting and valuing all of the contributions of the group equally. It is about finding ways to make the work we are doing as learners and makers socially relevant. And it is about having the contributions of students seen as valuable to multiple contexts.

A friend and fellow artist and educator Nils Norman introduced me to the book *Streetwork: The Exploding School* by Colin Ward and Anthony Fyson (Ward and Fyson 1973). It had a major influence on how he teaches and it did the same for me. I am going to share how that was put into practice for me from 2008 to 2013, when I was co-directing an MFA program in art and social practice. I believe in learning in the world, that environment has an impact, and that student interests can drive the direction of the class [9]. I know that being a listener is one of the most important contributions to the world. There needs to be a focus on teaching active listening. Understanding that we are bodies, and not just brains, is also important. Yoga, basketball, and walks were staples in the program. But maybe most important, and even less emphasized is love.

Comment [6]: Since writing this talk I spent a semester doing a fellowship at Carnegie Mellon and teaching a class on Art in Everyday Life at their School of Art.

Comment [7]: CORRECTION: Professor Michelle Illuminato informed me after I gave a talk at Alfred earlier this year that this has been a component of their freshman curriculum for years.

Comment [8]: I am now currently the Associate Director of the School of Art and Art History at UIC, the state's land grant university. The school remains committed to serving the needs of the people of Illinois and asking what that means in terms of access to arts education. I have never before been part of a school or administration that so actively pursues a mission of social justice and art.

Our school in the landscape of Chicago art schools is an underdog. For many in my ART 101 class this fall it was their first college class ever. For some they are also the first person in their family to go to college. It was humbling to be in the words of my friend Jovenico de la Paz, "the first face of college" for this group. I am looking forward to the responsibility of teaching this foundations class and exposing this group to so many ideas that I hope will help shape them into thoughtful artists, and more importantly present and conscious human beings— the true goal of education.

Comment [9]: While inspired by approaches to education ranging from the Highlander Folk School to the Pedagogy of the Oppressed the program at Portland State has made no explicit statements on the philosophy motivating the program.

In 2010, I team-taught a course with artist Mark Dion on museums. Mark also teaches at a prestigious MFA program in New York, and he commented to me on the differences between our cohorts. Our students were less interested in reading the latest issue of *Artforum* cover to cover, but the most notable difference was that they genuinely cared about one another. He was amazed at how generous the students were with each other, and how much support they offered. There was a distinct lack of competition and with that came open communication, dialogue, and resource sharing. While it is a hard thing to measure, quantify, or put a value on, I know that this atmosphere of care, and the emotional IQ of the group at the time was the most important, and least publicized, aspect of the program. It is also the kind of thing that is not built into a curriculum; it is set by example. It is our duty as teachers to model this. In Canadian education activist Satu Repo's publication, *This Book is About Schools*, there is an essay titled "If You Can't Love Them, You Can't Teach Them" (Repo 1971). This title sums it up completely. If you are an educator and you are starting to feel hatred or resentment towards your students, it is time to step back, take a break, and then return with the capacity for care.

The unfortunate reality of art schools, and academia as a whole is that it is not a place that is teaming with actualized, loving human beings. American author, feminist, social activist, and public intellectual bell hooks has spoken about the emotional toxicity of the academy, and why for her it was the right choice to distance herself and not teach full-time. This quote from hooks captures some of my own specific disappointments: "It was particularly disappointing to encounter white male professors who claimed to follow Freire's model even as their pedagogical practices were mired in structures of

domination, mirroring the styles of conservative professors even as they approached subjects from a more progressive standpoint" (hooks 1994: 17).

Yet, it still came as a surprise to me when a progressive-seeming, tenured white male colleague enacted similar systems of dominance and oppression in our own working relationship, telling me after six years of working to build a socially engaged art program that I had "become too visible" and was "taking too much credit for the work I was doing". So I asked myself, "What would bell hooks do?" Luckily for me I live in a time where texting a number for supportive quotes from bell hooks is an option: "Whenever domination is present, love is lacking." This exchange with this former colleague made it clear that this was no longer a program where I could teach from love or feel proud about the quality of the educational experience. To quote American educator and founder of the Highlander Folk School Myles Horton: "I think if I had to put a finger on what I consider a good education, *a good radical education*, it wouldn't be anything about methods or techniques. It would be about loving people first" (Horton et al. 1990: 177).

The last problem I will address about art schools is one of the biggest: the cost. Seven of the top ten most expensive schools in this country are art schools. How much would it cost if each of us in this room (100 people) received a BFA from the School of the Art Institute Chicago (a more expensive art school) and an MFA from Portland State University (a lower-cost state school)? Even before adding interest on loans, or cost of living expenses, both together would cost us $9,128,000.00. What other options could that money have if we approached education differently?

I want to propose some other ways that artists

could approach their education. Ways in which we take control, work together, and shape knowledge collectively. In the words of Myles Horton, "You have to bootleg education. It's illegal, really, because it's not proper, but you do it anyway." I think that many people would be surprised to know that Oxford was started by rebel students from Paris, Cambridge by rebels from Oxford, and Harvard by rebels from Cambridge. If these schools, which were born out of revolution, could become among the most revered sites of learning in the world, who is to say that other radical propositions could not be valued equally?

I am going to come to a close this morning by sharing an anecdote with you about a conference I attended last month in Cleveland. Members from BFAMFAPhD were also presenting at the conference and shared a lot of their research. During the Q&A portion someone from the audience asked an inflamed question about "who their target is?" The person was concerned that the end goal of the group was the closure of art schools. BFAMFAPhD ensured that was not their goal, and they were in no way interested in mass layoffs and tenured faculty losing their jobs. That night over dinner someone at my table knew the woman in the audience who had made that comment and said that she thought it was so important that she spoke up, especially since the group was presenting in the context of an art school. I am going to paraphrase what I said in response:

> This is not about targets and takedowns. This is about options. What we really need is to change our structures of value so that we can respect and acknowledge other approaches to education, whether that be free school, self-taught, community-based education, or other. We need to get to a place where culturally we truly value education and knowledge over purchasing power.

References

BFAMFAPhD (2015). Available at: http://www.artandeducation.net/school_watch/
 entire-usc-mfa-1st-year-class-is-dropping-out/. Accessed October 6, 2016.

Clowes, Daniel (1991), "Art School Confidential," *Eightball* 7, np.

Delos Reyes, Jen (2013), *Ten Lessons Graphic Designers Learn That Every Artist Should
 Understand*, Portland, OR: Ampersand.

Delos Reyes, Jen (2014), "What Are We Trying to Get Ahead Of? Leaving the Idea of the
 Avant-Garde Behind," *A Blade of Grass*. Available at:http://www.abladeofgrass.org/
 growing-dialogue/growing-dialogue-the-latest-thing-3/. Accessed October 6, 2016.

Freire, Paulo (2008), *Education for Critical Consciousness*, New York: Continuum.

hooks, bell (1994), *Teaching to Transgress: Education as the Practice of Freedom*, New
 York: Routledge.

Horton, Myles, Brenda Bell, John Gaventa, and John Marshall Peters (1990), *We Make
 the Road by Walking: Conversations on Education and Social Change*, Philadelphia,
 PA: Temple University Press.

Madoff, Steven Henry (2009), *Art School: (Propositions for the 21st Century)*, Cambridge,
 MA: MIT Press.

Repo, Satu (1971), *This Book Is about Schools*, New York: Vintage.

Ward, Colin and Anthony Fyson (1973), *Streetwork: The Exploding School*, New York:
 Routledge.

Pragmatics of Studio Critique

Judith Leemann

We study in the sound of an unasked question. Our study is the sound of an unasked question. We study the sound of an unasked question.

Fred Moten (2013)

One cannot not *communicate.*

Paul Watzlawick, Janet Beavin, and Don Jackson (1967)

Positions

I teach studio art in a public art college, where collegiality and trust of faculty leaves me great room to shape what happens in my classes. When something arises that wants to be studied, I may lay it out before my students for collective examination. In the Spring semester of 2010 I found myself teaching an advanced undergraduate sculpture studio with a number of students I already knew. I mention this familiarity because it made possible what in retrospect stands for me as one of the most fruitful moments of collective study with my students, a richly productive turning over and around of pedagogical habit in the service of renewed attention to what studio critique might yet become.

My own undergraduate education was not in a visual arts school. I recall collectively looking at work produced in the art classes I took, but critique wasn't the centralized practice I encountered in the graduate program I later entered. The lack of familiarity with the form produced in me a kind of anthropological fascination with the way studio critiques unfolded in that art school setting. *What is this well-rehearsed performance and how do I enter it?* The rules of engagement are never made explicit. I have to extrapolate them by watching and trying to find my way in.

I grew up as a girl, and as a queer person at a time when, at least in my environs, queerness was neither visible nor acknowledged. I grew up the child of immigrants. These are positions from which one learns to look behind the construction of normed forms to see what the "normalcy" of those forms conceals. One learns to do that looking-behind because survival (be it bodily or psychological) is at stake. Richard Wright borrows the phrase "frog perspectives" from Nietzsche to describe that which can only be seen from the down position of any dynamic of oppression (Wright 1978: 27). From a frog perspective, what caught my attention about the way critique was practiced wasn't in fact anything about the practice itself, but rather the naturalized way it was assumed everyone in the room already knew what was expected and how to dance the dance. What was notable was the *lack* of explicit instruction in the practice. From a frog perspective these assumptions of common understanding have so often masked the preservation of old power that the simple lack of explication sets off small alarms.

If biography primed me to suspect the many tacit arrangements animating studio critique, it was a set of writings encountered in my early twenties that provided the language I would later need to move from suspicion to study. These were the writings of Gregory Bateson, Paul Watzlawick, Janet Beavin, Don Jackson and others taking a cybernetic approach to communication studies. In their 1967 book *Pragmatics of Human Communication*, Watzlawick, Beavin, and Jackson lay out a number of useful tools for teasing apart the many things happening at once in a communication system as complex and enfolded as the one we call a studio critique.

Pragmatics

Fundamental to the research described in *Pragmatics of Human Communication* is the axiom that every communication "not only conveys information, but . . . at the same time it imposes behavior" (Watzlawick et al. 1967: 51). Every communication functions as both report and command. "The report aspect of a message conveys information and is, therefore, synonymous in human communication with the *content* of the message. . . . The command aspect, on the other hand, refers to what sort of a message it is to be taken as, and, therefore, ultimately to the *relationship* between the communicants" (Watzlawick et al. 1967: 51–52). Essential to understanding how these aspects can function

simultaneously is recognizing the distinction between digital and analog modes of communication. "Digital" indicates the purely informational aspects of a communication: *what* is being said rather than *how* or *to what end*. It is the part of a communication that can be transcribed into text with little loss. "Analog" refers to that continuum of affective, bodily, and historical relations through which any digital communication takes place and which every communication re-inscribes or bends in its own way. It is everything we register about what a communication *produces, generates,* or *does* in excess of transmitting content.

Watzlawick and his colleagues offer this example to illustrate the distinction: "the messages 'It is important to release the clutch gradually and smoothly' and 'Just let the clutch go, it'll ruin the transmission in no time' have approximately the same information content (report aspect), but they obviously define very different relationships" (Watzlawick et al. 1967: 52). Digging further into the operations of the analog, they offer this: "All such relationship statements are about one or several of the following assertions: 'This is how I see myself . . . this is how I see you . . . this is how I see you seeing me . . .' and so forth in theoretically infinite regress" (Watzlawick et al. 1967: 52).

Central to this systems-oriented approach to communication studies is the practice of questioning how cyclical behaviors get habitually punctuated. "Where the *why?* of a piece of behavior remains obscure, the question *what for?* can still supply a valid answer" (Watzlawick et al. 1967: 45). One can know a thing by seeing what it produces, generates or does without needing to take up the difficult if not impossible task of prying into origin or intention. Dropping the notion of linear causation for ever-circling interaction, any partial arc becomes a valid place to gather information about the system as a whole. Translating this approach to the studio art classroom, we take a chance and trust that reading the arc of a made object forward in terms of what it now produces/generates/does for viewers will reveal as much as any digging after the origins, the *why* of the work. We arrive in a place as speculative as it is pragmatic.

Propositions

I don't recall when I decided to fully open up to my students my accumulating suspicions about studio critique. I had established the habit of sharing with each new class a brief text I called *Observations on Forms and Patterns of Critique* (Leemann n.d.), in which I took up in a broad way the kinds of things I noticed

happening in critiques. I trusted that if we examined the form, taking time to discuss what we thought we were doing, we could produce a space for more consistently meaningful encounter.

We began in pairs: *What is the best thing a critique can do? What is the worst thing a critique can do?* And those conversations then shared with the whole group and that leading into another round of questions. *You say that critiques make you a better artist. How? What is it exactly that happens in critique that sends you back to the studio with greater capacity? You say the worst thing a critique can do is make you want to quit making art. What kinds of things get said that lead to that? Is it* what *is said or* how *it's said?* Here, though I don't at first make it explicit, we invoke the distinction between analog communication (tone, how it's said, the way you can read the assumptions playing out about you and your work) and digital communication (content, the concrete observations about the work itself).

In past classes I would jump from this priming conversation right into critique, but in this particular class I laid out my concern that it seemed too often a chance operation whether or not any given critique would be productive. I proposed dissecting the parts to see what we could make of them. I taped a large sheet of paper to the wall and we began by listing all the kinds of questions that get asked in critiques. We began teasing out what *else* each of those questions was doing: *What are you trying to say? Did you think about . . . ? Did you mean to . . . ? Why did you . . . ?* Not only questions but familiar frames of response: *It reminds me of. . . . I wish this part were. . . .*

I drew a simple diagram: a central circle for the work, an X to the left of that work, indicating the maker but also the time of the making, the protected space of the studio.[1] To the right of the work, I arrayed a half-circle of Xs indicating viewers but also the time of looking, the space of becoming public. We diagrammed what parts of these relations each question foregrounded. We mapped *What are you trying to say?* as a direct arrow from maker to viewers, noting the implication that the work *should* be able to deliver something like a statement directly to a viewer in the same way that the maker's speech could. Someone offered that there was in the word "trying" both a suggestion that work *should* be able to say like speech says and that the work was failing to do that, why else use the word "trying"? To map *Did you think about . . . ?* we needed to add to our diagram a kind of unborn sibling of the work sitting ghostly next to the work that was in fact made. We noted that having more feedback addressed to the unborn sibling of the work than to the work that was in fact made too

often left a maker disoriented, confused, impotent.[2] *It reminds me of . . .* was mapped as an arrow that left the viewer to bounce quickly off the work before landing on something that was already there near the viewer all along. Here the work mattered only as satellites do—as relay or reflector for some signal already prepared in advance. Reflection of this sort can be also *deflection*, a way to refuse engagement with the object at hand, a way to substitute a rehearsal of expertise for dialogue with this material thing newly arrived in the world.

Having worked our way through a number of these questions, registering how many of them veered away from actual encounter with the object that was in fact made, steering either toward the backstage process of making, the unborn siblings of the work, or to the tastes or associational ecologies of individual viewers, I asked what it would take to let those objects that *were* in fact made take center stage more consistently.

I proposed two broad categories of response to any object under critique. The first included observations about the work so obvious we would never think to mention them. These observations were generally verifiable and consensual—we could all agree that the thing before us was in fact the size of a fist, stark white, made of coarse cloth. We seemed, though, based on how rarely we took the time to name physical attributes (size, color, material, orientation to other things in the room, etc.) not to value that information much. On our diagram I placed these kinds of responses right on the skin of the object—far more about the object than about us as viewers. The other type of response had more to do with observer than object. *It reminds me of . . .; I like how you . . .; I wish you had* Not verifiable, not shared, but seemingly more interesting, or at least more frequently spoken. These kinds of communications we diagrammed as little moons orbiting viewers. I suggested we call them associations and understand their limited relationship to the object at hand.

We would need to take time to make obvious, verifiable observations about the object, no matter how silly or tedious it first seemed. Only then could we articulate connections between those things we could agree to call verifiable consensual facts about the work. To articulate a connection was not the same as making an association; it was re-tracing through language a relation between verifiable facts about the work in order to then articulate what this relation was itself generating. If we were serious in our belief that an artist should leave a critique with a better sense of how her decisions in the process of making communicated themselves to viewers, we would need to root ourselves firmly and consistently in this habit of spending time on the thing itself, the object

before us. The question of what the object was doing, generating, or producing became our central focus; the work of building connections from first observations our central labor. We dropped questions about the process leading up to the making of the work. We dropped, in fact, all questions to the maker, unless they were framed as observation (one of the things a work can do is generate questions): *The way this part connects with that one makes me think about which part came first* rather than *Which of these parts did you build first?*

With all this effort to ground ourselves in observation, there was an important speculative component to our experiment: *Assume everything you see is intended.* We know full well that every made object is the offspring of intention and accident (and necessity, habit, budget, will). *Choosing* to see an object as fully intended freed our minds from the lure of parsing intention and accident, in order to give ourselves over to the demanding task of articulating what a form is doing in the full complexity of its internal and external relations. Similarly held at bay was the expression of wishes for the work to be different. Instead of saying what we wished to be different we tried to name what the form was doing *as it was* that led us to wish it otherwise.

Looking back, I suspect that what these several constraints did was in some ways very simple. They conspired to keep us from escaping encounter with the object itself. Quite simply, it is easier to make associations and to share wishes for a slightly different version of the work than it is to settle the eye and mind and to humbly begin to name what is there.

We asked the artist to just listen and take notes. We asked the artist to say nothing until the following week, and in that time to take up privately the connect and disconnect between what was intended and what was in fact communicated. These are ethical choices with real consequences—time and privacy to contend with information this multiply loaded makes it possible to move one's thinking forward. Performing one's response to feedback before an audience limits greatly the ways forward. Intimate reading of a work needn't require skinning the maker.

We practiced this form for the remainder of the semester. Mostly with objects, but also with video and installation. Each slow start naming the seemingly obvious verifiable aspects of a form temporally re-inscribed our shared belief that materials and forms have the capacity to communicate. This common ground of observation served also to anchor dissenting views. *Can we come back to the way this section opens into this other one? We keep reading that as an invasion, but I see it in relation to this other opening and then it seems more like an*

inviting passage through. I was particularly interested in these branching moments when, from the common ground of verifiable observation, there emerged very different, but legitimate ways of connecting relations among elements.

We developed a nuanced sense of what constituted a connection and what an association, and which of those insistent but not immediately connectable associations were worth bringing forward. One person might say *Ok, I know this is an association, but I keep thinking about carnival rides.* Or *I don't know why but I feel incredibly sad the longer I look at this.* And then it was our work to trace back through the verifiable elements what relations it was among them that could be producing that sense. In one of the more beautiful moments of the semester, a series of four minimal towers, thin plaster skins around concrete cores, began to produce in the group a sense of estrangement, specifically familial estrangement. We traced our way back to the verifiable fact of the distances between the towers, in relationship to the proportion between insides and outsides, the cold neutrality of the outsides. I watched out of the corner of my eye as the artist sat quietly taking notes, her face reflecting the humble assurance of someone whose work was generating the very dynamic that led her to make it. Absolutely different than if she'd stood before the work telling us what it was about, before letting us loose to play the relatively easy game of comparing her work with her words.

Confluences

Classroom experiments like these happen all the time. Artists do not invent only in the studio. We work to forge spaces of study with and for our students. Sometimes a discovery is made of a precedent that, if known, would have made of one's own experiment a continuation rather than a seeming beginning. Artist and philosopher Erin Manning makes the useful distinction between influence and confluence, where the latter describes exactly this moment of discovering a heretofore unknown precedent (Manning 2015). To situate this classroom experiment within a wider ecology of pedagogical inquiry, I want to trace several bands of both influence and confluence.

In the realm of confluence there is the vital precedent of artist and professor Mary Kelly's method of critique. Recently brought to my attention, I attempted to track down some detailed report of it, and found only fragments tucked here

and there. In a video interview, Kelly delineates the essential approach as "a very, very detailed reading of the work where the artist doesn't speak at all but everyone else kind of works on the reading of the piece, semiotically speaking" (East of Borneo 2011):

> I start with the phenomenological. . . . Oh it was light or it was empty or it was confusing. How much meaning is already in place there and how do you kind of pull yourself away from what you're bringing and what the artist is bringing to that situation through the work. But not through their biography. You actually just unrealistically pretend you don't know them in my class, which I know is absurd. But just trying to pull away from that, not to make any assumptions on that basis. And often we as artists are not fully knowledgeable about exactly what it is we've done. There is an intentionality; you appreciate it if people could try to follow that argument, but you can find out things yourself. So why put you on the spot to say over again in words what you did in another way. . . . There must be more to it than someone just asking you why did you do that? Well maybe you don't even know, but I did *that* so what does *that* mean.
>
> East of Borneo 2011

I'm glad in some way that my students and I were able to make our own discoveries, but I do wonder how much else of early feminist pedagogy is lost to my generation and hence to succeeding ones.

Stefano Harney and Fred Moten, in their book *The Undercommons: Black Study and Fugitive Planning*, offer a notion of *study* that resonates strongly with my own understanding of what constitutes a rigorous studio practice. Requisite for both studio practice and study (and by extension for any practice of studio critique as close reading) is the devising of methodologies for holding back those forces that would otherwise encroach on the open field of study. A classroom can still be a place of study, but practices must be implemented to continually clear out all the calcifying habits that will otherwise maintain that space as their own. Moten offers this:

> What's totally interesting me is to just not call the class to order. And there's a way in which you can think about this literally as a simple gesture at the level of a certain kind of performative, dramatic mode. You're basically saying, let's just see what happens if I don't make that gesture of calling the class to order—just that little moment in which my tone of voice turns and becomes slightly more authoritative so that everyone will know that class has begun. What if I just say, 'well, we're here. Here we are now.' Instead of announcing that class has begun, just acknowledge that class began. It seems like a simple gesture and not very

important. But I think it's really important. And I also think it's important to acknowledge how hard it is not to do that.

<div align="right">Harney and Moten 2013: 126</div>

I introduce this provocation of Moten's partly as a dare (I have been experimenting with it and it *is* difficult) and partly to establish an order of nuance in what I am calling for in this paper. It might seem that Moten's refusal to call the class to order and my own insistence that the practice of critique be framed explicitly are on opposite sides of a continuum, but what they have in common is more important. In each case it is about recognizing and interrupting the habits of power in the context that is a classroom. *Not saying* "ok let's get started" and *saying* "how do we understand this thing called critique that we are about to engage in?" are each a kind of renunciation.

Jacques Rancière's *The Ignorant Schoolmaster* oriented me to the significant role of the *verifiable*, be it text or art object, as necessary ground for common study, and influenced my first attempts to distinguish among different ways of responding to an object. Rancière's text builds on the "intellectual adventure" of French-speaking Joseph Jacotot, sent in 1918 to teach in the Netherlands. Facing students with whom he shares no common language, he brings them a bilingual edition of *Télémaque* and instructs them to begin teaching themselves the French language. "He had only given them the order to pass through a forest whose openings and clearings he himself had not discovered" (Rancière 1991: 9). It is difficult not to read passages such as the following as renderings of what studio critique as study might look and feel like:

> ... by observing and retaining, repeating and verifying, by relating what they were trying to know to what they already knew, by doing and reflecting about what they had done. They moved along in a manner one shouldn't move along— the way children move, blindly, figuring out riddles. . . . All their effort, all their exploration, is strained toward this: someone has addressed words to them that they want to recognize and respond to, not as students or as learned men, but as people; in the way you respond to someone speaking to you and not to someone examining you: under the sign of equality.

<div align="right">Rancière 1991: 10–11</div>

His translator's choice of the word *stultification* to stand for Rancière's own *abrutir* ("to render stupid, to treat like a brute")[3] captures precisely my objection to the opinions of teachers being the primary thing communicated by any critique. If a student leaves a conversation about her work with only the opinions

of her teacher, she has indeed been educated, but perhaps only in the aesthetic inclinations of her teacher. By contrast, when time and effort are given to collectively tracing how a student's materialized decisions communicate, and effects are understood as arising from verifiable observations about the relations (and the relations of relations) of which any work consists, then a student will learn something about *and from* her own work. As one student put it: "I remember the ability to go back to the studio with concrete action points. Instead of being filled with people's personal stories I was filled with communication from the piece itself" (Benbernou 2015).

Remainders

As I prepared to write this text, I wanted confirmation that what I thought had taken place had in fact taken place for my students as well. I've kept in loose touch with many of them and they generously responded to a query I sent out. In reading their reflections five years on, I was struck by the centrality of what one student dubbed the "Axiom of Intention." I had seen it as a secondary constraint, but as their responses accumulated it was clearly more central than I had thought:

> There were few rules, but they were non-negotiable, and the first rule was more an axiom than a rule, anyway. The Axiom of Intention, let's call it. It's the idea that the art, the object, is exactly the way the artist wants it to be. Without that, the other ideas just sort of evaporate into a lot of talk. . . . When you assume intention, you give the artist a respect they can grow into. Does that make sense? I know and you know that when I produce a sculpture, some of it probably gets away from me. Who cares? That's life. Hopefully I'll have better control the next time. The Axiom of Intention focuses the discussion on an actual concrete object or experience that everyone in the room can perceive, and doesn't abuse the artist who was kind enough to put work on display.
>
> Underhill 2015

Several of the students wrote of the silent looking that kicked off our close reading and the clarity it produced:

> Not only did we nurture the observers' fresh perspective we recreated it for the exhibiting student artist. By beginning in silent empirical observation we gave the artist the critical distance that is lost while creating. In that moment of silence and final execution he/she is given time to see if all the elements involved

are actually serving the work in the way they were intended. In that still moment removed from the chaos of the communal studio space and relieved of the stress of preparing for that very critique the artist is finally able to step back and really see what it is he/she had put together.

Ristic 2015

In the time elapsed since this classroom experiment, other lines of curiosity have joined themselves to the ones that first led me in. One of these has to do broadly with how little trust members of the public appear to have in their own experience of art viewing. A person fully capable of noticing and responding to a tree outside a gallery crosses the threshold into the gallery and becomes suddenly unable to muster that same capacity facing a work of art. (It strikes me that tree, work of art, and viewer are all underestimated here.) Could changing how we talk about work amongst students and teachers ripple out to offer other kinds of orientation to works of art? And what of this fiction my students and I allowed ourselves: becoming "just eyes" for one another's work? How does this square with our knowledge that all seeing is located and that a viewer's gender, sexuality, race, class (but also humor, anger, hope) inflects their seeing? These differences don't make a difference equally, and in the context of higher education in studio art, it feels particularly vital to take up the question of racialized seeing.

Very much an open question for me is whether this close reading my students and I practiced tends toward the interruption or the reinforcement of those pervasive dynamics of marginalization that make it so difficult for students of color to get what they need out of classroom practices such as group studio critiques. It was both sobering and heartening to see in the results of a recent diversity survey at our college how often studio critique came up as a concern for our students of color. Sobering in the sense of seeing how much I hadn't seen of the way this central pedagogical practice, especially when performed in classes with one or only a few students of color, becomes another place in which insides and outsides, "included" others against a normed white background, get inscribed. Heartening in the sense that addressing that which is visible from a "frog perspective" may yet force a rigor and transparency to the practice of studio critique that will benefit every student artist. I want to be absolutely clear here: while "frog perspective" arises from navigating conditions of oppression (and is thus inextricable from a certain lack of privilege), where *sight* (and I would add *insight*) is concerned, this *is* the privileged position. It sees more, knows more, can name more.

I want to propose that we view the habitual enactment of studio critique as a kind of symptom. Our common understanding of a symptom is as an indication of some disorder in a system. Here symptom is seen primarily as expression. But in the cybernetic approach of those communications researchers whose thinking has so influenced my own, a symptom is not only a thing that kicks out of a body but also one that kicks back in and *makes* a larger collective body. In the context of family therapy, Watzlawick et al. suggest moving ". . . toward viewing symptoms as one kind of input into the family system rather than as an expression of intrapsychic conflict", and further as "a piece of behavior that has profound effects in influencing the surroundings" (Watzlawick et al. 1967: 44, 45). What happens if we transpose this repunctuation into our own context? Might we begin to recognize how certain dynamics of our field are protected or even produced by the seemingly minor habit of keeping studio critique a tacit set of agreements, not plainly asking in each new gathering of students what it is we mean to undertake. Habit is efficient, it need only remain unnoticed to continue its work.

Gregory Bateson famously called noise the only source of the new (Bateson 2000: 416). My students and I made one kind of noise in the system within which we found ourselves, and something came of that. Something immediate and something with a longer tail that flicks about still. Everything communicates; in the realm of studio critique, the lack of explicit instruction communicates whether we mean it to or not. When I addressed the distinction between digital and analog communications earlier, it may have seemed that I was most interested in those aspects of the analog realm that have to do with affect, with the state in which a student artist leaves a critique. That does matter to me. If we can transmit the same content in ways that leave students affectively mobilized, eager to get back into their studios, why would we *not* communicate that way? But there's another way that our lack of explicit instruction communicates analogically. Recall that analog communication is always a proposition about relationship. Every student studies her teachers as much as their subjects.

To the student studying her studio art teacher, what gets taught explicitly about contemporary art practice must always resolve itself against what gets taught implicitly about the context, habits, and power arrangements patterning the field. Recall this oscillation at the base of all analogic communication: "This is how I see myself . . . this is how I see you . . . this is how I see you seeing me. . . ." (Watzlawick et al. 1967: 52). In how we practice critique, in whether we take the time to find out what understandings of the task pre-exist each particular

gathering of students and teacher around a work, in how we privilege some subset of the multitude of communications that could be made in response to a work, we not only reveal our most fundamental epistemologies of art making and viewing, we enact them.

Notes

1 Illustrations and additional images at http://www.judithleemann.com/teaching.

2 The word "impotent" I borrow here from Fluxus artist Robert Filliou: "as soon as you have left a house where you were talking to friends, to a girl, etc. you realize clearly what you should have said or done, but somehow didn't. . . . Feeling too strongly that what we should have said is more important than what we actually did say, can only lead to guilt, or impotence, or both" (Filliou 1970: 74).

3 The principle of stultification emerges from the emphasis on explication as necessary to learning: "The pedagogical myth . . . divides the world into two. More precisely, it divides intelligence into two. It says that there is an inferior intelligence and a superior one" (Rancière 1991: 7).

References

Bateson, Gregory (2000), *Steps to an Ecology of Mind*, Chicago, IL: University of Chicago Press.

Benbernou, Courtney Kim (2015), "Re: Critique," Message to the author, September 23.

East of Borneo (2011), "Mary Kelly—Experimental Impulse Interview (2011)," Online video clip. YouTube, 14 November.

Filliou, Robert (1970), *Teaching and Learning as Performing Arts*, Cologne: Verlag Gebr. König.

Harney, Stefano and Fred Moten (2013), *The Undercommons: Fugitive Planning and Black Study*, Wivenhoe: Minor Compositions.

Leemann, Judith (n.d.), "Observations on Forms and Patterns of Critique." Available at: judithleemann.com/teaching.

Manning, Erin (2015), Personal communication to author, July 30.

Moten, Fred (2013), "Blackness and Nothingness (Mysticism in the Flesh)," *South Atlantic Quarterly* 112(4): 737–80.

Rancière, Jacques (1991), *The Ignorant Schoolmaster: Five Lessons in Intellectual Emancipation*, trans. Kristin Ross, Stanford, CA: Stanford University Press.

Ristic, Lidija (2015), "Re: Critique," Message to the author, September 22.

Underhill, Inanna (2015), "Re: Critique," Message to the author, September 22.

Watzlawick, Paul, Janet Beavin and Don Jackson (1967), *Pragmatics of Human Communication: A Study of Interactional Patterns, Pathologies, and Paradoxes*, New York: W. W. Norton & Company.

Wright, Richard (1978), *White Man, Listen!* Westport, CN: Greenwood Press.

Will the Circle Be Unbroken? Gift, Circulation, and Community Building in the Studio Art Crit

Shona Macdonald

Introduction

One of the exchanges that most concerns art educators is that of the studio critique, or "crit." Though ubiquitous, there lies much exhaustion and confusion around its use and purpose. This essay attempts to reframe the studio crit by considering how its format could lie within a "gift economy" and proposes some alternative pedagogical models that may rejuvenate it. Critique is explored in a theoretical sense, and "the crit" as a pedagogical practice. I theorize that the pedagogical studio crit lies under the heading of "new criticality," and becomes symbolically and physically circular. While critical analysis, or art criticism, might use the metaphor of the line: art work begins at point A and finishes with criticism at point B. New criticality, adopts a circular form, not only in its fluidity and continuity, but also in its circulatory exchange.

Gift

For it is only given you on condition that you make use of it for another or pass it on to a third person.

Marcel Mauss (1950: 55)

In his 1983 book, *The Gift: Imagination and the Erotic Life of Property*, scholar, essayist, and translator, Lewis Hyde, encourages us to rethink the indebtedness we may feel upon receiving a gift by removing the gift from market exchange and

placing it into what he calls a "protected gift-sphere" (Hyde 1983: 272). One example Hyde provides of this sphere is the university where the gift is one of intellectual growth. By distinguishing three types of gifts: natural, spiritual, and communal, Hyde theorizes that the passage of the gift from giver to receiver is one of circulation and return. The first type of gift refers to actual live gifts (an organic or edible gift). The second refers to what Hyde terms "agents of a spirit that survive the consumption of its individual embodiments" (Hyde 1983: 150): when cultural or spiritual enlightenment is achieved through imbibing a symbolic liquid, like mead, or giving a traditional object, such as a lump of coal on "Hogmanay" in Scotland, symbolizing prosperity and good health. The third, with which my essay will concern itself, applies to moments when community is created through the circulation of the gift. Gift exchange frames the studio crit so aptly because both work to form community among small groups of people who build cultural knowledge and consensus.

Through various narrative accounts of gift-giving, Hyde suggests we are moved by the spirit of the gift to return the gift back to the donor: "when the gift moves in a circle, its motion is beyond the control of the personal ego, and so each bearer must be a part of the group and each donation is an act of faith" (Hyde 1983: 16). The gift is not necessarily a material object, but may be words, thoughts, or actions. One example in Western culture is the tradition of sending hand-written notes back to the giver upon receiving physical gifts and the goodwill that stems from this, mutually benefitting recipient *and* note-writer.

If we consider the studio art crit to be cyclical, and acknowledge our role as educators in completing the cycle, the critique-as-gift gets offered back to the student in a spirit of reciprocity. We shift positions from the crit model Irit Rogoff describes as, "illuminating flaws", or berating students, to one that is optimistic and generous (Rogoff 2006: 2). The gift in this context lies in the generosity of spirit, labor, and time invested during the crit. The crit then returns the very same qualities embedded in the invention and construction of the artwork at the onset of the process.

One of Hyde's central ideas is that the gift should be understood as an *act* rather than an *object* and that it is made manifest in "cycles of obligatory return of gifts." Hyde's book is often framed as a critique of the 1925 book, 'The Gift,' by French sociologist, Marcel Mauss. Mauss' volume, of modest length, is widely considered the bedrock of anthropological, social, and cultural studies about gift exchange. In her forward to Mauss' book, Mary Douglas discusses how we "maintain the spirit of the gift and lead towards transformation of both giver and

recipient" (Mauss 1950: x). This "obligatory reciprocity" (as Mauss calls it) becomes the responsibility of the educator in ensuring a deep, thoughtful, and constructive crit. While Mauss embeds the gift in economies of trade, Hyde separates them. Mauss associates gift exchange with economic survival through many ethnographic examples, specifically of North American Pacific islanders' exchanges of "live" gifts, while Hyde proposes gift circulation continues to lie *outside* the market. Mauss' book provides an ethnographic account of gift-giving amongst various groups, mostly Pacific Islanders such as the Alaskan Tlingit, but also groups of people in Melanesia, Oceania, and Germanic dowry customs and legal systems. Despite his lament for these lost customs coming from a colonial position, Mauss' insistence upon a return of the gift within a system of circulation mirrors that of Hyde and intends reciprocity, goodwill and well-being.

The anti-individualism implicit in Mauss and Hyde's texts is an important antidote to the relatively solitary studio art practice (as opposed to theater, music and cinema) as is the gathering at the studio art critique. We can build community within this gathering as the whole process of critique becomes the gift. "Only when the increase of gifts moves with the gift may the accumulated wealth of our spirit continue to grow among us, so that each of us may enter, and be revived by, a vitality beyond his or her solitary powers" (Hyde 1983: 39). This requires some re-structuring as the current large group formats with their requisite random, unmonitored comments can be monolithic and impenetrable.

Many current studio crit models attempt to describe, analyze, interpret, evaluate, and judge work, all words that imply an archaeological practice of critiquing, as though answers are merely lying in wait for viewers or "critics" to unearth. These models no longer fit. There are a number of reasons why. For students, the purpose of the crit is not defined enough within the programs in which they study. Faculty fail to commit to words a clear rubric of the format and purpose of the crit. Also, the naturalized language we have constructed around crits is no longer relevant, tinges of Modernism permeate the words we use such as "powerful" and "strong," for example. The last major problem is that of authority. Students are rendered silent by dint of faculty frequently assuming this role. Irit Rogoff highlights these concerns, stating, "Criticality as I perceive it is precisely in the operations of recognizing the limitations of one's thought for one does not learn something new until one unlearns something old, otherwise one is simply adding information rather than rethinking a structure" (Rogoff

2003: 2). I propose that if crits can return the work back to students by re-structuring staid formats and re-thinking outcomes, we can achieve the spirit of generosity, of giving, and model what Hyde describes as transformative gift(ing): "It is also the case that a gift may be the actual agent of change, the bearer of new life" (Hyde 1983: 45).

Work of the gift in the studio crit

An essential portion of any artist's labor is not creation so much as invocation. Part of the work cannot be made, it must be received.

Hyde (1983: 143)

Parallels can be drawn between the completion of the circle called for in Hyde and what I am calling a "new criticality" and its move towards immediacy and reparation. Current scholars such as Rogoff and Bruno Latour describe critical thinking as destructive. As Rogoff puts it, "We have to be aware of the extreme limitations of putting work in 'context' or of the false isolation brought about by fields or disciplines ... and the fact that meaning is never produced in isolation or through isolating processes but rather through intricate webs of connectedness" (Rogoff 2006: 1). Both Latour and Rogoff are wary of any insistence upon critique as a form of unearthing or uncovering, as though meaning is already present and the role of the critic is to draw that out. Instead, they propose a way forward that would, in Latour's words, "indicate the direction of critique not *away* but *towards* the gathering, the Thing" (Latour 2004: 246). This echoes Rogoff's caution to bring immediacy to the site of the critique and not treat the work of critique as "digging" or "uncovering." Latour further compels that the critic "is not the one who debunks, but the one who assembles" (Latour 2004: 246).

Is it possible to reconstruct the studio crit along the lines of Hydian critique? A reformation? A job we do with, not for or against, students? During my own graduate experience, critique based on French deconstruction flattened, leveled, and destroyed work. Rather than finishing the work in the spirit of generosity outlined in Hyde, Mauss, Rogoff, and Latour, some faculty assume the role of power, and apportion blame on students. Now, as an educator myself, I strive to define my role in studio crits as acknowledgement of what the work invokes, a finishing or "completion" of the work, and a forming of community. Meaning shouldn't be excavated by one person alone (i.e., teacher as authority

figure) but rather take place at the time of the critique so all the requisite aspects of duration, location, and group dynamic, get included—in other words, the "site of the critique." This doubles back to Latour's call towards the immediacy of the critique with its attendant aspects of space, duration, and the sounds of gathering voices.

I am interested in focusing on the experience of receiving the work by the audience as gift, rather than Hyde's other idea of art-making or art-production as itself a gift. Hyde describes the gift's reception and what happens with that received (the returnability) as the gift, rather than the physical object of the work itself. This is the part of the process Hyde believes stands outside commerce. Even if the artwork later becomes commodified, this still holds. For teachers in studio art critiques, the privileged position of "first viewers" is conferred upon them and the gift is then for them to return, to pass back, as another form of gift. Hyde describes the market economy as "getting rather than giving" (Hyde 1983: xii), and this, he believes, is why art is a gift and not a commodity. Hyde expands his argument further by describing how the gift survives only by its ability to circulate. It doesn't stop after the gift is given: "a gift that cannot be given away ceases to be a gift. The spirit of a gift is kept alive by its constant donation" (Hyde 1983: xiv). The distinction between this returning of the gift and altruism is that any return of the gift within the "gift-sphere" described by Hyde carries the weight of responsibility to *want* to return it, whereas altruistic gift-giving does not. Altruism doesn't necessarily lend itself towards participation. One can act alone.

An objection to Hyde's point of view is that held by Jacques Derrida. In *Given Time*, Derrida posits the returnability of the gift (as described by Hyde and Mauss) as a double-bind: a gift is no longer spiritually a gift if it evokes the feeling to return it. In such cases, the recipient feels indebted to repay the favor of the gift and it turns the gift into a commodity. He believes returning gifts annuls the very intention of giving the gift in the first place—to give freely. He does not believe in the simultaneity laid out in Hyde and Mauss' theory of gift exchange. Derrida also claims that what a gift gives is time: it takes time to offer the gift, time to receive, time to respond, and time to return it: "the gift gives, demands, and takes time. The thing gives, demands, and takes time. That is one of the reasons these things of the gift will be linked to the internal—necessity of a certain narrative" (Derrida 1992: 41). Derrida asks, why should the gift be returned if the intention in giving a gift is unconditional? His notion of giving is devoid of any returnability or obligation to reciprocate. Derrida's position, in

regards to the returnability of the gift, is further illustrated in *Hospitality*: "For if I practice hospitality *out of* duty and not only *in conforming with* duty, this hospitality of paying up is no longer an absolute hospitality, it is no longer graciously offered beyond debt and economy, offered to the other" (Derrida 2000: 48). In this passage, Derrida outlines the symbolic differences between having to do something and accepting that one should do something out of a sense of responsibility (or hospitality). I would argue that if we re-define this position from "responsibility" to "willingness," the latter of which I would suggest lies at the heart of the position we take in studio critiques, we can re-frame critique as gift-exchange and keep the gift moving. In the system of the gift-critique, participants are moved to speak, reciprocate, and contribute.

The fundamental difference between Hyde and Derrida's points of view is that while Hyde believes the gift lies in its returnability, Derrida believes a gift must not be given back or it destroys the terms of the gift in the first place: "He ought not owe" (Derrida 1992: 13). Derrida cannot see beyond the reception of the gift as carrying debt (in the form of gratitude) that then, when expressed, annuls the gift. I would suggest, on the other hand, the gift is matched when goodwill from the donor provokes goodwill from the donee. Further, if we view the reception of the artwork at a studio critique as the beginning of the gift cycle and the role of crit as willing responsibility, the gift remains intact.

Circular critique: Models as gifts

The gift not only moves, it moves in a circle.

Hyde (1983: 13)

Above, I have discussed studio critique under the rubric of gifts to be returned back to students. How does this manifest in specific practices of the studio crit? Gifts, and new critique or critical practices, such as "Round Robin," and "Threeing," both use circles to direct the flow of bodies and thought. Circular thinking can, of course, be circuitous and indirect but it can also be holistic and able to replenish itself, a cycle, intended for circulation. Threeing and Round Robin illustrate both the symbolism of the circle in the physical motion of bodies in relation to space and, metaphorically, in the circulation of words and thoughts back around towards the maker.

Round Robin, invented by artist and professor, Matthew Kolodziej, from the University of Akron is a method where small consecutive groups form in which students critique each other simultaneously. According to Kolodziej, "this enables students to take charge of assessing their own work. This critique structure allows full participation from students while affording time for feedback from the perspective of the instructor." Agency shifts to the students in the Round Robin as "before the critique, students define specific issues they want covered" (Kolodziej 2015).

To implement, students split into four or five groups with approximately four students in each. If the class is larger, there will be more than five groups but the model is best suited to mid-sized classes of around twelve to fifteen students. A timer is set to around seven-minutes and one student per group presents their work to the group. The four students form a dialogue about the work then after concluding comments at the seven-minute mark, all but the presenter rotates clockwise to the next presenter. The presenter who stays put meets the next group who form a new dialogue. Again, after seven minutes, this second group moves on and the third group attends to the presenter. This action proceeds until the original group, having rotated all the way around the room, returns to its starting point. A new presenter self-selects and the Round Robin begins again. Through listening and offering prompts, the instructor engages with each group to help facilitate ideas and conversation.

Dynamic group movements, repetition, and carefully timed slots (seven minutes each), eradicate the "dead" weight of silence (common in current studio critique methods) and the physical, circular motion energizes the room and prevents lethargy or inattentiveness, as well as inspiring the notion to give back or return the gift-work in the form of gift-critique. After forming small, prescribed groups, I successfully tried Round Robin with my Advanced Drawing students. Positive outcomes included thoughtful, reflective commentary about the work of peers, physical engagement, shifted agency towards students, and pleasure in the act of analysis. According to one student, the circling motion of the Round Robin literally "kept me awake." Another student said he preferred Round Robin over other critique methods he had tried because normally, "I find critiques inhibiting because the whole class is listening to what I am saying like it is the most important thing ever." The critical point about Round Robin can even be found in its name, that the circular, returnability of the physical bodies moving in space draws out philosophical and poetic critique, given back in a

spirit of goodwill. Such a practice builds on Hyde's fundamental argument concerning the circularity of gift exchange:

> Reciprocal giving is a form of gift exchange, but it is the simplest. The gift moves in a circle, and two people do not make much of a circle. Two points establish a line, but a circle lies in a plane and needs at least three points. This is why ... most of the stories of gift exchange have a minimum of three people.
>
> Hyde 1983: 16

At the same time, Hyde's theory of exchange recalls Derrida's conception of the circularity of the gift: "One must in a *certain way* of course inhabit the circle, turn around in it ... and the gift, the gift of thinking, would be no stranger there" (Derrida 1992: 9).

Artist and teacher Paul Ryan's methodology of Threeing similarly utilizes the mechanics of space and carefully designed structure to upend power structures and rote conversation. As a practice, Threeing may be applied to any situation, such as a focus group discussion, conflict resolution, workshop, or an art crit. Threeing pledges to replace authoritative figureheads with community-building. Developed in the 1970s, Threeing was only recently brought to my attention by Professor Susan Jahoda, from the University of Massachusetts Amherst, and the New York City-based collective, The Pedagogy Group. Another member of the group describes replacing the "hierarchical" structure of critique with what she calls the "heterarchical" structure of Threeing (The Pedagogy Group 2014: 13). One of its main tenets is to re-balance power by positioning three people together, all who assume and carefully adhere to, specific, defined roles.

This practice can be tried as an art critique. First, the room or studio should be rearranged free from gridded desks and chairs. Groups of three—or four if three is unavailable—form, and within these groups roles are assigned based on individual skillsets. These roles are "initiator," "respondent," and "mediator." Bearing in mind that the critique should be considered as physical and not just propositional, within the circuit, there should be awareness of one's body as well as mind. The following is a description, from The Pedagogy Group of Threeing:

> Threeing ... assumes the roles of *firstness* (a free, spontaneous initiator), *secondness* (reacting without analysis to firstness), and *thirdness* (mediating between the two previous positions) subjects become aware of how they interact

and construct meaning and how these meanings change and can be negotiated. If we visualize these roles as part of a circuit, where what one individual presents impacts the responses and behavior of the other two, then we can recognize that all three subject-positions are potentially fluid.

The Pedagogy Group 2014: 424

Evident in the number of participants and the designated roles, I am drawn to the non-hierarchical aspect of Threeing. When implemented as an art critique, one faculty could be paired with two students, for example. Because faculty voices do not dominate the proceedings, Threeing lies firmly within the gift-giving philosophy of critique. Also, because of the balanced, intimate groups whereby students assume any one of three roles, they cannot be overshadowed by either the physical mass of faculty or their volume of voices.

The practice of Threeing is akin to Mauss' description of the distinct roles everyone plays in achieving equality and equilibrium during the gift-cycle. For example, everyone gets to speak for the same length of time and equal weight is placed upon what everyone says. The carefully designed roles each participant assumes in the circuit provides equilibrium and mediation. The gift is returned slowly, quietly, as conversation flows in what Mary Douglas describes as "a cycling gift system" (Mauss 1950: xi).

Because it demands that careful attention be paid to one's position in the circuit, Ryan's practice of Threeing has not yet been widely adopted as an alternative crit methodology. However, its practices could offer a welcome and innovative alternative to the current grandfathered system of critiques complete with the predictable language we have constructed around them. Rogoff suggests that "What interests me in 'criticality' is that it brings together that being studied and those doing the studying in an indelible unity" (Rogoff 2006: 2). Her statement embodies the intended outcomes of the practice of Threeing as well as Hyde's theory of how gifts flow in the spirit of bringing-togetherness.

During studio crits time is a crucial component. Time is also present in the process of gift-giving. Interchangeable with the word *gift* is *present*, and also *to present* something. It takes time to present objects or experiences (by experiences I mean work that is non-visual or non-tactile) to viewers. It also takes time to absorb, digest, and translate those experiences at the site of the crit. One useful idea I have gleaned from criticality is how to take things in at the time of the event and not, as in older critique frameworks, bringing established knowledge and/or opinions to the event. This latter model fails to

acknowledge the time and place of the crit itself, described above in terms of a circuit.

Transformation

The outer gift . . . has become the vehicle for culture.

<div align="right">Hyde (1983: xvii)</div>

Lewis Hyde describes above, and on many other occasions in his book, how the gift becomes "transformative." Transformation is experienced in many different ways (spiritual, physical, philosophical), but mostly what matters to Hyde is how the gift, as cultural exchange, builds communities amongst people. I have proposed that the crit can offer a similar transformative experience through various examples, such as how agency shifts (during Threeing and Round Robin), the redistribution of authority, or how certain predictable structures of the crit (faculty re-making work for students) get reclaimed through the student body. Having viewed many current conditions of the crit as a set of preconceived methods applied to artwork during a gathering, I would like to propose a new way, re-framed under gift-exchange, of coming together, precisely at that cultural moment, the site of the crit. Adopting circularity symbolically and metaphorically enables all participants to receive then return back into the rotating cycle of events. The whole, circular system of the crit, then, is where knowledge gets produced.

Critic Howard Risatti teases out the word "transformation," asking that we "recognize this trans-form-ation as intuitive knowledge thereby rejecting its alternative, the idea of art as a purely emotive endeavor with no basis in scholarly knowledge" (Risatti 1993: 14). He concludes by insisting that "after all, transformation of the world must begin with imagination" (Risatti 1993: 15). Risatti emphasizes the importance of *form* in which artistic practice culminates, but in my own view, what is most useful in this passage is the suggestion that the studio crit can shape students' educational experience. Teachers are students and students are teachers in the critique-circuit. Older crit models that favor set power-structures fail to see how boundaries between entities (students/teachers) attach, as much as they attempt to separate or define subjects. For example, a fence erected marks a neighbor's territory as much as it is barricaded from it. Although Threeing and Round Robin have defined structures and roles, they are

set in place to distribute rather than seize, authority—another reason why the circular critique can be viewed as such a progressive model.

Conclusion

Gift-economies make for an ideal framework to re-think studio art critiques. The goodwill and community-building called for in many of the writers I have cited seems to lie at the heart of the crit's persistence. The obligatory reciprocity of the gift within the gift-cycle and its relative detachment from commodity exchange successfully re-frames studio crits in ways both useful and invigorated. By continuing to perform the studio crit, we will re-structure, repair, and rejuvenate from within. Just as Thomas Lawson called for painting to heal painting in *Last Exit: Painting*: "It is painting itself, that last refuge of the mythology of individuality, which can be seized to deconstruct the illusions of the present" and "the discursive nature of painting is persuasively useful, due to its characteristic of being a never-ending web of representations" (Lawson 1990: 149, 152). As a formality, the crit will likely be with us for a long time. The work of rethinking and recovery lies within the crit itself. Since gifts are bestowed upon us, perhaps we can attempt, as educators, in expending time and labor, to bestow the same generosity in our crit as that invested in the artwork we consider.

References

Derrida, Jacques (1992), *Given Time: 1 Counterfeit Money*, trans. Peggy Kamuf, Chicago, IL: University of Chicago Press.

Derrida, Jacques (2000), *Of Hospitality*, trans. Rachel Bowlby, *Cultural Memory in the Present*, eds. Mieke Bat and Rent de Vries, Stanford, CA: Stanford University Press.

Hyde, Lewis (1983), *The Gift: Imagination and the Erotic Life of Property*, New York: Random House.

Kolodziej, Matthew (2015), Conversation with the author, October 18.

Latour, Bruno (2004), "Why Has Critique Run Out of Steam? From Matters of Fact to Matters of Concern," *Critical Inquiry*, 30: 225–48.

Lawson, Thomas (1990), "Last Exit: Painting," in *Postmodern Perspectives*, ed. Howard Risatti, New Jersey: Prentice Hall, pp. 140–52

Mauss, Marcel (1950), *The Gift*, London and New York: Routledge.

Risatti, Howard (1993), "Formal Education," *New Art Examiner*, February: 12–15.

Rogoff, Irit (2003), *From Criticism to Critique to Criticality*, European Institute for Progressive Cultural Policies. Available at: http://eipcp.net/transversal/0806/rogoff1/en. Accessed October 19, 2016.

Rogoff, Irit (2006), *Smuggling—An Embodied Criticality*, European Institute for Progressive Cultural Policies. Available at: http://eipcp.net/transversal/0806/rogoff1/en. Accessed October 19, 2016.

Ryan, Paul (2009), *The Three Person Solution: Creating Sustainable Collaborative Relationships*, Lafayette, IN: Purdue University Press.

Ryan, Paul (2011), *Themes, Earthscore*, Available at: http://www.earthscore.org/themes.html. Accessed October 19, 2016.

The Pedagogy Group (2014), "Listening, Thinking, and Acting Together," *Rethinking Marxism: A Journal of Economics, Culture & Society* 26:3, 414–26.

Index